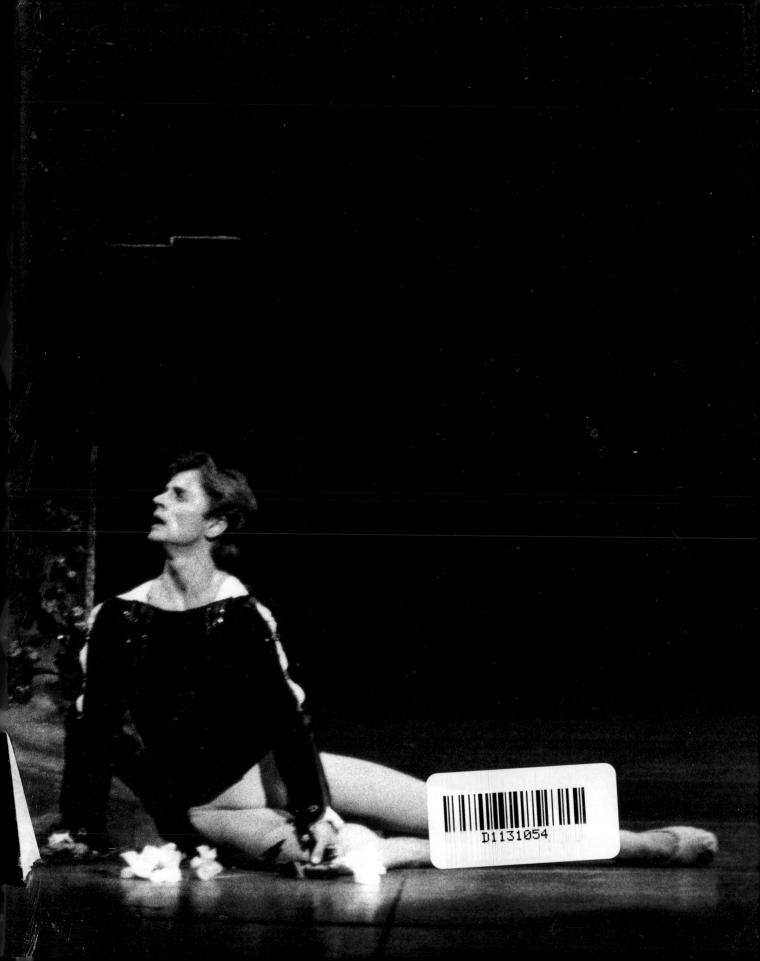

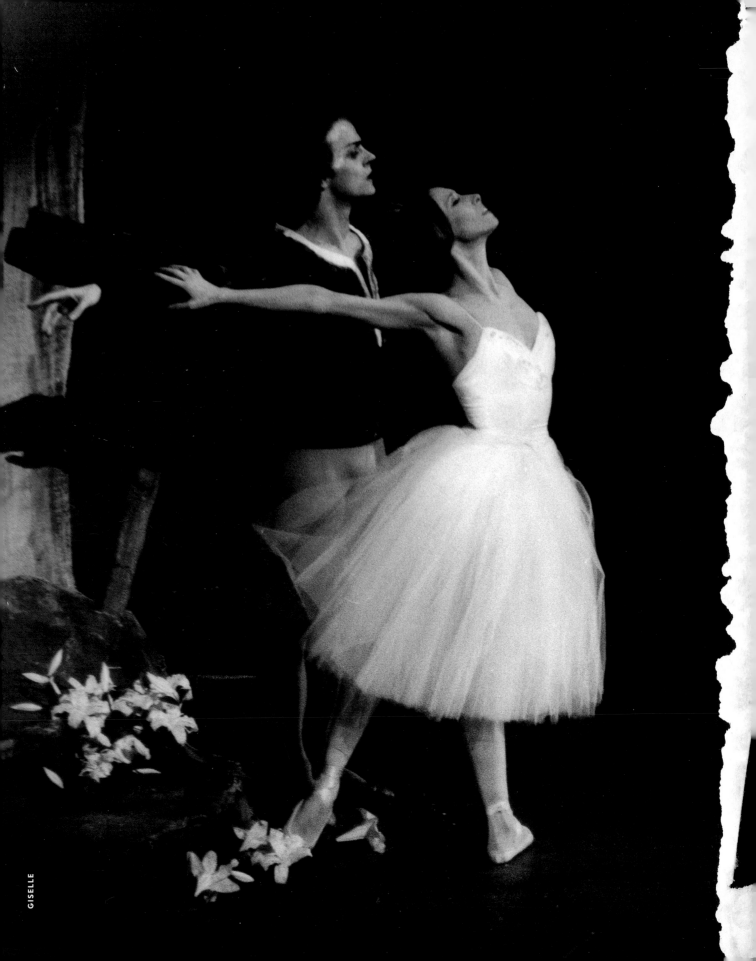

GISELLE

NINETEEN SEVENTY FOUR

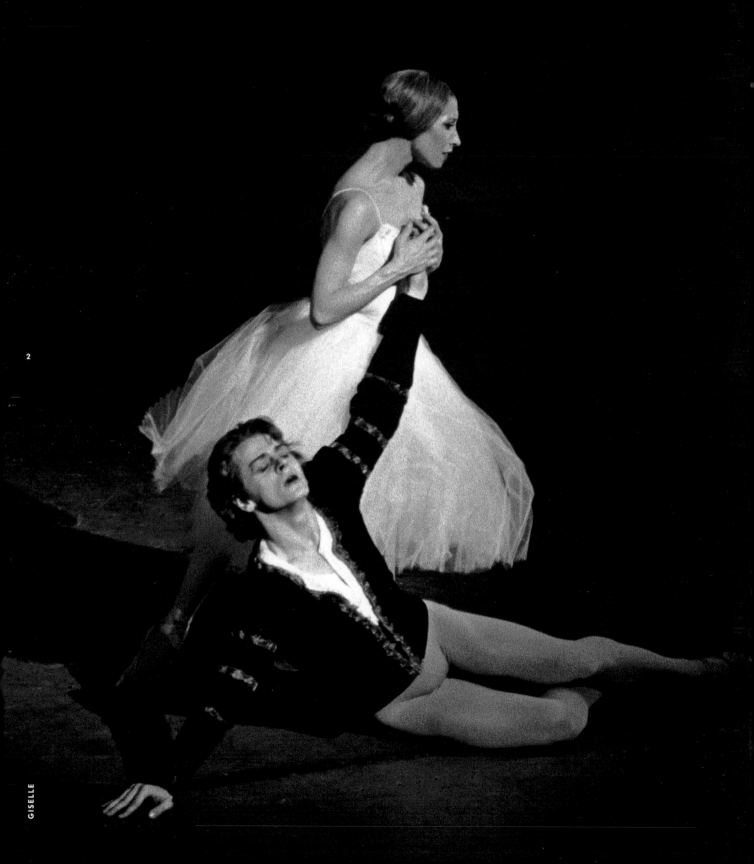

2

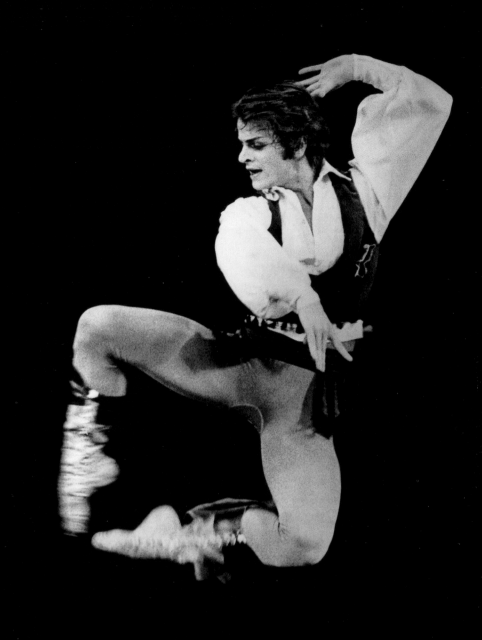

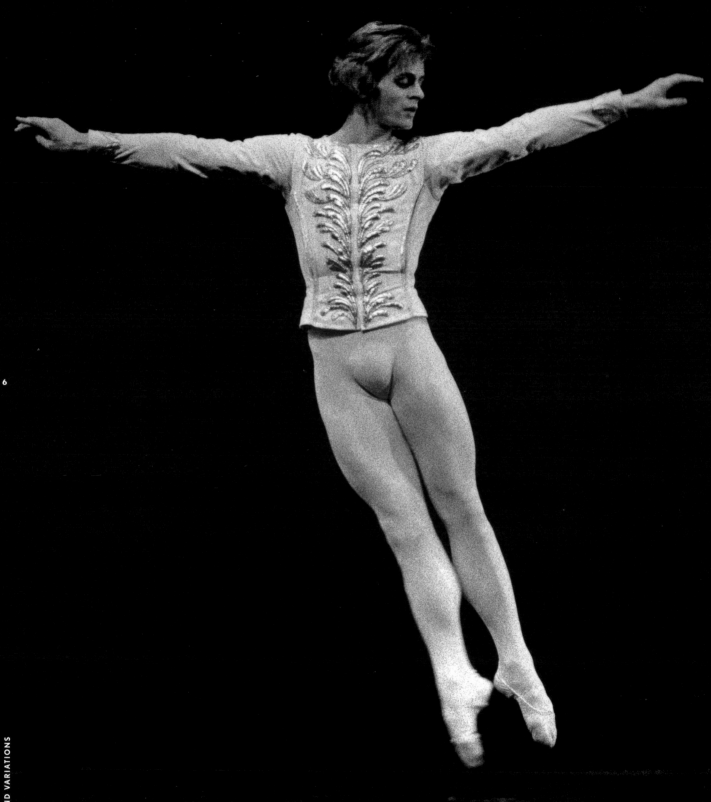

NINETEEN SEVENTY FIVE

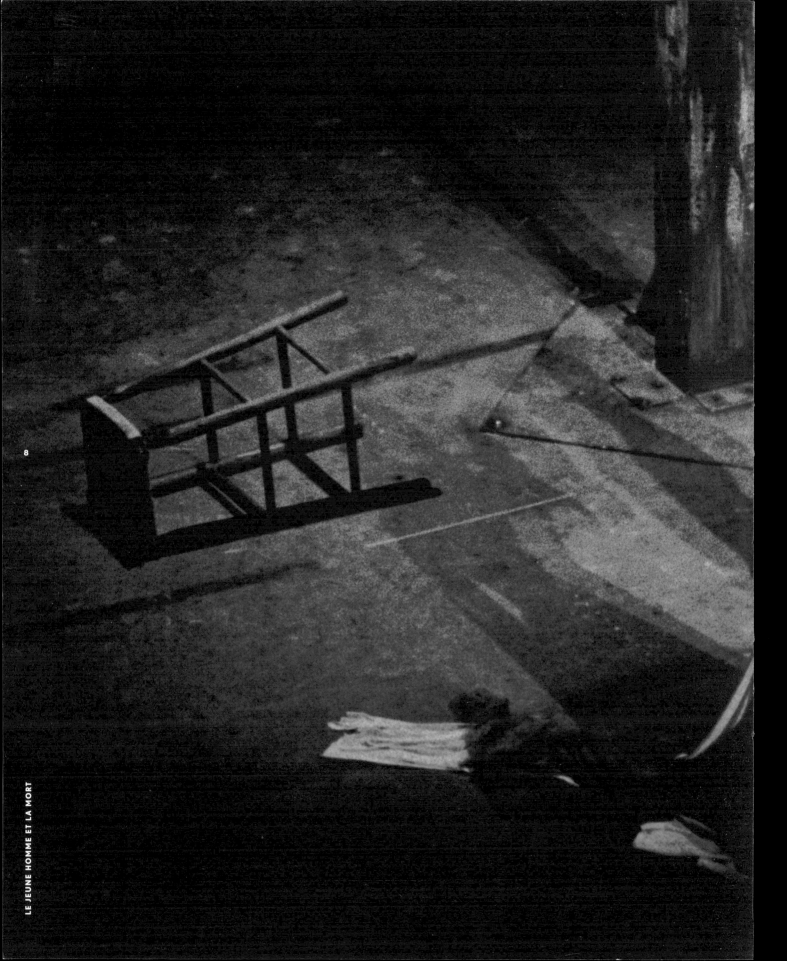

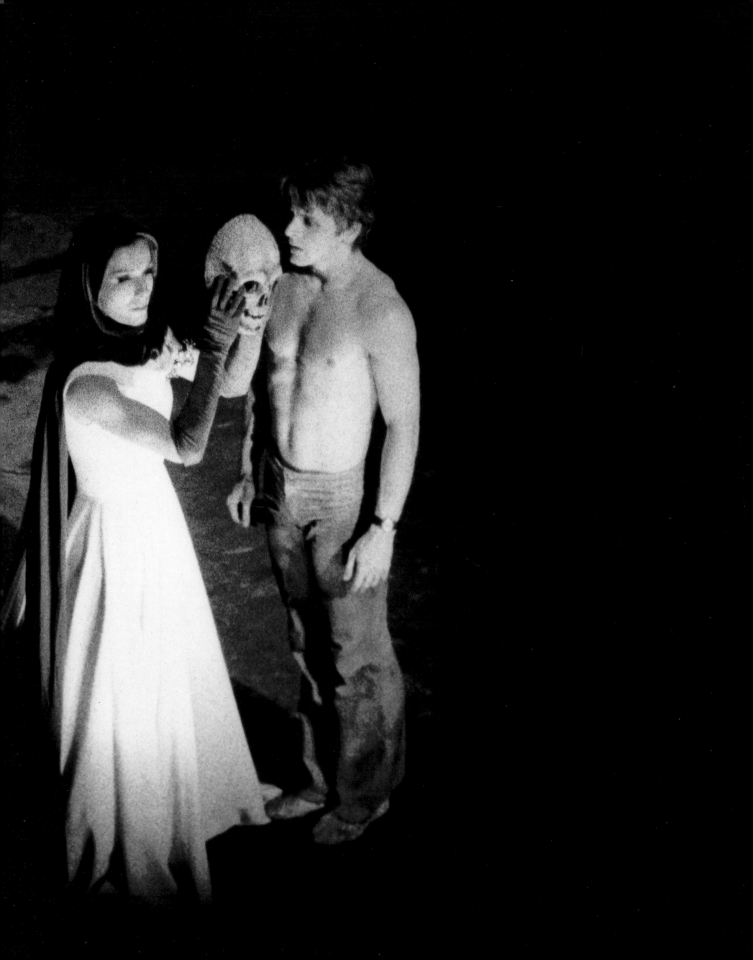

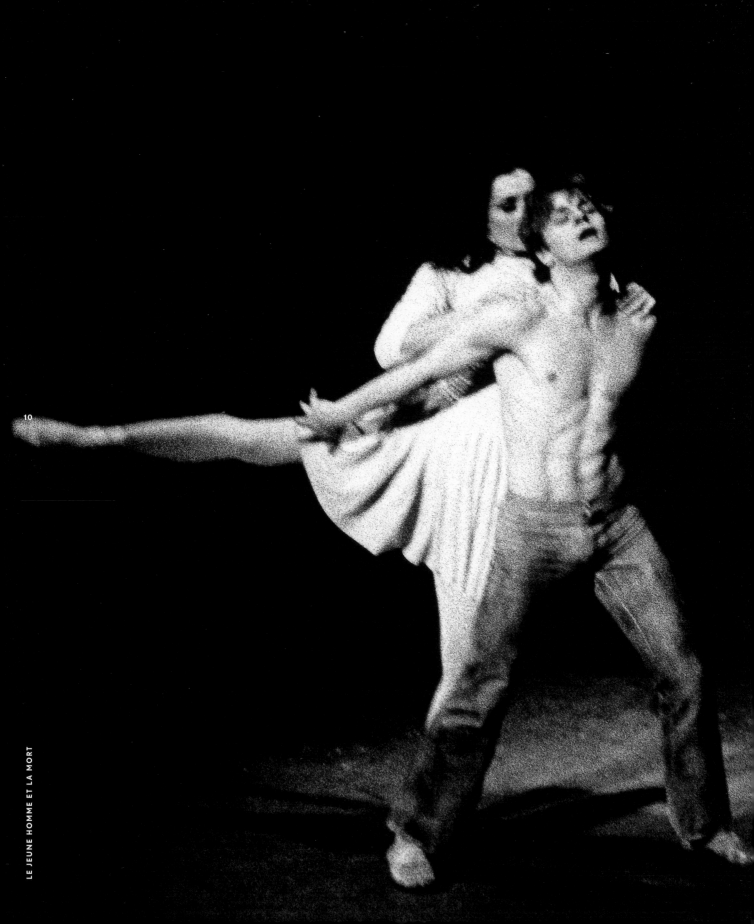

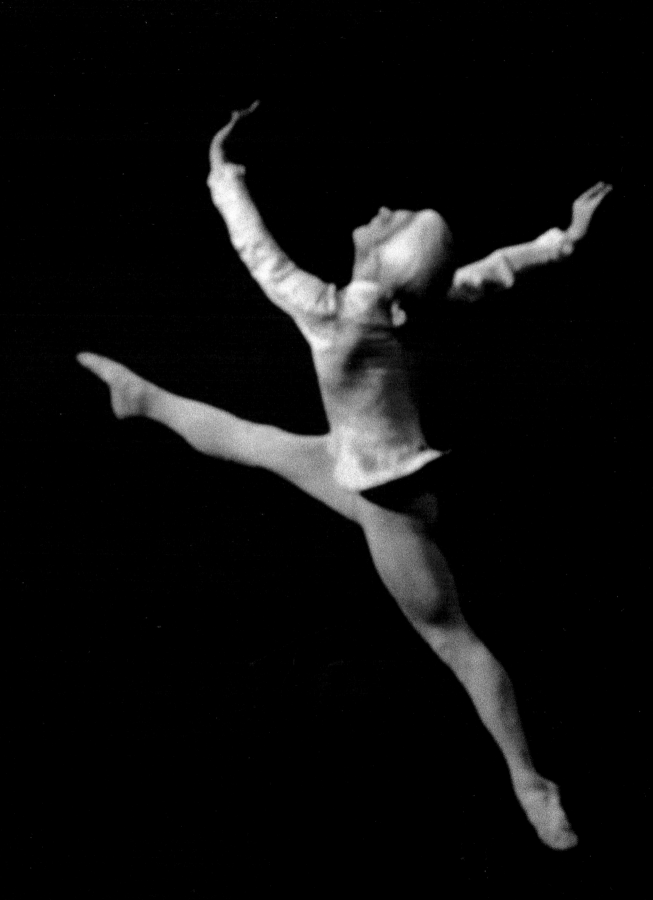

VESTRIS

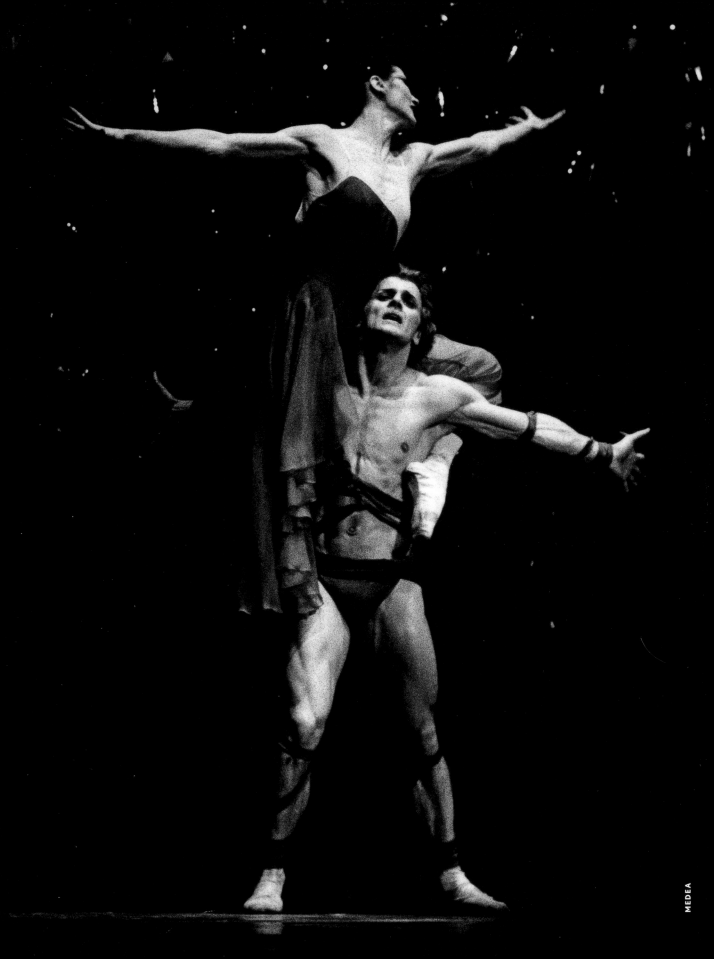

MEDEA

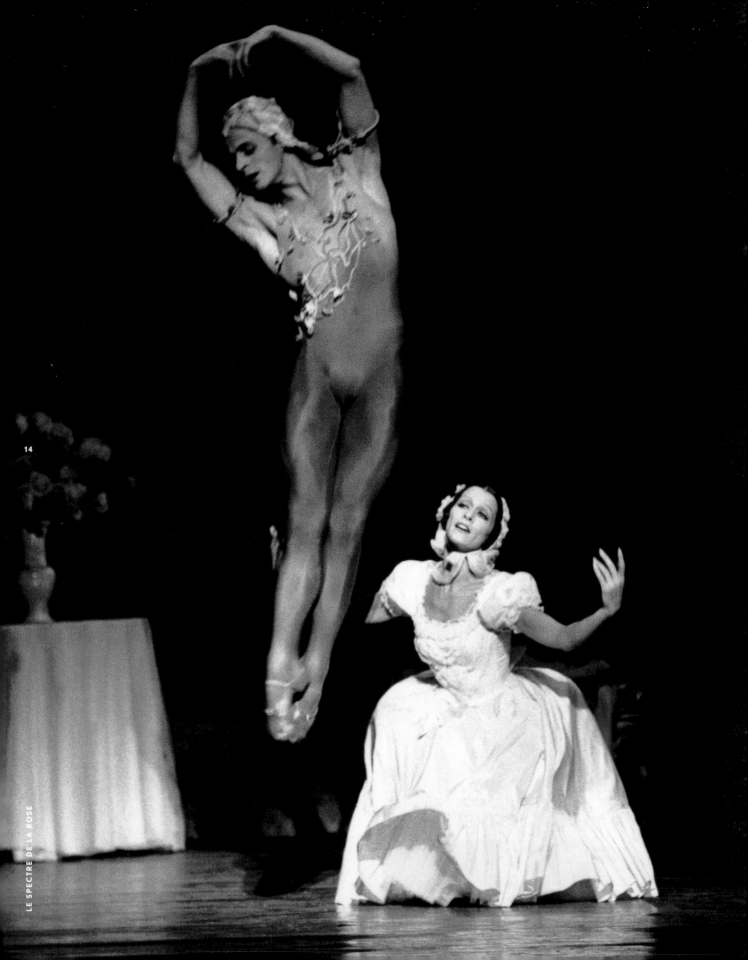

14

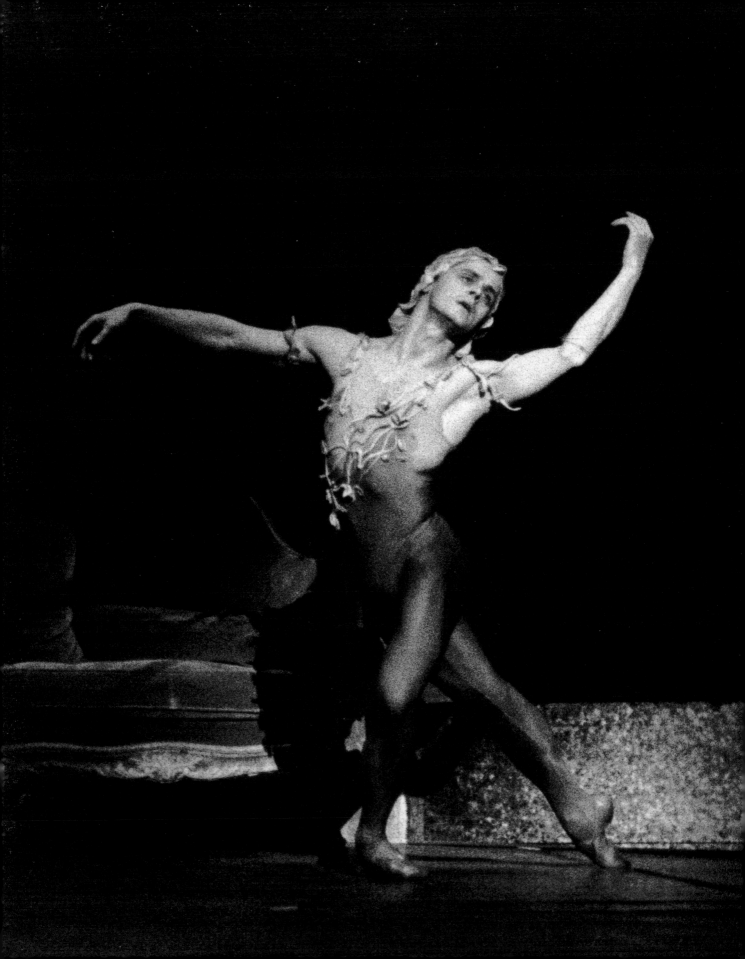

BARYSHNIKOV

IN BLACK AND WHITE

In the summer of 1974 the New York dance critic Arlene Croce, together with a posse of other ballet people, flew up to Montreal to see the new sensation of the Kirov Ballet, Mikhail Baryshnikov, twenty-six years old. The company he was appearing with was not the Kirov — for political reasons, the great Saint Petersburg troupe had not set foot in North America since 1964 — but a pickup group of Bolshoi, Kirov, and other dancers looking to get a breather from Soviet life and bring home some hard currency. The repertory, for the most part, was what the Russians call a 'highlights' program — that is, assorted pas de deux and showstoppers. In the middle of this unadventurous material stood the young Baryshnikov, and to Croce's eye he was everything that had been said about him. First, the classical-ballet purity, the schooling. Second, the virtuosity: the thing the audience loves most about ballet, and that they have loved passionately about Baryshnikov — the pause-in-the-air leaps, the double, quadruple, octuple beats and turns. And he accomplished these wonders with no sacrifice of correctness. He was able, Croce said, 'to perform unparalleled spectacular feats as an extension of *classical* rather than character or acrobatic dancing'. (Behind that statement is a long acquaintance with Moscow's Bolshoi Ballet — Dionysus to the Kirov's Apollo — which so often, and thrillingly, traded correctness for bravura.) But Baryshnikov's greatest gift, Croce wrote, was 'his sense of fantasy in classical gesture. He pursues the extremes of its logic so that every step takes on an unforeseen dimension'.

It is a tribute not just to Baryshnikov but also to Croce that in the pieces she saw him dance in Montreal (two pas de deux, one from *The Nutcracker*, the other from *Don Quixote*) she was able to discern an unforeseen dimension. He indeed had one. From the beginning, Baryshnikov was an actor-dancer. For him, no role, no highlights-program set piece, was not a dramatic opportunity. Even in the *Don Quixote* pas de deux, the man is a certain kind of man — Spanish, and in love — and Baryshnikov showed you that. As Vera Krasovskaya, late dean of Russian dance critics, put it, he treated classical dance not as an end, but as a means, 'to embody the grand world of thoughts and feelings'. As she added, this was not grandeur in the Soviet sense — blunt, exclamatory — but the opposite: subtle, suggestive. In him, she said, there was a note of 'melancholic, almost grieving, contemplativeness'. In *Don Quixote* no one was ever a happier, healthier young animal than he, but here and in all his dancing there was a 'soft chiaroscuro' (Krasovskaya's phrase), a sort of secret message that seemed to say, 'This is the main story, but there could be an understory.' Such textur-

ing could be seen in his tragic portrayals as well. In *Giselle* he was fully, even extravagantly, poignant; yet still, if only in the sheer verve of his performing, there was a suppressed joy, or a memory of joy, which made the tragedy more piercing.

This was not a matter of training, or not primarily. It was an expression of character. Many years after his appearance in Montreal, Baryshnikov, in his foreword to Robert Greskovic's book *Ballet 101*, wrote that when a dancer comes on stage, he reveals who he is whether he wants to or not: 'All the experiences he has had ... these come up as colors in the dancing, giving it sparkle and complexity. They come up through the eyes, through the pores. Exceptional dancers, in my experience, are also exceptional people, with an attitude toward life...They know who they are, and they show this to you.' He was speaking of others, but this was true of him as well — of him preeminently. Everyone saw it, and apart from the beats and turns, it is what made him a star.

Krasovskaya's essay, like Croce's, was written in 1974. What neither of these critics knew as they watched the young Soviet artist was that by the end of that summer he would no longer be a Soviet artist. From Montreal, the little Russian troupe went on to Toronto, and there, on the night of June 29, Baryshnikov finished his performance, chatted with some friends backstage (they later recalled that he had seemed distracted), and then exited the stage door into the theater's parking lot, where the KGB men accompanying the tour were herding the company on to a bus. 'This way, Misha,' said one of the men, and Baryshnikov went the other way. The KGB agents called after him, but he was gone. It was only a few blocks to the getaway car that friends had arranged for him. The car drove for several hours, to a country house in the Ontario woods that would be his hideout for the weeks to come. Three days later, the Canadian government granted him political asylum.

The news was badly received back home. He was not the first dancer the Kirov had lost. Rudolf Nureyev had defected in 1961, Natalia Makarova in 1970. Soon after Makarova's departure, her Kirov colleague Valery Panov applied for permission to emigrate to Israel. He was not only turned down; thereafter, he was no longer used by his own company. Panov's situation became an international cause. In Europe and America, people signed petitions and picketed Soviet embassies. Panov went on a hunger strike. Finally, in June of 1974, just as Baryshnikov was departing for the Canadian tour, the Soviet authorities threw up their hands and let Panov and his wife leave. That was not the only bad publicity the USSR received in 1974. Early that year, Aleksandr

Solzhenitsyn's *Gulag Archipelago* was published in the West, whereupon Solzhenitsyn was arrested, accused of treason, stripped of his citizenship, and deported. After such events, the Russian authorities were not ready to lose another prize artist. (In general, those who left voluntarily were only the best. Only the best could hope for a Western career sufficient to justify the risk.) More important, in those days, was the political damage. With each escape, the USSR was made to look more and more like a prison.

The Soviet authorities announced to the public that Baryshnikov was merely taking a leave of absence, and would return. (To support this fiction, his apartment was kept empty for several years.) Then they set out to erase his name from the story of Russian ballet. His pictures were taken down off the walls of his school. Magazines with articles on him were no longer available in the library. In the official ballet encyclopedia published in Moscow in 1981, there was no entry on him, and in the entries on ballets that were made for him, his name was replaced by the names of the men who took those roles after him. He no longer existed; he had never existed. Krasovskaya's farsighted essay, which had not yet been published when Baryshnikov defected, was handed back to her. It did not come out until 1993, after glasnost. Arlene Croce's piece was printed, but by that time (July 8) it was out of date. Soon afterward, Baryshnikov made his United States debut, and now Croce wrote a new essay, flush with anticipation. 'To watch Baryshnikov dance for the first time,' she said, 'is to see a door open on the future — on the possibilities, as yet untold, of male classical style in this century.'

For Baryshnikov, that door opened slowly and painfully. According to the people who were with him at the time, the defection was traumatic to him. First, it was very dangerous. If it had not succeeded, he would probably have spent time in a Soviet prison. In any case, his career would have been over. It is hard to get him to talk about his defection, but once, in an article on his friend Rudolf Nureyev, he spoke of it indirectly: 'Rudolf's defection was the most natural thing in the world. For other people … there were years of thoughts and plans and doubts, and the long business of working up your courage. But Rudolf didn't need courage. He had so much courage that it wasn't even courage any more…For him to bolt at that French airport — it was like a bird in a cage, and suddenly the door is open. What does he do? He flies, of course.' Baryshnikov, a different person, could not just fly, and his anxiety had to do with more than his own well-being. He left behind a family — father, half-brother, half-sister —

plus many friends. It was not unknown for the Soviet authorities to punish the relatives of those who behaved badly, and thus teach a lesson to others. For many years after his defection, Baryshnikov said not a single word in public against the Soviet Union. He was protecting the people who were still there.

After the fear came the grief. Baryshnikov knew, or hoped, that he would have a career in the West, but what else would he have? He had lost his language. (He spoke Latvian, Russian, and French, but not a word of English. He learned English off the television during his first months in New York.) He had also forfeited his place in the world, his very grasp on the world, his set of meanings. I asked his friend Valery Golovitser, who left the USSR in 1981, about this. 'You cannot understand,' he said. 'In those days, to leave Russia, it meant never to return. You closed the door, forever. They will never let you back. Your friends, your streets, your dog — all gone.' In the West, there were other streets, other dogs, but not yours. Baryshnikov had a large shaggy poodle, Foma, whom he adored. When he went to Canada, he left Foma with his friend Alla Bor, and the dog lived with her for the rest of his life. His picture, with Baryshnikov's, hangs on her dining-room wall.

Added to the émigré's grief, sometimes, is an element of shame. As we know from their literature, Russians have a sense of national destiny unmatched, perhaps, by any other people except the Americans, and their long history of persecution by their governments has only hardened it. Great Russian thinkers — Tolstoy, Dostoevsky — routinely spat on Western values. Artists who embraced European styles at one time or another (Tchaikovsky, Prokofiev) or who actually moved to Europe (Turgenev, Diaghilev, Stravinsky) were spoken of as traitors. Suffering, many Russians believed, was part of their national lot — indeed, their spiritual mission — and they were supposed to stay home and suffer together, not decamp to more temperate climes. Solzhenitsyn, though he had been imprisoned, did not leave until the authorities threw him out. His countrymen loved him for this.

Baryshnikov is what people in the former Soviet Union call an 'ethnic Russian'. (In the Soviet Union, former and otherwise, your passport specifies your ethnic group — Russian, Jew, Chechen, Ukrainian — and Eastern Europeans take such categories seriously, as we know from recent history.) Also, he could not possibly look more Russian. He is not a nationalist; he is too intelligent. Furthermore, his personal history does not dispose him that way. He was raised not in Russia, but in Latvia, and his childhood friends were Latvians and Jews as well as Russians. He did not move to

Saint Petersburg until he was sixteen, and though he lived there for ten years, he felt like a tourist much of the time, he says. In other words, he has been an exile since birth. Nevertheless, he is Russian, or a child of Russian thought, and according to some émigrés, there is often a problem of shame for a Russian who leaves. Tellingly, Baryshnikov hates the word 'defector'. 'It is like a defect, like you are defective,' he told an interviewer. Russian culture is a very great thing, not to speak of Baryshnikov's corner of it, Russian ballet, the foundation of most twentieth-century ballet. To walk away from that was a loss, to a serious mind, that we cannot calculate.

An artist's work cannot be accounted for by his or her life. Others, given that life, would have turned out otherwise. People have tried to explain Babe Ruth by the fact that he grew up in an orphanage, or Dickens by his childhood stint in a blacking factory. But countless other orphans and child laborers have grown up to lead undistinguished lives. How is that explained? The root of art will always be a mystery, or it will be called 'imagination', which is simply another word for the mystery. Psychologists invoke the concept of 'ego strength'. What this means is the ability to survive hardship, even use it — turn straw into gold — but that too is an enigma. Apart from good mothering, no one knows where it comes from.

Granted all that, one can still track, in Baryshnikov's life, certain events that nudged him in the directions he took. His mother, Aleksandra Vasilievna Kiseleva (née Grigorieva) was a country girl — 'a peasant, really,' says Baryshnikov— from a village, Kstovo, on the upper Volga. 'Tiny town,' says Baryshnikov. 'Couple of stores and nothing else. My grandmother has her own little house, with a goat and a couple of chickens. People raise cabbages and cucumbers, and that's what you live on. Sleep on top of stove. On one side of stove, you cook. On other side, you climb up and sleep. Like a folk tale.' Aleksandra married young. Then came World War II, the event that Russians call the Great Patriotic War, in which they lost twenty million people, including Aleksandra's husband. She was a widow, in her mid-twenties, with a small son, Vladimir, when she met Nikolai Petrovich Baryshnikov, a handsome army officer, in Kstovo at the end of the war. He had been married before and had a daughter — Nadezhda, who still lives in Saint Petersburg — by that union. 'We didn't know why first marriage didn't work out,' says Baryshnikov. 'There were rumors that he was a gambler.' In any case, that marriage was over, and in 1945 the beautiful, soft-spoken Aleksandra married this man whom Baryshnikov remembers as a hard, distant person with a newspaper in

front of his face. The following year, Nikolai Baryshnikov's regiment was transferred to Riga, the capital of Latvia, one of the Soviet republics obliged, after the war, to house Russia's population overflow. Nikolai went to work as an instructor in military topography at Riga's air force academy. On January 27, 1948, Aleksandra gave birth to her second son, Mikhail Nikolaievich Baryshnikov.

Like many people in Soviet cities, the Baryshnikovs lived in a communal apartment. They had two rooms, one a small bedroom for the two boys, the other a larger room where the family lived and ate, and where the parents slept. Down the hall were four other families. 'For twelve, thirteen people,' Baryshnikov recalled, 'one kitchen, one toilet, one bathroom, room with bathtub. But no hot water for bath. On Tuesday and Saturday Vladimir and I went with Father to public bath.'

However modest her upbringing, Aleksandra Kiseleva (she kept her first married name, probably out of solidarity with Vladimir) was a thinking person. She was religious — she had Mikhail baptized, though she did not tell her husband this — and she was an arts lover. She went to matinées of opera and ballet, and as soon as Misha was old enough, she took him with her. He loved these shows, and he looked like a ballet candidate himself. He had beautiful proportions, and he was a mover, one of those children who cannot sit still. Erika Vitina, a neighbor and friend of the family, says that when he ate at their house you could see his legs dancing around under the glass-topped dinner table. He himself remembers movement as an outlet for emotion: 'One time I recall is when my mother took me to visit my grandmother, on the Volga. Volga, it's a long way up from Latvia. We took a train through Moscow, and Moscow to Gorky, plus you drive another seventy miles. . .It was very early morning when we arrived, and there was my grandmother. I was in such anticipation, because I was like five or so, maybe six. My mother said to me, "Mikhail, hug your grandmother." But I was so overwhelmed that I couldn't just run to her. So I started to jump and jump, jump like crazy, around and around. It was embarrassing, but same time totally what I needed to do. Mother and Grandmother just stood and looked until it was over.'

When Baryshnikov was about six, his mother met a woman who had danced with the Bolshoi and who now gave ballet lessons for children in a little studio in Riga. 'Mother was very excited by this friendship,' says Baryshnikov. She enrolled him in her friend's class. Later, when he was eleven, he moved over to the Riga School of Choreography, the state ballet academy. Erika Vitina recalls Aleksandra's involvement in her son's ballet studies: 'The father had no interest whatsoever in the ballet school.

The mother brought Misha, put him there. All this happened physically, hand to hand.' Vitina too had a son in the ballet academy, and when she and Aleksandra went to pick up the children in the afternoon, they often went home together. Vitina remembers Aleksandra and Misha walking hand in hand. 'I was a mama's boy in a way,' Baryshnikov says.

During the summer when he was twelve, Aleksandra again took Misha to Kstovo, and left him with her mother. Then she went back to Riga and hanged herself in the family's apartment. Vladimir found her. Baryshnikov never knew why she did it. 'Father did not want to talk about it,' he says. Vladimir too is still mystified, though he points out that his mother's marriage was not happy. Soon after her death, Vladimir, who was then twenty, left for the army, and Colonel Baryshnikov told Misha that now they would live together, just the two of them. The following year, he went off on a business trip and returned with a new wife, a new life. Soon he moved the family to an apartment on the outskirts of town. Baryshnikov lived with them for a few more years, but he no longer felt at home.

Yet people who knew him as a teenager remember him as a happy, sunny boy. Still today, in discussing (with the utmost reluctance) his mother's death, he is quick to banish any atmosphere of pathos: 'Children being left, it's not always like books of Charles Dickens. When you lose your parents in childhood, it's a fact of life, and, you know, human beings are extraordinarily powerful survivors. My mother committed suicide. I was lucky it was not in front of me, okay? Which is the truth, and father was confused, and we never had any relationship, serious relationship. I never knew my father, in a way. But what? It's made me different? No. I mean, I blame for all fuckups in my life my parents? No.'

What he did was throw himself, utterly, into ballet. Soon after his mother's death he was given a new teacher, Juris Kapralis, a handsome, big-hearted man who was a dancer with the Latvian National Opera Ballet and an instructor at the Riga School of Choreography. (He still teaches there.) Kapralis remembers Baryshnikov as a child workaholic. During breaks, he says, the other boys would go in the corners of the studio and play. 'Not Misha. He is still working, practicing steps till he gets them right. Very serious boy.'

'And artist,' Kapralis adds. Among ballet people in the former Soviet Union, the term 'artistic' usually means interpretive, dramatic. Like all Soviet troupes, the Latvian National Opera Ballet used children from its school in its productions. When

Baryshnikov was perhaps twelve or thirteen, he got to be a toy soldier in a *Nutcracker* in which Kapralis played the Prince. 'I remember,' Kapralis says, 'after the Mouse King died, Misha relaxed his body. No longer stiff, like a wooden soldier. Soft. Our ballet director asked him, "Who said you should do this?" And Misha answered, "When the Mouse King dies, the toys become human. Movements must change." He devised that himself. Small boy, but thinking.'

The late Peter Ostwald, in his biography of Glenn Gould, described the three-year-old Gould's first piano lessons, from his mother. She would sit down at the piano and take her son on her lap, and they would play together. One embrace: the mother, the child, and the piano. Ostwald, a psychiatrist, saw this early experience as key to Gould's career: Later, as an adult, when Gould sat down at the piano, he returned to his mother's arms. This story makes one think of Erika Vitina's memory of Aleksandra Kiseleva's placing her son in ballet class 'hand to hand' and of her coming to pick him up after class, and their walking home hand in hand. The boy's obsessional devotion to ballet after his mother's death: Could it have been a way of returning to her? A psychiatrist would say yes. But most artists, if you ask them, will tell you that in their youth there was one person — if not a parent, usually a teacher — whom they loved, and who loved them, and also loved a certain art and guided them to it. So here too, almost always, we see the three-way embrace, with the child's love of the art growing as an extension of the pleasure of being cherished, or even just respected. This is perfectly logical. Art is a conversion of emotion, and it surely begins in emotion. Baryshnikov's mother was not an artist, nor is love sufficient to make an artist. Most of the things on which he built his career — the physical gift, the fusion of steps with fantasy, the effort to make his dancing reveal 'the great world of thoughts and feelings' — were his alone. The one thing he probably owed to his mother, or to her death, was his sheer devotion to ballet. He was filling, with something beautiful, the void this beautiful woman left in his life.

In 1964 the Latvian National Opera Ballet went on tour to Saint Petersburg. Baryshnikov, then sixteen, had a role in one of the ballets they took, so he got to go too. While they were there, one of the troupe's dancers had the idea of taking him to Alexander Ivanovich Pushkin at the Vaganova Choreographic Institute. 'I was lucky,' Baryshnikov said later. 'I went to the best school, had the best teacher.' The Vaganova Institute, allied to what was then called the Kirov Ballet — today, as before the revolution, the Russians call it the Maryinsky Ballet — was the institution that produced Anna Pavlova, Michel

Fokine, Tamara Karsavina, Vaslav Nijinsky, George Balanchine, Alexandra Danilova, Galina Ulanova, Yuri Soloviev, Rudolf Nureyev, Natalia Makarova. The school was the spine of Russian ballet. As for Pushkin, he was one of its most honored teachers, and unquestionably its most respected men's teacher. Baryshnikov remembers the audition — how Pushkin had him do a few steps, a few jumps, then examined his legs, then said, 'Come in the fall.' In September the boy was installed at the barre in Pushkin's class. Thereafter, he rarely returned to Riga, nor did his father often visit him.

Pushkin's gifts as a teacher are only beginning to be analyzed. (The first book on him, Gennady Albert's *Alexander Pushkin: Master Teacher of Dance*, with a foreword by Baryshnikov, was published in English in 2001 by the New York Public Library.) Like many great teachers, he was not a great practitioner. When Baryshnikov walked into his class, Pushkin was fifty-seven and past dancing, but even when he was dancing — with the Kirov — he was never a featured performer. 'Pas de deux, pas de trois,' Baryshnikov says. 'Sometimes substitute for principal, but he was not principal type. Not very handsome — big nose, long legs, short body — and not very expressive. But classical, classical. Old-school, traditional, square. Academician. Usually, it's those kind of people, people who dance twenty-five years the same parts, who know more about technique than people who are advancing and trying out other areas. Twenty-five years, you come back after summer vacation and tune your body into the same routine, you figure out timing, you figure out what to do.' In other words, Pushkin saw dancing not as a mystique — a personal matter, where you were summoned by the finger of God or not — but as a method, and his method was natural and modest. There is a story that the other men's teachers at the Vaganova School used to wonder what Pushkin's secret was, 'how the hell he comes up with students like that,' as Baryshnikov puts it. They would listen at the door of his classroom to hear his magic words, and all they ever heard him say was 'Don't fall' or 'Get up'. (He is not the only great ballet teacher who was famously laconic. Stanley Williams, at New York's School of American Ballet, was another.) According to Baryshnikov, what made Pushkin so effective was the *logic* of the combinations he assigned, the fact that they were true not just to classical ballet, but to human musculature. They seemed right to the body; you could do them. And the more you did them, the more you became a classical dancer.

But of course, there *is* a mystique to ballet dancing. Pushkin's trick was that he fostered your mystique, not his. Like many great teachers, he inculcated technique openly and art secretly. According to his students, he was a developer of individuality.

He steered his students toward themselves, helped them find out who they were. 'Plus,' Baryshnikov says, 'he was extraordinarily patient and extraordinarily kind. Really, really kind.' In 2001 I interviewed a man, Valery Zvezdochkin, who, by his own description, was the black sheep of Pushkin's class in the mid-sixties, Baryshnikov's time. (He was Baryshnikov's closest friend in the school.) When he was sixteen, Zvezdochkin says, he analyzed classical ballet and decided that Pushkin's method was all wrong. Ballet was simply a matter of the shifting of weight. So every day he came to class with a roll of lead weights in his socks, and as Pushkin taught the others coupé, passé, and pas de bourrée, Zvezdochkin labored to hoist his encumbered feet into these positions. 'Can you believe it?' Zvezdochkin said. 'He never threw me out. He knew that if he did, no one else would take me. The man was a saint.'

After Aleksandra, Pushkin was the most important person of Baryshnikov's youth. He took certain students very directly under his wing. The most famous example is Nureyev, who entered his class in 1955, when Baryshnikov was still a child in Riga. Nureyev was a late starter. It was not until he was seventeen that he came to Saint Petersburg and embarked on a rigorous ballet training. 'He took this opportunity very — *errgghh* — like a tank,' Baryshnikov says. 'Very aggressive in terms of the education, in terms of the catch-up. And short temper. Sometimes, in rehearsal, if he cannot do the steps, he will just run out, crying, run home. Then, ten o'clock in the evening, he is back in the studio working on the step until he will get it. People think he is an oddball. And already his ambivalent sexuality was obvious, which in that atmosphere was a big problem. People were teasing him.' So Pushkin and his wife, Xenia Jurgensen, another former Kirov dancer, took Nureyev into their home. He lived with them for a long time, not just while he was in school but also during his early years at the Kirov. The fact that Nureyev defected in 1961, that he was accomplished enough and brave enough to go, was probably due in large measure to them, though it broke their hearts. When Baryshnikov first went to their house, he saw Nureyev's electric train installed as a sort of icon in their living room. In their closets were Nureyev's costumes. When he defected, his luggage had been sent back to them: They were his family.

And they became Baryshnikov's family. Most nights, he ate with them, after which he went with Pushkin on his evening walk to the Fontanka Bridge. Then they came back to the apartment and worked, on matters that perhaps had not been stressed in class. 'Find my way of moving arms, coordination,' says Baryshnikov.

'Young dancers don't think about this. Only think about feet.' By the time they were finished, it was often past dormitory curfew, and Baryshnikov slept on their couch.

At this point Baryshnikov had one overriding concern: his height. He was a small child, and he had fretted about this since the moment he started ballet class. He drank a great deal of tomato juice, which was said to foster growth. He slept on a wooden plank, for the same reason. (A mattress you would sink into, and thus it would stem your growth in the night. On a wooden plank, you could elongate freely.) Eventually he grew to five feet seven inches, but only eventually, and five feet seven is not tall, particularly for a male ballet dancer, since the women he partners gain perhaps six inches of height when they rise on point. Russian ballet had (and in some measure, still has) a system called *emploi*, whereby dancers were sorted into categories — for men, character, *demi-caractère*, and *danseur noble* — in which they remained for the rest of their professional lives. Character dancers — beefy, vital, and not quite classical — led the mazurka or played the wicked witch. *Demi-caractère* dancers — small, fast, and witty — were Mercutio or the court jester; they were classical, often virtuosos, but not grand. *Danseurs nobles* were grand. They got the big roles, the complex roles: the leading man, the prince. Baryshnikov's height and also his personality — he was vivacious, boyish — seemed to destine him for *demi-caractère* roles. The prospect of being confined to so narrow a category grieved him horribly.

But Pushkin believed that Baryshnikov would be a *danseur noble*. Why did he believe this? *Emploi* was very strict. His faith is a moving example of foresightedness, or of the self-fulfilling prophecy. When Baryshnikov, time and again, came to him with worries about his height, he calmed him down and got him to go on working, as a potential *danseur noble* or as a potential anything. One wonders whether Pushkin, after his experience with Nureyev, did not foresee that Baryshnikov would defect. He more or less trained him to do so — to be too good, too ambitious, for what Soviet ballet could offer him.

In 1967 Baryshnikov graduated from the Vaganova School. At his graduation performance, in the *Don Quixote* pas de deux, 'the scene was unimaginable,' his biographer Gennady Smakov writes. The spectators howled; the chandeliers shook. Baryshnikov was taken into the Kirov Ballet as a soloist, skipping the normal entry position in the corps de ballet.

'I joined the company when it was falling apart,' Baryshnikov told Smakov. In the late sixties and the seventies, the Kirov went through a period of repression from which it has never fully recovered. In part, this was due to a society-wide tightening-up after the Khrushchev 'thaw'. But in the ballet world there was redoubled anxiety, the result of Nureyev's defection. Konstantin Sergeyev, the director of the Kirov, turned the company into a mini-police state. The repertory consisted either of nineteenth-century classics, restaged by Sergeyev, or of Communist flag wavers. (In 1963 Sergeyev made a ballet, *The Distant Planet*, inspired by Yuri Gagarin's space flight.) Any newly commissioned ballets were vetted to ensure that they threatened neither Soviet ideals nor Sergeyev's primacy as company choreographer. The dancers were vigilantly watched for signs of insubordination. If they looked like defection risks — indeed, if they even had the wrong friends, or failed to attend company meetings — they were often barred from foreign tours, which were their only means of supplementing their tiny incomes. Typically, the list of those who were going on a tour was not posted until the day of departure. Shortly beforehand, dancers were called into private meetings with the management, where they were encouraged to tell tales on their colleagues, so that their own names, not their colleagues', would be on the list. In other words, the tours were used as a lever of obedience. Many people cooperated, and those who didn't were also harmed. Righteous suffering can ruin you almost as fast as shame. Other privileges at the Kirov — choice of roles, choice of partners, time onstage — were awarded less on the basis of ability than on that of good behavior. The careers of what were reportedly superb artists, people who were one in a thousand, were destroyed in this way. The company was awash in cynicism.

Such were the circumstances in which Baryshnikov, nineteen years old and dying to dance, found himself in 1967. He had to fight just to get on stage — at that time even leading Kirov dancers performed only three or four times a month — and also to get the partners he wanted. As he had expected, he had to struggle over casting, over *emploi*. (He waited six years to dance Count Albrecht in *Giselle*, a part he desperately wanted, and in which, once he got it, he had an enormous success.) Worse was the problem of getting to appear in something other than the standard repertory. Baryshnikov wanted to dance in new ballets, modern ballets. Occasionally, grudgingly, the Kirov did permit the creation of such pieces, with excellent roles for him, but they did not last long. In 1969 a young choreographer, Igor Tchernichov, choreographed a new-style *Romeo and Juliet* with a prominent part (Mercutio) for Barysh-

nikov. But the ballet was given only one performance before it was dropped on the grounds of 'formalism', eroticism, and other vices. Baryshnikov was sent back into *Don Quixote*.

In 1970, midway into his seven-year career in Russia, the Kirov went on tour to London, and there Natalia Makarova, one of the company's leading ballerinas, defected. Baryshnikov was on this tour, and it was to him, not to Makarova, that the KGB devoted their special attention. As he sees it, the authorities did not take Makarova seriously as a potential defector, because she was a woman. Baryshnikov, on the other hand, sometimes had as many as three KGB agents tailing him as he walked down the streets of London. He says that at that time he had no thoughts of defecting. If he was closely confined at the Kirov, that was because he was greatly valued by the company, and by the Russian ballet world in general. Baryshnikov was a prophet in his own land. In 1973 he was made an Honored Artist of the Republic, a title that thereafter was given before his name in programs. When he first joined the Kirov, he was still living in a dormitory. From there he graduated to a communal apartment, then to his own private studio. Finally, thanks to his salary as a principal dancer, he exchanged the studio for a very nice apartment near the Hermitage. He had a piano (inherited from the Pushkins) and a cleaning lady and a car. 'People used to borrow money from me,' he says. 'I was really very well off.' More than privileges, however, it was artistic goals that tied him to the Kirov: 'I wanted to do *this* dance, with *these* people.'

But the events that led to his defection were already accumulating. Four months before the London tour, Pushkin died — of a heart attack, on a sidewalk, in the rain — at the age of sixty-two. At that point, Baryshnikov later told an interviewer, 'I realized I was totally on my own.' A second important factor was the London tour itself. The critics went crazy over him. So did the audience. One night, he was forced to encore a whole long solo of his, *Vestris*, from beginning to end. But London gave him more than praise. 'You cannot know what it meant to travel,' he says. 'Just to see that what's supposed to be *your* life is not just in a cocoon, that other people in other countries do have the same emotions.' He met Western dancers. He attended rehearsals at the Royal Ballet. He watched modern-dance classes. He saw American Ballet Theatre, his future company, which was performing in London at the same time.

He also met Nureyev, who was now living in London and performing with the Royal Ballet. Nureyev went to see the Kirov performances and managed to get a message passed to Baryshnikov. 'A man we both knew came to me and said, "Rudolf wants

to see you if you want to." ' So the next morning Baryshnikov gave the KGB the slip and spent a whole day at Nureyev's big house near Richmond Park. They talked about ballet, he says: 'Russian exercises, French exercises, teachers, class, how long barre — all technique, Rudolf's obsession.' At lunch Nureyev drank a whole bottle of wine. (Baryshnikov couldn't drink; he was performing that night.) Then they went out and lay on the grass and talked some more about technique. 'When I left, he gave me couple of books — one with beautiful Michelangelo drawings — and some scarf he gave me. I was very touched by him.' The two men remained friends until Nureyev's death in 1993.

With Makarova's defection, the panic at the Kirov was even worse than it had been with Nureyev's. Sergeyev was removed from his post. A number of brief, fumbling directorships followed. Baryshnikov was watched more and more closely. If Western ballet people came to Saint Petersburg and he went out to dinner with them, this was noted in his file, and the KGB came to talk to him about it. When Western choreographers got in touch with the Kirov to ask if they could work with him — Roland Petit, director of the Ballet de Marseille, made such a request — they were told that he was sick, that he was unavailable. He was under pressure to go to political rallies, and privileges in the theater were made contingent upon his attendance: 'They'd say, if not this, then not this.' He briefly considered moving over to the Bolshoi, but he did not like the offer the rival company made to him, so he stayed put, increasingly frustrated, at the Kirov.

He remembers Saint Petersburg, that magical city, as a place of immense tedium: 'The most interesting objects were people, saying what they would have done, if they could have. Which is what they talked about if they drank a little. But they didn't drink a little. They drank a lot.' In a 1986 interview, Arlene Croce asked Joseph Brodsky, a close friend of Baryshnikov's, what would have become of the dancer if he had stayed in Russia. 'He'd be a ruin by now,' Brodsky answered, 'both physically and mentally. Physically because of the bottle...Mentally because of that mixture of impotence and cynicism that corrodes everyone there — the stronger you are, the worse it is.'

In 1974 Baryshnikov staged what was called a 'Creative Evening' — a favor sometimes accorded to leading members of the Kirov. The dancer would commission an evening's worth of works, often from young choreographers. (Whatever nonconformist ballets made it onto the Kirov stage were usually part of a Creative Evening. That was the case with Tchernichov's *Romeo and Juliet*.) The dancer would also choose the casts, assem-

ble the sets and costumes, and star in the program. Then, after this display of open-mindedness, the administration would normally shelve the ballets.

For his Creative Evening Baryshnikov hired two young choreographers, Georgy Aleksidze, based in Tbilisi, and Mai Murdmaa, an Estonian. There followed several months of anguish as, faced with harassment from the administration and apathy from the demoralized dancers, Baryshnikov labored to get the ballets on stage. Cast members dropped out; costume designs were argued over (too revealing). Shortly before the premiere, Baryshnikov was pulled out of rehearsals to go to Moscow for another political rally. After the first preview, he met with the company's *artsoviet*, or artistic committee, and they told him how worthless they thought the show was. It was allowed a few performances anyway — all the tickets were already sold — but afterward, at a cast banquet, Baryshnikov choked up in the middle of a speech he was making to the dancers. 'Some people listened to him,' Nina Alovert reports in her book *Baryshnikov in Russia*. 'Others continued to eat, scraping their plates with their forks.'

Shortly afterward, the Canadian tour was offered, and he went. Did he know that he would not come back? He says he didn't, and the fact that immediately before leaving he bought a new car, and borrowed a considerable sum of money from a friend in order to do so, supports that story. (Repaying the loan from the United States was not easy.) The thought of defecting had surely occurred to him, but he dismissed it, he says. In 1973, shortly before he left, he was taking French lessons from his friend Gennady Smakov, and Smakov said to him that what he needed was not French but English — that he needed to go to America. 'Are you crazy?' Baryshnikov replied. In his mind, he was a Kirov dancer.

Nevertheless, the momentum was accumulating: his anguish over the Creative Evening, his disappointment over the repertory offered to him on the Canadian tour—just three standard pas de deux. 'I thought, what am I *doing?*' he says. 'I am at my peak, physically, and I am in a prison.' Makarova was not the only friend of his who had left. There was also Alexander Minz, who had emigrated to Israel, and then to the United States, in the early seventies, when the Soviet authorities began letting Jews out. While Baryshnikov was in Canada, he spoke to Minz on the telephone, and a message was passed to him from Makarova. 'They gave me courage,' he recalls, 'that if I go, I will not suffer. Natasha said she will take care of me, that we will dance together.' At the same time, Western friends told him they would take care of the details of

the escape — provide the car, the house, the lawyer. And so, in a matter of days, he made up his mind, and he went.

All that history precedes the story documented by this book, which is a photographic history of Baryshnikov's Western career exclusively. The events of his Russian life — exile, the mother's love, Pushkin's love, the frustrations at the Kirov — laid the foundations for his life in the West, but again, they cannot fully account for it. When he defected, Baryshnikov said that he did so because he wanted artistic freedom, a wider repertory. That's what the earlier defectors, Nureyev and Makarova, had said too. And then, in the West, they mostly danced the nineteenth-century Russian repertory, together with modern story ballets inspired by those 'classics'. They might leave Russia, but they did not abandon its ballet traditions. One cannot regret their choice. Nureyev's performances in *The Sleeping Beauty*, Makarova's in *Giselle*, set new standards for Western dancers. After Nureyev arrived, with his glamour and fire and 180-degree turnout, male dancing in Europe and America was never the same. In the female ranks, many young dancers — for example, Gelsey Kirkland, who was to be Baryshnikov's most important early partner in the West — became what they did by watching Makarova. Still, it must be said that the early defectors made conservative choices. They did what they already knew how to do, and that, among other things, is their difference from Baryshnikov, whose object in coming West was to learn what he didn't know how to do.

He did not turn his back on the classical repertory. That is what audiences wanted to see him in, and therefore what the companies he worked for — American Ballet Theatre, his home base from 1974 to 1978, and the many troupes with which he made guest appearances — wanted to give them. Baryshnikov in *Giselle:* Nothing was better for box office. It was in *Giselle*, with Makarova, who kept her promise to help him, that he made his United States debut on July 27, 1974 [p. 2]. There were twenty-four curtain calls. Soon afterward, he returned to Canada, a country he was grateful to, and danced, for free, the lead in *La Sylphide* with the National Ballet of Canada. It was an outdoor performance, open to the public, and thousands of people came. I spoke to a woman who was there. She said she arrived four hours before curtain and still didn't get a good seat.

For the rest of his first year, and indeed for much of his first decade in the West, he performed again and again in nineteenth-century ballets, or adaptations of them — not just *Giselle* and *La Sylphide*, but *The Sleeping Beauty*, *Swan Lake*, *La Bayadère*,

Coppélia [p. 5], *Don Quixote*, *The Nutcracker* — and also in early-twentieth-century classics, Ballets Russes works such as *Les Sylphides* [p. 152], Petrouchka [pp. 86–87], and *Le Spectre de la Rose* [pp. 14–15]. Eventually, however, he took less and less pleasure in these assignments. If one had to list Baryshnikov's personality traits on one hand, curiosity would be among them. Always, he wanted new roles — even just to learn them, forget the performance. He made this point in his essay on Nureyev. For Nureyev, he said, 'The rehearsal, the learning, was always too slow. He wanted to get it over with fast, fast. In two, three days, sometimes, he learned a piece that he had never seen before, and then he was onstage, which is where he wanted to be.' Baryshnikov was the opposite: 'For me, the joy was rehearsal — learning a style, putting the dance together. When it came time to perform, I would start to get bored. I wanted to go on to something else.'

As soon as he arrived, Baryshnikov began sampling Western ballet's modern classical repertory, the extensions that George Balanchine at New York City Ballet and Frederick Ashton at England's Royal Ballet had built on Russian classicism. Before his first year was out, he had danced Balanchine's *ne-plus-ultra* classical *Theme and Variations* [p. 6], an immensely difficult ballet. (Fifteen years later, Altynai Asylmuratova of the Kirov told me that when she and her husband/partner, Konstantin Zakinsky, were learning *Theme and Variations*, they would watch a 1978 videotape of Baryshnikov and Gelsey Kirkland performing the ballet and cry, because they felt they could never do it.) He also danced Ashton's *Les Patineurs* and *La Fille Mal Gardée* — again, very hard classical ballets, with steps such as double *sauts de basque* and endless pirouettes *à la seconde*.

But Baryshnikov's tastes were formed in the Soviet Union. He wanted strong stuff, with big dramatic opportunities. At the same time, his tastes were formed *against* the Soviet Union; it was not to do double *sauts de basque* that he had left Russia. I would guess that his greatest pleasure in his first years in the West came from dancing modern dramatic ballets — descendants of Bolshoi histrio-acrobatics — by choreographers based in Continental Europe. In the 1946 *Le Jeune Homme et la Mort* (libretto by Jean Cocteau, choreography by Roland Petit) he triumphed as the tortured artist whose frightening girlfriend, a sort of postwar femme fatale, stubbed out her Gauloises with her point shoe [pp. 8–10]. (In the seventies, a Max Waldman photograph of him in this role became a dormitory poster to rival van Gogh's *Starry Night*.) To later ballets by Petit, *Carmen* [pp. 138–143] and *La Dame de Pique* [pp. 108–113], he brought an inno-

cent dramatic conviction that carried these rather overwrought works past one's skepticism. In Glen Tetley's version of *Le Sacre du Printemps* [pp. 88–91] he looked as though he was going to be killed, willingly, before the end of the show. In the same period, he was taking on more laid-back works by American choreographers: Eliot Feld's *Santa Fe Saga* and *Variations on 'America'* [pp. 102–103], Alvin Ailey's *Pas de 'Duke'* [pp. 79–85]. He danced *Pas de 'Duke'* with the Ailey troupe's Amazonian star, Judith Jamison, to a score by Duke Ellington. This was his first jazz ballet. He felt 'like a cow on ice,' he said. No matter; he did it, and everybody liked him for it.

In 1976 came a turning point: his first collaboration with Twyla Tharp. Tharp started out in the sixties as a modern-dance choreographer. In the seventies she was undergoing a transition to ballet. Baryshnikov, needless to say, was also in transition, so he made a perfect subject for her. Starting with *Push Comes to Shove* [pp. 66–71], she created for him a series of ballets that seemed to be about the project facing both of them: how to marry the Old World dance to the New — in particular, how to join ballet, so outward and perfect, to the inwardness, the ruminations of jazz. In Tharp's works, Baryshnikov's dancing became more shaded, with more hitches and grace notes, more little thoughts, tucked in between one step and the next. And it was these secret places between the steps that seemed to give the dance its meaning. The big ballet moves were still there, but they were thrown off casually, like something taken for granted. Suddenly, out of some low-down noodling, Baryshnikov would rise up into a placement-perfect leap, and then land and noodle some more. This was witty, but it also seemed philosophical: a meditation on history, a memory of innocence in a mind past innocence.

Many of Baryshnikov's fans did not like what Tharp made of him. P*ush Comes to Shove* was a big hit, but the next piece she made for him — *Once More, Frank*, a duet for the two of them, to Sinatra — was booed at its premiere, a rare event at American ballet performances. Again, most people wanted to see him in the classics. Actually, his work with Tharp was a thoroughly classical project. In most of the ballets being created in Continental Europe at that time — Petit's works, for example — the standard ballet steps were smudged, or frankly eliminated, for the sake of heightened drama. When a dancer is trying to do a correct pirouette/*grand rond de jambe*, it's hard for him to have a realistic nervous breakdown over Carmen at the same time. Tharp's choreography, on the other hand, was quite faithful to the *danse d'école*. She adjusted it, she bent it, she spliced it with jazz and jitterbug, but it was still present. More than present, it was the medium, the language: whatever meanings the work had came not

through story or acting, but just through the steps. Tharp's ballets were an extension of a new, American classicism, an accelerated, complicated, step-packed modern version of nineteenth-century academic ballet.

The primary creator of that style was George Balanchine, who had escaped from Russia in 1924 — fifty years, almost to the day, before Baryshnikov's defection — and in 1948 founded New York City Ballet. Under his thirty-five-year directorship, NYCB became the fountainhead of the new American classicism, which stood in relation to the nineteenth-century classics as New York State Theater, home of NYCB, stood in relation to the Metropolitan Opera House, home of American Ballet Theatre, in Lincoln Center Plaza: sideways, and closer to the street. In 1978 Baryshnikov walked across the plaza and joined New York City Ballet. This involved some sacrifices — a major pay cut, for example. (At ABT and other companies he received several thousand dollars per performance. NYCB dancers, including him, were on normal, medium-level salaries.) And many of his admirers, together with a number of critics, deplored the move. He was an old-style Russian ballet dancer. Were they never going to see him again in the old-style Russian ballets? But to Baryshnikov the move was a natural extension of his training. Balanchine's work, in his view, was what Russian ballet would have become but for the revolution: modernist classicism, a twentieth-century continuation of the great nineteenth-century art. 'I am entering the ideal future of the Maryinsky Ballet,' he told interviewers.

At NYCB Balanchine treated him like a son: 'He said to me, "I wish I could be a little younger, a little healthier" '— he was seventy-four years old, soon to have heart surgery, and would die in five years —' "but let's not waste time. Let's do *Harlequinade*, let's do *Prodigal*, let's do this, let's do that, and think, whatever you want to do." He cared what I will do.' The story is a sad one. The homeless boy found a home; the sonless master found a son, from his own school. But it was late. Balanchine was not well enough to make any new ballets for Baryshnikov. His co-ballet master, Jerome Robbins, who had worked with Baryshnikov before (*Other Dances*, 1976 [pp. 72–77]), made two pieces for the young star: one, *Opus 19* [p. 151], a sort of enthronement, almost a cartoon, of Baryshnikov the Melancholic; the other, *The Four Seasons*, a showcase for Baryshnikov the Soviet Virtuoso. And if Baryshnikov couldn't perform new ballets by Balanchine, he could dance old ones — which he did, quite thoroughly: *Coppélia* [p. 115], *Rubies* [pp. 116–117], *Stars and Stripes*, *The Nutcracker*, *Harlequinade* [p. 135], *Tschaikovsky Pas de Deux*, *Orpheus*, *Donizetti Variations*, *The Four*

Temperaments, Symphony in C, La Sonnambula, Union Jack, Tarantella, The Steadfast Tin Soldier, A Midsummer Night's Dream, Sonatine. Ironically, some NYCB regulars felt that he was too Russian for the works of the Russo-American master — that he overacted. (In some cases this was true. He needed more time.) But in certain Balanchine ballets — above all, two central works, *Apollo* [pp. 118–127] and *Prodigal Son* [pp. 94–101], both requiring a sincere young man — he was not only great; he seemed to be what these two ballets, both nearly a half-century old, had been waiting for all those years. God sent him to do them.

Baryshnikov had been with NYCB for less than a year when American Ballet Theatre asked him to come back, this time as head of the company. 'I went to Balanchine,' he later recalled, 'and we talked for a long time. We talked for an hour one day, and he said, "Come back tomorrow." And he was very, sort of — not encouraging me, but said, "If you can see what you want to do and can deal with people on the board and you have a clear vision, I think you should do it, take this chance." He said, "If it doesn't work, it doesn't work. You can come back, any time. This is your home." ' With that net beneath him, Baryshnikov walked back across the plaza and became the artistic director of American Ballet Theatre.

Though he had been gone for only a year, he was now a different man, with new confidence and new goals. Aided by his assistant Charles France, he mapped out a policy for ABT's future. The company's corps de ballet, a notoriously feckless crew, had to be redisciplined, re-energized. As part of that effort, promotions would now come from within the company. Before, ABT brought in most of its principal dancers (Baryshnikov, for example), and many of its soloists as well, from outside the troupe. This system was bad for morale. Corps dancers and soloists felt that no matter how hard they worked, they had little chance of being promoted, and they were right. Baryshnikov changed that policy. With the help of newly hired coaches, he nursed up young dancers, gave them starring roles, made them principals.

And then there was the repertory. As might have been expected in view of his prior employment, Baryshnikov acquired a number of Balanchine ballets, and he made imaginative choices: *Bourrée Fantasque*, a marvelous, perfumed, Frenchy thing, set to the music of Chabrier, that Balanchine's company had not performed for many years; *Symphonie Concertante*, another nearly forgotten ballet, this one in the Russian style. He also expanded ABT's arsenal of classics. In the 1970s, before he became director, he had made a new *Nutcracker* [p. 93] for the company, together with a *Don Quixote*

adapted from the Kirov version. Now he created his own *Swan Lake* and, with Peter Anastos, a lavish *Cinderella*. He acquired Kenneth MacMillan's *Romeo and Juliet* and also MacMillan's production of *The Sleeping Beauty*. In other words, he did not scold the ABT fans for their old-fashioned tastes. He gave them nice, big story ballets, with tutus and Russian music.

But he had tarried for a year with Balanchine, and like Balanchine, he wanted to make new things. Forget the old! Do the new! That was Balanchine's motto. Baryshnikov subscribed to it, but he was two generations younger, and his idea of doing something new was to turn to American modern dance. He had been dipping into that well almost since his arrival in the West. As noted, he worked with Alvin Ailey, and a number of the ballet choreographers who used him in the seventies — John Butler, John Neumeier, Eliot Feld — were heavily influenced by modern dance. Then there was his collaboration with Twyla Tharp, America's first forthright 'crossover' (ballet-cum-modern) choreographer. Later, he would appear in modern-dance works by Martha Graham [pp. 174–200], Paul Taylor [pp. 156–157, 164–165, 242–245], Merce Cunningham [pp. 282–289], Trisha Brown [pp. 260–265], and Erick Hawkins — with their companies. In these guest appearances, he was invariably doing a favor for the company in question. Modern dance is not a lucrative business, but when the Russian wonder boy was performing on opening night, the house was invariably sold out. Nevertheless, Baryshnikov was quite serious about such ventures. Nureyev too put in appearances with modern-dance choreographers, but he did not bother to study their technique; he just went on stage and was wonderful, in his own, Russian way. Baryshnikov went to Graham classes, Cunningham classes. He tried to learn their way of dancing, their use of the back, the pelvis, the arms. He *studied*. He was fascinated by modern dance, and in violation of what has historically been the *de haut en bas* attitude of the ballet people to the barefoot people, he told interviewers that he felt he was actually handicapped by not having studied modern dance earlier: 'My timing in classical dance, in *Swan Lake* or *Giselle*, would have been much more interesting. Young dancers in classical dance, they have a tendency to over-dance everything.' Modern dance, he said, was a chastening influence. It made people honest. 'It's plainer, it's much more grounded, it's much more exposed. It teaches how to pace, how to suppress unnecessary impulses, just do the steps, but fully.' His own best performances, he feels, came later in his career, after he was straightened out by time and modern dance. 'I didn't try any longer to impress — over-jump, over-turn, over-partner, over-act.'

This is what he says today, when his repertory is entirely modern dance, but he had those thoughts already in the eighties, when he was directing ABT. He acquired modern-dance works for the company: Paul Taylor's *Sunset*, Merce Cunningham's *Duets*. More important, he commissioned classical ballets from modern-dance choreographers: David Gordon, Karole Armitage [pp. 170–173], Mark Morris. He made Twyla Tharp an 'artistic associate' of the company. Under his directorship, she created six ballets for ABT.

Still, ABT was a conservative organization. Its subscribers wanted to see *Giselle* or, failing that, some heartfelt European number. Many of them did not get Gordon's deadpan humor, or sympathize with Armitage's punk mentality, or understand Morris's moonlit meditations on Virgil Thomson. Nor were the subscribers Baryshnikov's only problem at ABT. The company's board of directors wanted him to perform much more often than, with a new knee injury, he felt able to do. They also wanted him to join in their fundraising efforts far more enthusiastically than, with his extreme reticence, he was comfortable doing or, with a director's salary of one dollar per year (his choice), he felt obliged to do. Charles France ran interference for him, but he too was worn down eventually. In 1989 Baryshnikov announced that he would leave ABT in 1990. Soon afterward, the company went behind his back and fired France. Baryshnikov resigned in protest.

All that clamor and publicity (*Cinderella* and *Swan Lake* were multimillion-dollar productions), all those young dancers demanding roles and promotions: This was not an assignment for Baryshnikov. He was not fitted for it by temperament. He made decisions slowly. He hated confrontations, any unpleasantness. This did not mean he couldn't run a dance company; it only meant that he had trouble running a big, commercial ballet company. He had seen another way, however. Between ABT seasons, he would normally take a small group of his own, Baryshnikov & Co., on the road. 'That was the counterexample,' says the dance critic Robert Greskovic. 'That's where he learned that there was another way — that he could have a company with people *he* wanted to work with, dancing the pieces *he* wanted to dance.'

Soon he found another alternative model, this one a modern-dance company, the Mark Morris Dance Group. When Morris created *Drink to Me Only with Thine Eyes* for ABT in 1988, the two men became friends. Immediately after resigning from ABT, Baryshnikov went to Brussels, where Morris and his dancers were then stationed, to dance with them [pp. 203–207], and during that time he saw how a small troupe could

work. In 1990, with Morris's collaboration, he founded his own small troupe, called White Oak Dance Project. From the time he arrived in the West, Baryshnikov had been friends with the paper-manufacturing magnate and philanthropist Howard Gilman. (It was in an apartment provided by Gilman that he lived during his first few years in New York.) Gilman owned a property, the White Oak Plantation, on the Georgia-Florida border, that was used as a wildlife preserve and arts center as well as for business purposes. When Baryshnikov got the idea of starting a company, Gilman offered to build him a rehearsal studio there. In gratitude, Baryshnikov named the organization after its new home.

He designed White Oak very carefully so that, unlike ABT, it would not be a millstone around his neck. The company has never had more than fifteen members, and Baryshnikov has tended to hire people who are somewhat older than the average dancer — in other words, better able to take care of themselves. He has no board of directors to boss him around or cover losses. White Oak tours about four months a year. When a tour is over, the group disbands, and Baryshnikov has the freedom to go out on projects of his own. He has done American tours with Twyla Tharp and with the modern-dance choreographer Dana Reitz [pp. 257–259]. In 1998 he toured Japan with the Kabuki star Tamasaburo Bando [pp. 276–280].

But from 1990 to the present, White Oak has been his main project, and it is a modern-dance company. This is appropriate to Baryshnikov's age: he is fifty-four, with a trick knee. Most lifting, and some jumping, is hard for him now. Still, he vigorously objects to any argument that modern dance is what he did, *faute de mieux*, when he could no longer hack ballet. As he sees it, modern dance was the heaven-sent medium of his later career. White Oak began somewhat cautiously, with works by established choreographers such as Graham, Taylor, Feld [p. 250], Tharp [pp. 238–241], Gordon, and Morris [pp. 208–228, 232–235, 252–255, 290]. But soon the repertory became more adventurous. Within the past few years, audiences that went to see Baryshnikov, and him only — such audiences are probably still the majority — have also seen works by choreographers who up till then had presented their pieces only in small 'downtown' spaces. How these choreographers will develop we don't know, but Baryshnikov has had the pleasure of aiding that development. With each tour, as it were, he has had another Creative Evening, with no *artsoviet* to tell him yes or no.

At the same time, he has remained true to the history of modern dance. In 2000-2001 he toured a show, PAST*Forward* (directed by David Gordon), that was a compila-

tion of old and new dances by the Judson Church choreographers of the sixties, the founders of the so-called postmodern dance [pp. 296, 300–305, 308–319]. In doing so, he probably did not think that he was paying back a debt to the United States, but that was the effect. Most of these dances had not been seen for years. Baryshnikov was a star — *the* star, for a time — of Russian ballet, and many of us still regard him as Russian: the face, the accent. In his mind, however, that was in another country. He has now lived in the United States for most of his life. He has an American wife, Lisa Rinehart (a former ABT dancer), and four children who speak no Russian. He sees himself as an American, and he sees America's history as his history.

This book began as a glasnost project. After the freeing-up of the Russian press, Baryshnikov's friend Valery Golovitser decided that the Russian public might be interested in a collection of photographs of the dancer's Western career — the part they didn't see. Baryshnikov helped choose the photos. (Always, says Golovitser, Baryshnikov favored the later photos, the modern-dance photos, and that bias is still reflected in the present volume.) The book was published in Moscow in 1998 under the title *The Unknown Baryshnikov*. Later, Golovitser had the idea that Americans too, though Baryshnikov's Western career was not unknown to them, might like to see such a compilation. For the book's American edition, some photos have been added, some dropped. Robert Greskovic has updated the chronology and annotated the picture captions. I have added this essay, to stand alongside Vera Krasovskaya's original preface, which now appears as an afterword.

F. Scott Fitzgerald said that American lives have no second acts, but he was not thinking about immigrants. Baryshnikov has had a second act. This book is the record.

— *Joan Acocella, New York City 2001*

CHRONOLOGY OF DEBUT PERFORMANCES COMPILED BY VALERY GOLOVITSER AND ROBERT GRESKOVIC

This list represents the first times Mikhail Baryshnikov appeared in the given works outside Russia. The code 'cr' indicates a role Baryshnikov created — that is, the choreography was fashioned especially for him, and he was the first dancer to perform the role at the work's première. Otherwise, the dates refer not to a work's première but to when it entered Baryshnikov's Western repertory. There is some overlap after 1990, when Baryshnikov founded his White Oak Dance Project. The roles he performed for the first time with WODP are listed together. Those works that entered his repertory with other companies are given in the main chronology. Throughout, American Ballet Theatre and the New York City Ballet are cited by their familiar acronyms, ABT and NYCB.

1974

GISELLE Albrecht. Choreography by Jean Coralli, Jules Perrot, Marius Petipa. Music by Adolphe Adam. ABT.

LA BAYADÈRE (The Kingdom of the Shades) Solor. Choreography by Marius Petipa. Music by Léon Minkus. ABT.

DON QUIXOTE Pas de Deux. Choreography by Marius Petipa. Music by Léon Minkus. ABT.

LA SYLPHIDE James. Choreography by August Bournonville. Music by Herman Løvenskjold. National Ballet of Canada.

COPPÉLIA Franz. Choreography by Enrique Martinez after Arthur Saint-Léon. Music by Léo Delibes. ABT.

THEME AND VARIATIONS Principal dancer. Choreography by George Balanchine. Music by Peter Ilich Tchaikovsky. ABT.

LES PATINEURS The Boy in Green. Choreography by Frederick Ashton. Music by Giacomo Meyerbeer. ABT.

LA FILLE MAL GARDÉE Colin. Choreography by Dimitri Romanoff after Jean Dauberval. Music by Peter Ludwig Hertel. ABT.

1975

LE JEUNE HOMME ET LA MORT The Young Man. Choreography by Roland Petit. Music by Johann Sebastian Bach. ABT.

LE CORSAIRE Pas de Deux. Choreography by Marius Petipa. Music by Riccardo Drigo. ABT.

VESTRIS (cr 1969) Choreography by Leonid Yakobson. Music by Gennady Banschikov. ABT.

MEDEA Jason (cr) Choreography by John Butler. Music by Samuel Barber. Spoleto Festival, Italy.

SHADOWPLAY The Boy with Matted Hair. Choreography by Antony Tudor. Music by Charles Koechlin. ABT.

LE SPECTRE DE LA ROSE The Rose. Choreography by Michel Fokine. Music by Carl Maria von Weber. Hamburg Ballet Festival, Germany.

LE PAVILLON D'ARMIDE Pas de Quatre. Choreography by Michel Fokine. Music by Nicholas Tcherepnin. Hamburg Ballet Festival, Germany.

SWAN LAKE Prince Siegfried. Choreography by Erik Bruhn after Marius Petipa and Lev Ivanov. Music by Peter Ilich Tchaikovsky. National Ballet of Canada.

SWAN LAKE Prince Siegfried. Choreography by Marius Petipa and Lev Ivanov. Music by Peter Ilich Tchaikovsky. The Royal Ballet.

ROMEO AND JULIET Romeo. Choreography by Kenneth MacMillan. Music by Sergei Prokofiev. The Royal Ballet.

AWAKENING Principal dancer (cr). Choreography by Robert Weiss. Music by Craig Steven Shuler. ABT.

1976

HAMLET CONNOTATIONS Hamlet (cr). Choreography by John Neumeier. Music by Aaron Copland. ABT.

PUSH COMES TO SHOVE Principal dancer (cr). Choreography by Twyla Tharp. Music by Joseph Lamb, Franz Joseph Haydn. ABT.

OTHER DANCES Principal dancer (cr). Choreography by Jerome Robbins. Music by Frédéric Chopin. Star Spangled Gala.

PAS DE 'DUKE' Principal dancer (cr). Choreography by Alvin Ailey. Music by Duke Ellington. Alvin Ailey City Center Dance Theater.

THE SLEEPING BEAUTY Prince Désiré. Choreography by Marius Petipa. Music by Peter Ilich Tchaikovsky. ABT.

PETROUCHKA Petrouchka. Choreography by Michel Fokine. Music by Igor Stravinsky. ABT.

LE SACRE DU PRINTEMPS Principal dancer. Choreography by Glen Tetley. Music by Igor Stravinsky. ABT.

ONCE MORE, FRANK Principal dancer (cr). Choreography by Twyla Tharp. Three songs sung by Frank Sinatra; music and lyrics by C. Carson Parks; Harold Arlen and Johnny Mercer; and Dean Kay and Kelly Gordon. ABT.

THE NUTCRACKER Nutcracker/Prince (cr). Choreography by Mikhail Baryshnikov; choreography for Snowflake Waltz by Vasily Vainonen. Music by Peter Ilich Tchaikovsky. ABT.

1977

VARIATIONS ON 'AMERICA' Principal dancer (cr). Choreography by Eliot Feld. Music by Charles Ives, William Schuman. Eliot Feld Ballet.

THE PRODIGAL SON Title role. Choreography by George Balanchine. Music by Sergei Prokofiev. Geneva Ballet.

LA FILLE MAL GARDÉE Colas. Choreography by Frederick Ashton. Music by Ferdinand Hérold. The Royal Ballet.

ROMEO AND JULIET Romeo. Choreography by Igor Tchernichev. Music by Hector Berlioz. Maryland Ballet.

APOLLO Apollo. Choreography by George Balanchine. Music by Igor Stravinsky. Vienna State Opera Ballet.

1978

DON QUIXOTE (or **KITRI'S WEDDING**) Basilio (cr). Choreography by Mikhail Baryshnikov after Marius Petipa and Alexander Gorsky. Music by Léon Minkus. ABT.

SANTA FE SAGA (cr) Choreography by Eliot Feld. Music by Morton Gould. Eliot Feld Ballet.

LA DAME DE PIQUE Hermann (cr). Choreography by Roland Petit. Music by Peter Ilich Tchaikovsky. Les Ballets de Marseille.

COPPÉLIA Frantz. Choreography by Alexandra Danilova and George Balanchine after Marius Petipa. Music by Léo Delibes. NYCB.

JEWELS ('Rubies') Principal dancer. Choreography by George Balanchine. Music by Igor Stravinsky. NYCB.

STARS AND STRIPES Fourth movement, principal dancer. Choreography by George Balanchine. Music by John Philip Sousa. NYCB.

AFTERNOON OF A FAUN Principal dancer. Choreography by Jerome Robbins. Music by Claude Debussy. NYCB.

THE NUTCRACKER Sugar Plum Fairy's Cavalier. Choreography by George Balanchine. Music by Peter Ilich Tchaikovsky. NYCB.

HARLEQUINADE Harlequin. Choreography by George Balanchine. Music by Riccardo Drigo. NYCB.

44

TSCHAIKOVSKY PAS DE DEUX Choreography by George Balanchine. Music by Peter Ilich Tchaikovsky. NYCB.

1979

AIRS Principal dancer. Choreography by Paul Taylor. Music by George Frederick Handel. Paul Taylor Dance Company.

CARMEN Don José. Choreography by Roland Petit. Music by Georges Bizet. Les Ballets de Marseille.

EATIN' RAIN IN SPACE Principal dancer (cr). Choreography by Richard Tanner. Music by Cecil Taylor. International Dance Festival of Stars.

ORPHEUS Orpheus. Choreography by George Balanchine. Music by Igor Stravinsky. NYCB.

DONIZETTI VARIATIONS Principal dancer. Choreography by George Balanchine. Music by Gaetano Donizetti. NYCB.

THE FOUR TEMPERAMENTS Melancholic. Choreography by George Balanchine. Music by Paul Hindemith. NYCB.

SYMPHONY IN C Third movement, principal dancer. Choreography by George Balanchine. Music by Georges Bizet. NYCB.

LA SONNAMBULA The Poet. Choreography by George Balanchine. Music by Vittoria Rieti after Vincenzo Bellini. NYCB.

UNION JACK Costermonger Pas de Deux, Pearly King. Choreography by George Balanchine. Music: Traditional British sources, orchestrated by Hershy Kay. NYCB.

TARANTELLA Principal dancer. Choreography by George Balanchine. Music by Louis Moreau Gottschalk. NYCB.

DANCES AT A GATHERING Brown. Choreography by Jerome Robbins. Music by Frédéric Chopin. NYCB.

THE FOUR SEASONS Fall, principal dancer (cr). Choreography by Jerome Robbins. NYCB.

THREE VARIATIONS FROM FANCY FREE Second sailor. Choreography by Jerome Robbins. NYCB.

OPUS 19 (later called **OPUS 19/THE DREAMER**) principal dancer (cr). Choreography by Jerome Robbins. Music by Sergei Prokofiev. NYCB.

THE STEADFAST TIN SOLDIER The Soldier. Choreography by George Balanchine. Music by Georges Bizet. NYCB.

A MIDSUMMER NIGHT'S DREAM Oberon. Choreography by George Balanchine. Music by Felix Mendelssohn. NYCB.

SONATINE Principal dancer. Choreography by George Balanchine. Music by Maurice Ravel. NYCB.

1980

RHAPSODY Principal dancer (cr). Choreography by Frederick Ashton. Music by Sergei Rachmaninoff. The Royal Ballet.

LES SYLPHIDES Principal dancer. Choreography by Michel Fokine. Music by Frédéric Chopin. ABT.

1981

THE GUARDS OF AMAGER Pas de Trois. Choreography by August Bournonville. Music by W. C. Holm. ABT.

RAYMONDA Grand Pas Hongrois. Choreography by Mikhail Baryshnikov after Marius Petipa. Music by Alexander Glazunov. ABT.

CONFIGURATIONS Principal dancer (cr). Choreography by Choo San Goh. Music by Samuel Barber. ABT.

THE WILD BOY Title role (cr). Choreography by Kenneth MacMillan. Music by Gordon Crosse. ABT.

FROM SEA TO SHINING SEA Principal dancer. Choreography by Paul Taylor. Music by J. H. McDowell. Paul Taylor Dance Company.

1982

WHO CARES? (Suite) Principal dancer. Choreography by George Balanchine. Baryshnikov & Co.

1983

FOLLOW THE FEET Principal dancer (cr). Choreography by John McFall. Music by Igor Stravinsky. ABT.

THE LITTLE BALLET Principal dancer (cr). Choreography by Twyla Tharp. Music by Alexander Glazunov. ABT.

SINATRA SUITE Principal dancer (cr). Choreography by Twyla Tharp. Music: Various songs sung by Frank Sinatra. ABT.

THREE VIRGINS AND A DEVIL The Devil. Choreography by Agnes de Mille. Music by Ottorino Respighi. ABT.

IMAGES Principal dancer. Choreography by Paul Taylor. Music by Claude Debussy. Paul Taylor Dance Company.

1985

A MONTH IN THE COUNTRY Beliaev. Choreography by Frederick Ashton. Music by Frédéric Chopin. The Royal Ballet.

1986

THE MOLLINO ROOM Principal dancer (cr). Choreography by Karole Armitage. Music by Paul Hindemith. ABT.

MURDER Principal dancer (cr). Choreography by David Gordon. Music by Hector Berlioz. ABT.

MADNESS OF A GREAT ONE Hamlet. Choreography by Maurice Béjart. Music by Duke Ellington, Henry Purcell. Ballet of the Twentieth Century.

1987

APPALACHIAN SPRING Husbandman. Choreography by Martha Graham. Music by Aaron Copland. Martha Graham Dance Company.

NOCTURNES Principal dancer (cr). Choreography by Dan Siretta. Music by George Gershwin. Gala, 'Celebrating Gershwin'.

1988

DRINK TO ME ONLY WITH THINE EYES (cr) Choreography by Mark Morris. Music by Virgil Thomson. ABT.

EL PENITENTE Penitent. Choreography by Martha Graham. Music by Louis Horst. Martha Graham Dance Company.

1989

AMERICAN DOCUMENT Principal dancer (cr). Choreography by Martha Graham. Music by John Corigliano. Martha Graham Dance Company.

NIGHT JOURNEY Oedipus. Choreography by Martha Graham. Music by William Schuman. Gala for ABT and Martha Graham Dance Company.

WONDERLAND Principal dancer (cr). Choreography by Mark Morris. Music by Arnold Schoenberg. Théâtre de la Monnaie/Mark Morris.

1992

CUTTING UP Principal dancer (cr). Choreography by Twyla Tharp. Music: mixture of jazz pieces; Giovanni Battista Pergolesi. Twyla Tharp and Mikhail Baryshnikov Tour.

DUO CONCERTANT Principal dancer. Choreography by George Balanchine. Music by Igor Stravinsky. NYCB.

1993

AUREOLE Principal dancer. Choreography by Paul Taylor. Music by George Frideric Handel. Paul Taylor Dance Company.

1996

TODAY, WITH DRAGONS Principal dancer (cr). Choreography by Erick Hawkins. Music by Ge Gan Ru. Erick Hawkins Dance Company.

YOU CAN SEE US Principal dancer. Choreography by Trisha Brown. Music by Robert Rauschenberg. Trisha Brown Dance Company.

1999

OCCASION PIECE Principal dancer (cr). Choreography by Merce Cunningham. Music by John Cage. Merce Cunningham Dance Company.

2000

HOMEMADE Choreography by Trisha Brown. Performed in silence. Trisha Brown Dance Company.

WHITE OAK DANCE PROJECT

Repertory of works chosen and/or commissioned by Baryshnikov, in which he performed

1990

GOING AWAY PARTY Choreography by Mark Morris. Music by Bob Wills and His Texas Playboys.

MOTORCADE (cr) Choreography by Mark Morris. Music by Camille Saint-Saëns.

PAS DE POISSON (cr) Choreography by Mark Morris. Music by Erik Satie.

TEN SUGGESTIONS Choreography by Mark Morris. Music by Alexander Tcherepnin.

1991

CANONIC 3/4 STUDIES Choreography by Mark Morris. Music by various composers: piano waltzes, arranged by Harriet Cavalli.

DECK OF CARDS Choreography by Mark Morris. Music by J. Logsdon, D. Frazier, T. Tyler.

A LAKE (cr) Choreography by Mark Morris. Music by Franz Joseph Haydn.

WAITING FOR THE SUNRISE (cr) Choreography by Lar Lubovitch. Music: seven songs by Les Paul & Mary Ford, and three songs by Johnny Puleo and His Harmonica Gang.

DUET FROM CONCERTO SIX TWENTY-TWO Choreography by Lar Lubovitch. Music by Wolfgang Amadeus Mozart.

1992

PUNCH & JUDY (cr) Choreography by David Gordon. Music by Carl Stalling, William Walton, Angel Villodo.

THREE PRELUDES (cr) Choreography by Mark Morris. Music by George Gershwin.

1993

JOCOSE Choreography by Hanya Holm (reconstructed by Don Redlich). Music by Maurice Ravel.

MOSAIC AND UNITED (cr) Choreography by Mark Morris. Music by Henry Cowell.

PERGOLESI (cr) Choreography by Twyla Tharp. Music by Giovanni Battista Pergolesi.

1994

SIGNALS Choreography by Merce Cunningham. Music by David Tudor, Takehisa Kosugi, John Adams, D'Arcy Gray.

A SUITE OF DANCES (cr) Choreography by Jerome Robbins. Music by Johann Sebastian Bach.

BEHIND WHITE LILIES (cr) Choreography by Joachim Schloemer. Music by Arnold Schoenberg.

'THE GOOD ARMY' (cr) Choreography by Kevin O'Day. Music by John Lurie.

1995

GRETA IN THE DITCH (cr) Choreography by Tere O'Connor. Music by Grazyna Bacewicz.

TONGUE & GROOVE (cr) Choreography by Eliot Feld. Music by Steve Reich.

THREE RUSSIAN PRELUDES (cr) Choreography by Mark Morris. Music by Dmitri Shostakovich.

UNSPOKEN TERRITORY (cr) Choreography by Dana Reitz. Performed in silence.

1996

STILLE NACHT (cr) Choreography by Joachim Schloemer. Music by Alfred Schnittke.

A CLOUD IN TROUSERS (cr) Choreography by Kevin O'Day. Music by Dmitri Shostakovich.

SEPTET Choreography by Merce Cunningham. Music by Erik Satie.

WHAT A BEAUTY! (cr) Choreography by Kraig Patterson. Music by Bedrich Smetana.

CHACONNE Choreography by José Limón. Music by Johann Sebastian Bach.

MEETING PLACE (cr) Choreography by Dana Reitz. Music by Domenico Scarlatti.

EMBODIED (cr) Choreography by Graeme Murphy. Music by Alfred Schnittke.

1997

JOURNEY OF A POET (cr) Choreography by Erick Hawkins. Music by Lucia Dlugoszewski.

REMOTE (cr) Choreography by Meg Stuart. Music by Eleanor Hovda.

TRYST (cr) Choreography by Kraig Patterson. Music by Johann Sebastian Bach.

PIANO BAR (cr) Choreography by Maurice Béjart. Music by Manzi-Demares, A. Bardi, A. Consentino, Johann Sebastian Bach, Brian May.

HEARTBEAT: MB (cr) Project Conception and Sound Score: Christopher Janney. Choreographic Direction by Sara Rudner. Movement and Improvisation by Mikhail Baryshnikov. Music by Samuel Barber.

1998

TCHAIKOVSKY DANCE (cr) Choreography by Neil Greenberg. Music by Peter Ilich Tchaikovsky.

DANCE WITH TWO DRUMS AND FLUTE (cr) Choreography by Tamasaburo Bando. Music by Rosen Tusha.

CANTATA FOR TWO (cr) Choreography by Dana Reitz in collaboration with Mikhail Baryshnikov and Tamasaburo Bando. Music by Johann Sebastian Bach.

1999

MACGUFFIN, OR HOW MEANINGS GET LOST (REVISITED) (cr) Choreography by Neil Greenberg. Music by Bernard Herrmann.

SOFT CENTER (cr) Choreography by Lucy Guerin. Music by various artists.

THE ARGUMENT (cr) Choreography by Mark Morris. Music by Robert Schumann.

THE LAST LAP (cr) Choreography by Karole Armitage. Music by Dmitri Shostakovich.

2000

PECCADILLOS (cr) Choreography by Mark Morris. Music by Erik Satie.

SEE THROUGH KNOT (cr) Choreography by John Jasperse. Music by Frances-Marie Uitti with Stephen Vitiello.

AFTER MANY A SUMMER DIES THE SWAN (cr) Choreography by Yvonne Rainer. Music by Edvard Grieg, Ludwig van Beethoven, (recordings) by Ike and Tina Turner.

FOR THE LOVE OF REHEARSAL (cr) Choreography by David Gordon. Music by Johann Sebastian Bach.

FLAT Choreography by Steve Paxton. Performed in silence.

SINGLE DUET (cr) Choreography by Deborah Hay. Music by Morton Feldman.

CONCERTO Choreography by Lucinda Childs. Music by Henryk Górecki.

OVERTURE TO THE MATTER Choreography by David Gordon. Music by Léon Minkus.

CHAIR Choreography by David Gordon. Music by John Philip Sousa.

WHIZZ (cr) Choreography by Deborah Hay. Music by Alvin Lucier.

CHAIR/PILLOW Choreography by Yvonne Rainer. Music (recordings) by Ike and Tina Turner.

ANNOTATED PHOTO CAPTIONS BY ROBERT GRESKOVIC

The dates given in the photo spreads are there to fix a time-line for Baryshnikov's Western career. They do not indicate the date of the photograph, or of Baryshnikov's first performance of the role in question, but rather of his first performance of that role after his move to the West in 1974.

FRONT COVER *Don Quixote* Pas De Deux (Choreography: Marius Petipa) The *grand pas de deux* from the multi-act *Don Quixote* became a staple of Russian ballet as a 'highlight', or concert, number. Here Baryshnikov dances it for American audiences.

(END PAGE) 1 *Giselle* (Choreography: Jean Coralli, Jules Perrot, Marius Petipa)

(END PAGE) 2 *Giselle* with Natalia Makarova

2 *Giselle* with Natalia Makarova. Baryshnikov made his U.S. debut in this ballet opposite Makarova, who, four years previous to these performances, made her ABT debut in the same work.

5 *Coppélia* ABT (Choreography: Enrique Martinez) This moment, at the height of one of Baryshnikov's famed jumps, is from the first of the story ballet's three acts.

6 *Theme and Variations* (Choreography: George Balanchine) This at once academic and imperial showpiece of a ballet was the first Balanchine work Baryshnikov danced in the U.S. Here he is shown in the ABT staging, which he danced early with the company and which the Public Broadcasting System subsequently telecast in the redesigned production shown here.

8–9 *Le Jeune Homme et la Mort* with Bonnie Mathis (Choreography: Roland Petit)

10 *Le Jeune Homme et la Mort* with Bonnie Mathis. This 1946 ballet, with a contemporary death-and-the-young-artist scenario by Jean Cocteau, had previously been in ABT's repertory. It was brought back especially for Baryshnikov in 1975.

11 *Vestris* (Choreography: Leonid Yakobson)

12 *Vestris* This solo, named after the great Auguste Vestris (1760-1842), was choreographed by Yakobson for Baryshnikov to perform in Moscow's 1969 International Ballet Competition. These two moments illustrate the choreography's aim to showcase the dancer in forceful, dynamic movement and in grand mimetic gesture.

13 *Medea* with Carla Fracci (Choreography: John Butler) As the offending and hapless Jason of Greek mythology, Baryshnikov here carries the wronged Medea. The choreography's Graham-styled movement reflected Butler's connections to both ballet and modern dance, a combination which held a real fascination for the ballet-schooled Baryshnikov at the time.

14 *Le Spectre de la Rose* with Dominique Khalfouni (Choreography: Michel Fokine)

15 *Le Spectre de la Rose* This historic ballet from 1911 originally showcased the renowned Vaslav Nijinsky. Baryshnikov responded to the ballet's Old World atmosphere while shying away from facile comparisons between himself and his rather different predecessor.

66, 68–69 *Push Comes to Shove* (Choreography: Twyla Tharp)

70–71 *Push Comes to Shove* with Marianna Tcherkassky and Martine van Hamel. The solo pictures here show Baryshnikov in the dynamic and witty choreography Tharp created for the recently arrived Russian, each revealing something of the heady mix the choreographer wrought by combining ballet, jazz, and various social-dance accents.

72–73 *Other Dances* rehearsal, with Natalia Makarova and Jerome Robbins

75 *Other Dances* with Natalia Makarova (Choreography: Jerome Robbins)

76–77 *Other Dances* with Natalia Makarova. This duet, commissioned as a wedding present for Makarova, brought together the two Kirov Ballet alumni to selections of Chopin piano music. Robbins choreographed it to make equal use of the two dancers' contemporary-dance prowess and of the Slavic accent inherent in their ballet schooling.

79 *Pas de 'Duke'* (Choreography: Alvin Ailey)

80–83 *Pas de 'Duke'* with Judith Jamison

85 *Pas de 'Duke'* Somewhere between a teasing competition and an artistic collaboration, this duet, with individual solos for the two dancers, combined the jazziness of Ellington with the full-body movement of modern dance. Opposite the stellar and virtuosic Jamison, who was perfectly at home with Ailey's jazz-inflected modernism, Baryshnikov said how initially 'foreign' he felt in the mix. But the choreographer and his company's star both showed confidence in Baryshnikov and encouraged him to enter this new arena.

86–87 *Petrouchka* with ABT ensemble (Choreography: Michel Fokine) Another Fokine/Nijinsky ballet with much historical baggage, the work had been performed in Soviet Russia, but not accurately. Baryshnikov found it challenging and fascinating. Russian through and through by way of Stravinsky's score, Alexandre Benois's designs, and Fokine's choreography, the story centers on three commedia dell'arte figures refashioned as Russian puppets.

88–89 *Le Sacre du Printemps* (Choreography: Glen Tetley)

90–91 *Le Sacre du Printemps* Any number of stagings of Stravinsky's ground-breaking score have honored the composer's intentions concerning 'scenes from pagan Russia'. This 1976 version by Tetley appealed to Baryshnikov because it was more a series of 'impressionistic and symbolic' episodes and expressed what the dancer saw as the score's rich, primitive eroticism.

93 *The Nutcracker* with Marianna Tcherkassky (Choreography: Mikhail Baryshnikov) Baryshnikov's very own staging of what had become a perennial classic in the U.S. was his first venture as a choreographer in the United States.

94 *The Prodigal Son* (Choreography: George Balanchine)

96 *The Prodigal Son*

97 *The Prodigal Son* rehearsal, with George Balanchine

99 *The Prodigal Son* rehearsal, with Karin von Aroldingen

101 *The Prodigal Son* with NYCB male ensemble. Though Balanchine often downplayed his 1929 ballet as somewhat old-fashioned, he worked directly with Baryshnikov to bring the biblical parable back to life in 1978. When Baryshnikov made his 1977 debut in the work in Geneva, he was not yet working directly with the choreographer. These pictures are from later Balanchine-tutored performances.

102–103 *Variations on 'America'* (Choreography: Eliot Feld) The often oblique and slyly cynical Feld here made light of Baryshnikov's 'foreignness' by fashioning for the prodigious Russian a duet and solo that demanded fierce strength and self-mocking playfulness.

104 *Santa Fe Saga* (Choreography: Eliot Feld)

106–107 *Santa Fe Saga* As in *Variations on 'America'*, which was set to Charles Ives's take on his national music, so here, in *Santa Fe Saga*, set to Morton Gould's musical evocation of the American Southwest, Feld created a distinctly American role for Baryshnikov.

108–109 *La Dame de Pique* (Choreography: Roland Petit)

111 *La Dame de Pique* with Evelyn Desutter

112 *La Dame de Pique* with Ballet de Marseille ensemble

113 *La Dame de Pique* Three years after first dancing *Le Jeune Homme et La Mort*, Baryshnikov reacquainted himself with the workings of Western Europe's influential Petit. As Robbins did in *Other Dances*, Petit worked with Baryshnikov's Russianness, as well as with his native affinity for Pushkin's great story and Tchaikovsky's stirring music.

115 *Coppélia* NYCB (Choreography: Alexandra Danilova and George Balanchine) It was in this role, as the flippant Frantz, that Baryshnikov made his first appearance with Balanchine's New York City Ballet. His debut performance came on a Saturday matinée, July 8, 1978, at the company's summer home in Saratoga Springs and was matter-of-factly introduced to the family audience by Ronald McDonald.

116 *Rubies* with Patricia McBride (Choreography: George Balanchine)

117 *Rubies* Eventually, as a regular member of NYCB, Baryshnikov took on a large number of roles that were part of no other repertory. Here he dances *Rubies*, alongside the ballet's original female lead, Patricia McBride, and performs the role created for NYCB's quintessentially American danseur Edward Villella in 1967. Inspired by Stravinsky's jazz-flavored *Capriccio for Piano and Orchestra*, the ballet's physical challenges readily suited Baryshnikov's formidable athleticism and vivid performing personality.

118–119 *Apollo* rehearsal, with Jerome Robbins

121, 123 *Apollo* (Choreography: George Balanchine)

124–125 *Apollo* with Elyse Borne, Bonita Borne, and Heather Watts

126–127 *Apollo* with Heather Watts. Though he danced this iconic Balanchine role before joining NYCB, it was in these performances with Balanchine's own company that Baryshnikov solidified his understanding of the seminal ballet's neoclassical approach to Greek themes. Around this time Balanchine tinkered with his 1928 creation, making it the pared-down version that he left

upon his death in 1983. The picture of Baryshnikov working with Robbins reminds us that the less-than-two-year period Baryshnikov spent with City Ballet coincided with Balanchine's ill health. In his stead, ballet-master Robbins took on increased responsibilities. In the photograph on pages 118–119, Robbins is discussing with Baryshnikov a costume question: Apollo's tights. And as the later pictures show, the white tights, favored by Robbins, prevailed.

128 *Afternoon of a Faun* with Allegra Kent. (Choreography: Jerome Robbins)

130 *Afternoon of a Faun* with Allegra Kent. Robbins's American version of Nijinsky's legendary ballet strips away the trappings of ancient Greece and presents two innocent young dancers — here, Baryshnikov and Kent — in a sun-filled studio. The performance occurred during a time when Kent's much-admired career was winding down and Baryshnikov's was accelerating. He was about to take over the directorship of ABT. Part of the ballet's tension comes from the fact that the two seemingly self-absorbed dancers spend much of their time together staring straight ahead, as if into the mirrored wall of a ballet studio. A break in this mood, captured in the photographs printed here, comes when the young man leans forward to kiss the cheek of the woman.

132 *Airs* (Choreography: Paul Taylor) Taylor's barefoot dance for three men and four women was Baryshnikov's first foray into this modern master's repertory.

135 *Harlequinade* (Choreography: George Balanchine) In 1979 Baryshnikov performed the role of Harlequin in Balanchine's *Harlequinade*, a ballet with strong roots in Russia, where, in 1900 Marius Petipa's two-act *Les Millions d'Arlequin* was first performed. Even though Nijinsky put his indelible stamp on a similarly conceived Harlequin in Michel Fokine's *Carnaval*, Baryshnikov's portrayal of this bright character in motley set still higher standards for the rascal from the Italian commedia dell'arte.

137 *Rehearsal with Paul Taylor* Baryshnikov's fascination with the modern-dance works he brought into his repertory included a keen curiosity about the personal ways in which these 'moderns' worked with dance and dancers. Here the choreographer rehearses the ballet-trained guest artist in *Airs*.

138–139 *Carmen* with Zizi Jeanmaire (Choreography: Roland Petit)

141 *Carmen*

142–143 *Carmen* rehearsal with Roland Petit. In *Carmen*, another of his Petit's modernizations of long-standing theatrical themes, Baryshnikov performed the character of Don José, a role originally danced by Petit himself. He is seen pictured with the famous Zizi Jeanmaire, Petit's wife and the originator of the title role. When the ballet was first given in 1949, it was considered scandalously erotic.

144 *National Dance Institute* with students. The National Dance Institute is a personal project of former NYCB star Jacques d'Amboise. Its aim is to offer a taste of dance, choreography, and performing to schoolchildren.

146–147 *Three Variations from Fancy Free* (Choreography: Jerome Robbins)

148–149 *Three Variations from Fancy Free* with Jean-Pierre Frohlich, Stephanie Saland, and Sara Leland. The year before Robbins brought his 1944 classic, *Fancy Free*, into NYCB's repertory, he mounted a section of it, the three sailors' central 'dance competition', with Baryshnikov in the role often known as the 'Second Sailor'. Originally danced by ABT's John Kriza, the Second Sailor is the charmer of the trio, in contrast to the overconfident braggart (the 'First Sailor') and the rhumba-hipped hotblood (the 'Third Sailor').

151 *Opus 19* with NYCB ensemble (Choreography: Jerome Robbins) This mysterious and evocative reverie set to the music of Prokofiev was the first original work fashioned especially for Baryshnikov during his NYCB stay. When Baryshnikov

starred in the ballet, it was simply named after its music: *Opus 19*, for Prokofiev's Violin Concerto in D, op. 19. When, eventually, other NYCB dancers took on the role, Robbins changed the title to *Opus 19: The Dreamer*, thus spelling out what Baryshnikov had indicated through his dancing.

152 *Les Sylphides* (Choreography: Michel Fokine) Baryshnikov's rendering of the lone male dancer at the center of Fokine's *Les Sylphides* remains one of his many outstanding achievements as a classical ballet stylist. Here he is shown at the end of the 'slow mazurka' solo, which goes back, as far as his Kirov Ballet lineage can tell him, to the solo that Nijinsky originally performed in the 1909 première of this Chopin ballet.

154 *Configurations* with Marianna Tcherkassky (Choreography: Choo San Goh)

156–157 *From Sea to Shining Sea* rehearsal with Rudolf Nureyev and Paul Taylor. Over the years, Baryshnikov often agreed to appear in gala programs mounted to raise money for modern-dance troupes. This 1981 benefit for Paul Taylor and his company featured Baryshnikov alongside Nureyev in a specially arranged version of *From Sea to Shining Sea*.

158 *Who Cares?* with Cynthia Harvey (Choreography: George Balanchine) Before Baryshnikov founded his White Oak Dance Project, he spent summers directing a little ballet ensemble known as Baryshnikov & Co. For this chamber-sized group, he arranged a suite of dances from Balanchine's Gershwin panoply *Who Cares?* Here he dances with Harvey, in the ballet's central duet, to 'The Man I Love'.

160 *Three Virgins and a Devil* with Ruth Mayer (Choreography: Agnes de Mille)

162–163 *Three Virgins and a Devil* De Mille's ballet about the hard-to-resist temptations of a brilliant devil gave Baryshnikov numerous chances to show his formidable comic gifts.

164–165 *Images* with Paul Taylor Dance Company women (Choreography: Paul Taylor) This further

foray into Taylor's repertory put Baryshnikov in a world of 'images' that conjured figures from Aegean art. Themes such as 'Totem Dolphins' and 'Totem Horses' surface during the dance suite set to Debussy piano music.

166 *A Month in the Country* (Choreography: Frederick Ashton)

168 *A Month in the Country* with Antoinette Sibley

169 *A Month in the Country* rehearsal, with Frederick Ashton and Karen Paisey. Here Baryshnikov takes on the role Ashton created in 1976 for Anthony Dowell, England's finest male dancer. He plays Beliaev, the tutor, whose presence at a Russian summer estate causes most of the hearts on the premises to flutter uncontrollably. His charms are shown in solo moments like the one caught here, perfectly poised atop an arabesque penchée, and in his pas de deux, with Natalia, the lady of the house, here played brightly by Sibley. The scene with Ashton in rehearsal shows how Vera, Natalia's ward, also finds the newly arrived tutor impossible to resist.

170 *The Mollino Room* (Choreography: Karole Armitage)

172–173 *The Mollino Room* rehearsal, with ensemble couples. The title of Armitage's ballet, created in careful concert with striking visual designs by David Salle, refers to the modernist Italian designer Carlo Mollino. Baryshnikov, as the central dancer, was simply garbed in midnight blue, with a rendering of Brancusi's *Sleeping Muse* on his chest. The ballet was wittily arranged to a score combining Hindemith with 'My Son the Nurse', a hilarious routine by Mike Nichols and Elaine May. Though some in the audience booed, others cheered the ballet's flair and dash.

174, 177 *Appalachian Spring* with Terese Capucilli (Choreography: Martha Graham)

178–179 *Appalachian Spring* with Martha Graham Dance Company female ensemble and Rudolf Nureyev.

181 *Appalachian Spring* with Terese Capucilli It was in *Appalachian Spring* that Baryshnikov first danced a work by Martha Graham. These pictures capture the avidity with which the Russian classicist took to the special angles and emphases of American modern dance. In 1987, when Baryshnikov made his debut in this role, the matriarch of modern dance was in her nineties. Still, he had some benefit from her tutelage. For one of his performances, Baryshnikov danced in a cast that included Nureyev as the Revivalist, a role originally created for Merce Cunningham.

182 *El Penitente* with Joyce Herring (Choreography: Martha Graham)

184–185 *El Penitente*

186–187 *El Penitente* with Terese Capucilli

189–191 *El Penitente* with Joyce Herring and Pascal Rioult. For his second foray into Graham's distinctive world, Baryshnikov assumed the title role of the Penitent in Graham's modernist rendering of Southwestern religious ritual.

192 *Night Journey* with Terese Capucilli (Choreography: Martha Graham) Baryshnikov played the lead role in Graham's 1947 version of the Oedipus myth.

194–195 *American Document* with Martha Graham Dance Company female ensemble (Choreography: Martha Graham)

196–199 *American Document* with Maxine Sherman. In this 1989 'revival' of a 1938 work, Graham did not actually try to recreate the original, but merely to recast its intentions some fifty years later.

200 *Studio rehearsal* with Martha Graham. This picture, taken in Graham's own studio (since destroyed), dates from 1989, the year of the revival of *American Document*, which means it probably shows a moment when the ninety-five-year-old choreographer was refashioning her half-century-old work for her newest male dancer.

203 *Wonderland* with Rob Besserer
(Choreography: Mark Morris)

205 *Wonderland* with Olivia Maridjan-Koop.
Having worked with and for Morris while still
artistic director of ABT, Baryshnikov eagerly
sought to dance with him again. This 'film noir'
work, made for the Théâtre de la Monnaie in
Brussels (where Morris was dance director at
the time), used Schoenberg's eerie music to
suitably mysterious effect.

206–207 Rehearsal with Mark Morris. In 1990,
when Baryshnikov formed his own performing
ensemble, White Oak Dance Project, he did so
with the 'right-hand' cooperation of Morris.
Here the two work together on new choreogra-
phy in a Brussels studio.

208 *Going Away Party* with Kate Johnson
(Choreography: Mark Morris)

210–211 *Going Away Party* with Kathleen Moore,
Kate Johnson, and Denise Pons. This presentation
of a social gathering in a cowboy-and-cowgirl
world of four men and three women was created
for Morris's own troupe in 1989 and was adopted
by Baryshnikov's WODP the next year. Baryshni–
kov took the role originally performed by
Morris himself.

213 *Motorcade* with Kate Johnson (Choreo-
graphy: Mark Morris) This dance for eight
(four men and four women) was the first dance
Morris created especially for WODP. The plain,
contemporary American title contrasts sharply
with the nineteenth-century European mood
of its chosen score, *Saint-Saëns's Septet, op. 65.*

214–215 *Pas de Poisson* with Penny Hutchinson
and Mark Morris (Choreography: Mark Morris)

216–217, 219 *Pas de Poisson* As he would do
again in *Peccadillos*, Morris chose Satie to inspire
a dance for Baryshnikov. In this case the choreog-
rapher appeared alongside the Russian and one of
his own dancers and counterpoised his dancing
expertise and charisma with Baryshnikov's. Some
of the work's wit and biting edge is caught in the

pictures shown here, with Baryshnikov costumed
like a wrestling-team athlete.

220–223 *Ten Suggestions* (Choreography:
Mark Morris)

225, 227 *Ten Suggestions* Baryshnikov was born
too late to have worked with some of the pioneers
of modern dance. The same is true for the younger
Morris. But the world of early-twentieth-century
modernism stayed alive and well in showcases
such as this one for a lone, pajama-clad man.

228 *A Lake* (Choreography: Mark Morris) Like
the earlier *Motorcade*, this group composition
(for a combination of WODP and Morris's own
dancers: five men and five women) showed a lyri-
cal momentum as well as a modern dance-like,
'weighted' gravity.

231 *Duet from Concerto Six Twenty-Two* with
John Gardner (Choreography: Lar Lubovitch)
This male duet comes from a longer dance created
by Lubovitch for his own company and set to
Mozart's famous clarinet concerto. Baryshnikov
dances alongside Gardner, a ballet-trained dancer
who had worked under him at ABT. The duet's
configurations repeatedly play with a coordinated
linking of curved arms, as in this picture.

232 *Three Preludes* (Choreography: Mark Morris)

235 *Three Preludes* As he had done before in
Ten Suggestions and would do again in *Pecca-
dillos*, Baryshnikov performed a solo devised
by Morris to be danced by either of them. This
one was set to piano preludes by Gershwin.

236 *Duo Concertant* with Yvonne Borree
(Choreography: George Balanchine)

237 *Duo Concertant* with Yvonne Borree. After
leaving NYCB, Baryshnikov sometimes agreed, on
special occasions, to dance as a guest artist with
the company. Here he took on a part made by
Balanchine in 1972 for Peter Martins, director of
NYCB when Baryshnikov returned for these
performances. *Duo Concertant* is a work of pointed
simplicity. The violin and piano combine to make
Stravinsky's music mirror — while not matching

note for note — the interaction of the casually virtuosic male dancer and the delicately lyrical female dancer.

238 *Pergolesi* (Choreography: Twyla Tharp)

240–241 *Pergolesi* Dressed in tennis whites and alone on stage, Baryshnikov made this Tharp dance a musically keen, witty, and matter-of-fact journey through some eight Pergolesi compositions. Originally entitled *Bare Bones*, the piece was created for a 1992 tour, 'Cutting Up', that showcased the dancing of Baryshnikov and Tharp. The following year, the choreographer reworked the duet as a solo for Baryshnikov and renamed it.

242–243 *Aureole* (Choreography: Paul Taylor)

245 *Aureole* Although, as Paul Taylor repeatedly pointed out, his 1962 *Aureole* was a decidedly modern-dance creation, many ballet companies performed it. Baryshnikov took on the role originated by Taylor himself, and had to work hard to avoid doing the 'pretty-pretty' things Taylor so disliked about ballet troupes performing his works.

246 *A Suite of Dances* (Choreography: Jerome Robbins) Finding the aging Robbins in a mood to be inspired, Baryshnikov was again dancing in ballet slippers. The solo, with cellist on stage, featured seemingly improvisational movements set to selections from Bach's cello suites.

248–249 *Signals* with John Gardner, Ruthlyn Salomons, and Rob Besserer. (Choreography: Merce Cunningham) This 1970 dance for three women and three men was the first Cunningham work to enter Baryshnikov's repertory. In it, he performed the part originally danced by the choreographer himself. This involved his working with a long, pointer-like stick, which takes on varied functions, sometimes seeming to be a stickball bat, sometimes a magician's wand. Elsewhere, it is merely an extension of one dancer's means of partnering another. Though he could not have seen Cunningham do the role, Baryshnikov managed to capture the finesse of the great dancer-choreographer.

250 *Tongue & Groove* (Choreography: Eliot Feld) Nearly twenty years elapsed between Feld's earliest choreography for Baryshnikov and this later solo excursion. In the interim the American 'upstart' choreographer had developed a new interest in the bare bones of dancing, frequently outfitting his company in the most basic dancewear, such as the cutoff tights, tank top, and T-shirt that Baryshnikov wears here. Often scornful of ballet's 'prettier' aspirations, Feld prided himself on seeing dancing as a sometimes almost awkward presentation of movement and posture.

252–254 *Three Russian Preludes* (Choreography: Mark Morris)

255 *Three Russian Preludes* The 'Russian' air of this three-part dance springs from its Shostakovich score. Performed in what looks like casually undone dress clothes, the little choreographic études arranged by Morris display his flashing wit as well as his masterly sharpness.

257, 259 *Unspoken Territory* (Choreography: Dana Reitz) Reitz worked with Baryshnikov without music, but with a strict lighting plan by Jennifer Tipton that produced geometric plots of light on the stage. Santo Loquasto's costume — tailored, ribbed, translucent, somewhat starchy — lends Baryshnikov the hint of an Egyptian fresco figure. His movements are sometimes hieratic and sometimes casually spontaneous.

260, 262–263 *You Can See Us* with Trisha Brown (Choreography: Trisha Brown)

265 *You Can See Us* with Trisha Brown. In 1994 Trisha Brown created a solo for herself in collaboration with Robert Rauschenberg, who provided the music and costume design. Calling the dance *If You Couldn't See Me*, she performed it with her back to the audience. The following year, she refashioned the solo as a duet, *You Can See Us*, in which she continued to perform facing away from the audience while her partner (originally dancer-choreographer Bill T. Jones) executed mirror images of her steps while facing the audience.

In 1996 Baryshnikov appeared as a guest artist with Brown's company and joined her in the work.

266-267 *Chaconne* (Choreography: José Limón) Limón's 1942 solo, danced to Bach's Partita in D minor for unaccompanied violin, gained fame as a signature work during the dancer-choreographer's lifetime. Baryshnikov's revival brought it before a wider public.

268 *Piano Bar* (Choreography: Maurice Béjart)

271 *Piano Bar* rehearsal with Maurice Béjart. As one of the reigning modern ballet choreographers in Europe, Béjart made a career of reshaping ballet's *danse d'école* academicism into 'contemporary' movements and moods, in this instance for Baryshnikov and a wooden chair.

272-273 *HeartBeat: mb* (Project conception: Christopher Janney, Choreography: Sara Rudner, Mikhail Baryshnikov)

275 *HeartBeat: mb* As the credits indicate, this experimental solo included electronic technology (by Christopher Janney), choreographic super-structuring (by Sara Rudner), and improvisation (by Baryshnikov). The title refers to the fact that Baryshnikov performed with a sensor fixed to his bare chest, transmitting, by way of amplifiers, his pulsing heartbeat. Eventually, this sound was mixed with a soothing Barber adagio.

276 *Cantata for Two* (Choreography: Dana Reitz)

278 *Cantata for Two* Reitz's American, postmodernist mix of Eastern and Western modes and moods grew out of observations she made of her two participating dancers, Baryshnikov and Tamasaburo Bando, arguably the most famous *onnagata* (actor specializing in female roles) of late-twentieth-century Grand Kabuki. Once more in Baryshnikov's career, Bach served as accompaniment.

280 *Dance with Two Drums and Flute* (Choreography: Tamasaburo Bando) This work, together with the related Japanese-styled *Cantata for Two*, came out of a collaborative work period that Baryshnikov spent with Dana Reitz and Tama-
saburo Bando in 1998. The solo was choreographed by Tamasaburo for Baryshnikov, who wore tabi socks and kimono.

282, 285 *Occasion Piece* (Choreography: Merce Cunningham)

286-287 *Occasion Piece* with Merce Cunningham

289 *Occasion Piece* rehearsal, with Merce Cunningham. Though Baryshnikov had previously danced in Cunningham works, before this 1999 season of Merce Cunningham Dance Company he probably never dreamed of actually sharing the stage with the revered iconoclast. Cunningham was eighty years old when he created this dance for himself and Baryshnikov. The piece, in which the largely infirm Cunningham worked mostly in place, gesticulating and toying with arm movements, is a good example of the choreographer's late period, in which he has used a computer to suggest movements and patterns. You can see this influence especially in the angularity of Baryshnikov's arms.

290 *The Argument* with Marjorie Folkman (Choreography: Mark Morris) As Morris's title suggests, there is more going on in this dance than a formal reaction to its folk-flavored Schumann score for piano and cello. Both contemporary in feeling and duly obedient to Schumann's Old World atmosphere, this 'argument' suggests turmoil without taking shape as a physical battle. Baryshnikov, the lone man interacting with three different women, alternatively gives and takes the brunt of the emotion. The result is a delicate web of uncertain and compelling feelings.

292-293 *MacGuffin or How Meanings Get Lost (Revisited)*, with Emmanuèle Phuon, Susan Shields, and Emily Coates (Choreography: Neil Greenberg) Greenberg's plainly physical dance (originally made for the choreographer and his own dancers in 1987 and here reworked especially for White Oak Dance Project) draws some of its atmosphere from the notion of a 'MacGuffin', a term coined by Alfred Hitchcock to identify a plot device crucial to the mystery of his individual

films. During the dance, pithy lines of text are addressed to the audience via slide projections on the back wall.

294–295 *The Last Lap* with Emily Coates (Choreography: Karole Armitage) After *The Mollino Room*, the more elaborate work Armitage made for Baryshnikov at ABT, the Cunningham-trained choreographer chose to create a simpler study for WODP. The result presented Baryshnikov as a lone male presence in a 'world' of five different women. The women's choreography is dominated by lush and supple legwork, while Baryshnikov's is filled with precisely calibrated moves and postures. Eventually he 'bonds' with Emily Coates (pictured here), for a sensual yet unsentimental duet.

296 *For the love of rehearsal* with Emmanuèle Phuon (Choreography: David Gordon) Gordon, another founding member of postmodernism, had worked with Baryshnikov when the latter was directing ABT. Presumably taking Baryshnikov at his often-expressed word that the process of working on a dance was frequently more interesting than performing it, Gordon confected a work out of the business, mood, and particulars of rehearsal.

298–299 *Peccadillos* (Choreography: Mark Morris) Dressed something like a Picasso sailor, and dancing to Satie piano pieces played on stage on a toy piano, Baryshnikov made Morris's solo into a series of charming and often witty vignettes. As he'd done before, Morris created his choreography to be performed by either Baryshnikov or himself.

300–301 *After Many a Summer Dies the Swan* with Raquel Aedo and Emmanuèle Phuon (Choreography: Yvonne Rainer)

302–303 *After Many a Summer Dies the Swan* with Raquel Aedo and Rosalynde LeBlanc

304–305 *After Many a Summer Dies the Swan* After her stint in the 1960s as one of the upstart founders of what came to be known as postmodern dance, Rainer left the world of dance to become a filmmaker. Baryshnikov, increasingly interested in the work of an era he hadn't witnessed firsthand, coaxed the 'retired' choreographer back to theater. Here she created a kind of assemblage of previous works, in which Baryshnikov and his WODP dancers could all find a part.

306–307 *See Through Knot* with Michael Lomeka, Emmanuèle Phuon, Emily Coates, and Raquel Aedo (Choreography: John Jasperse) Created by Jasperse, a younger-generation postmodernist, this group work builds slowly in a calculated lighting scheme that gives the stage a continuously glowing effect. The title refers to transparency and to the weave of strands that come and go in the process of a little group composition that, due to Jasperse's savvy sense of theatrical scale, seems not at all small on an opera-house stage.

308–309 *Single Duet* with Deborah Hay (Choreography: Deborah Hay) In this case veteran experimental choreographer Hay joined Baryshnikov in the creation and performance of her latest work.

311 *Chair* (Choreography: David Gordon) Gordon made this work in 1974 for himself and his wife, Valda Setterfield. Though a duet, it was also a pas de quatre, since it involved two dancers happily engaged with two folding chairs. The version for Baryshnikov became a duet with his chair, which he treated throughout with smiling admiration, respect, and interest.

312–313 *Homemade* (Choreography: Trisha Brown)

314–315 *Homemade* In this solo, which Brown made for herself in 1966, she performed with a 16-mm film projector strapped to her back, projecting Robert Whitman's film of the very same dance. As she moved, the film's images traveled across the surfaces of the theater. At the time, Brown said that her movements were drawn from her personal life and memories. For Baryshnikov's version (with a film by Babette Mangolte), the choreographer reworked the moves to integrate references to his life.

316–317 PAST*Forward* curtain call, with
Steve Paxton, Trisha Brown, Yvonne Rainer, and
Deborah Hay. Part of Baryshnikov's pleasure in
mounting shows such as this one came from
working directly with the dancemakers who had
made the history now being reclaimed. Here
the happiness and pride in the venture shows
in the faces of all concerned.

319 *Flat* (Choreography: Steve Paxton)

(END PAGE) 3–4 *Flat* Paxton is widely known for
having developed contact improvisation, a form of
improvisational interaction with two or more
dancers. Here Baryshnikov performs a solo that
Paxton had made for himself in 1964. Based on the
postmodernists' deep-seated belief in pedestrian
movement, the work is a curious kind of strip
show, but one utterly devoid of coyness. The suit-
wearing Baryshnikov starts the dance on a bare
stage set with a single folding chair, and follows it
to a conclusion that finds him stripped to his
underwear. The dance is not just an undressing,
though. It is also a re-dressing, as the removed
garments get hung on hooks attached to random
parts of the dancer's torso. The final image cap-
tured here has all the simplicity of a purposefully
struck seated pose, yet it also hints at the pathos
of an ancient piece of statuary — say, the famed
Fallen Gaul.

BACK COVER *Whizz* (Choreography: Deborah Hay)
Here, in a dance created for PAST*Forward*, Hay
has worked to include all the WODP dancers.
Baryshnikov remained dominant only if you chose
to pick him out of the full cast. Otherwise, the
democratic (or nonhierarchical) preferences of the
early postmodernists prevailed, giving equal
weight and focus to all the participants.

ABOUT THE AUTHORS

MIKHAIL BARYSHNIKOV has danced nearly 150 different works during his career. He worked with New York City Ballet, and the American Ballet Theatre where he served as Artistic Director for nine years. In addition to his dancing, he has starred in five films, earning an Oscar nomination for his performance in *The Turning Point*. He has performed numerous times on television, including three Emmy award-winning specials. In 1989, he appeared on Broadway in *Metamorphosis*, earning a Tony nomination and a Drama Critics Award. He is currently the director and co-founder of White Oak Dance Project, which has been touring internationally since 1990. Among his many awards, he received both the Kennedy Center honor and the National Medal of Arts in 2000.

JOAN ACOCELLA is an essayist and dance critic for *The New Yorker*. She is the author of *Mark Morris, Willa Cather and the Politics of Criticism*, and *Creating Hysteria: Women and Multiple Personality Disorder*, as well as the editor of *The Diary of Vaslav Nijinsky*.

VALERY GOLOVITSER is head of Val G. Productions, Ltd. He oversaw production of the Russian/English *Unknown Baryshnikov* (1998), on which *Baryshnikov in Black and White* is based. He is the author of *Ekaterina Maximova and Vladimir Vasiliev*, a study of two stars of the Bolshoi Ballet. He emigrated from Moscow and now lives in New York City.

ROBERT GRESKOVIC is the author of *Ballet 101*, and writes about dance for *The Wall Street Journal*. He served as consulting editor for *The Best Ever Book of Ballet* and wrote the afterword for *Balanchine Pointework*. He has taught dance history and dance aesthetics in New York City colleges and ballet schools since 1984. He lives in Brooklyn, New York.

VERA MIKHAILOVNA KRASOVSKAYA (1915–1999), author of the multivolume *Russian Ballet Theater* and *Western European Ballet Theater*, among other books, was long regarded as Russia's leading critic, scholar, and historian of dance.

How splendid late at night, Old Russia worlds apart,
To watch Baryshnikov, his talent still as forceful!

—Joseph Brodsky, from *A Part of Speech*

And all my former life is seen —
A crazy, drowsy, beautiful and
Utterly appalling dream…

—Alexander Blok, from *Alexander Blok: Selected Poems*

Mikhail Baryshnikov was twenty-six when he defected during a foreign tour of a group of Russian Ballet stars. This happened in Canada, although it could have happened in any country where there was a dance stage. He broke free, but as always remained a solitary figure, even as the world clamored to know him. In breaking from Russia, he was possibly most aggrieved about being separated from his big white poodle, Foma.

By the time he fled to the West, he had already accomplished heroic deeds in the wide-ranging classical repertoire. This certainly could not be said of his contribution to contemporary choreography. Here in Russia, his only roles of note were Adam in the ballet *The Creation of the World*, choreographed by Natalia Kasatkina and Vladimir Vasilyov to music by Andrei Petrov (1971), and, of particular importance, Vestris, in a solo concert piece of that name by Leonid Yakobson to music by Gennady Banschikov (1969). Baryshnikov's humorous approach to the role of Adam at times eclipsed his virtuosic dancing. Baryshnikov's Adam was touching in his childlike manner and in the naive curiosity with which he took his first steps in the newly created world. But for all their new ideas, this ballet's two choreographers lacked inspiration. Baryshnikov was capable of greater challenges.

Conversely, *Vestris*, a choreographic miniature marked by Yakobson's genius, touched new chords in the young Baryshnikov's soul. It was as if his Auguste Vestris, the arrogant king of dance in the late eighteenth and early nineteenth century, was questioning himself — he appeared to be expressing his own artistic soul. A sudden burst of passion would break through the dainty lacework of his minuets and pavanes. He was no longer recreating what had already existed, but anticipating novelty. This, at any rate, was how it turned out for Baryshnikov, who soon embarked on a new course. And once he did, he put everything behind him, just as Adam had.

Of course, Baryshnikov paid a price for the right to be himself. Like Adam, the dancer did not allow the authorities to determine his fate. And like Vestris, his predecessor, he would opt for untrodden paths.

A young star of world renown, Baryshnikov stood at the end of his romantic period. Did I say 'young star'? This is hardly correct. Twenty-six is not so young for a dancer; it is more like the halfway mark. I could argue that at the time Baryshnikov resembled a teenager — so radiant was his face, so childlike was he as he played with his poodle. Misha Baryshnikov allowed no one into his secret world . . . unless by chance.

I peeped into it twice.

The first time was on a sunny March day at Komarovo, on the Karelian isthmus. Between the beach and the iced-over waters of the Gulf of Finland lay rocks of ice the height of a two-story house. Our group climbed over the icy rocks and spread out over the frozen gulf. Misha sat down on the ice, his legs stretched out. In his blue coat and red knitted hood, he looked like a gnome out of a fairy tale.

'What ails the gnome?' I asked.

'It's the gnome's soul that ails him,' he answered seriously.

And the second time was after Misha had bought a car of which he was very proud. He wanted to drive us back to the city from Komarovo and loaded our bags into the car himself. I sat beside him. Naturally we talked of the ballet world. I don't remember how we got around to the subject of those who had fled from our country (or 'native paradise', as we cynically called it). This was a painful and forbidden theme at the time.

'I can understand them and I don't condemn them,' I said.

Misha stared intently at the road ahead and said nothing. But the car suddenly jolted. Later, at home, sitting at our table and leaning back against the couch, he was quiet and collected, avoiding the subject that never left his thoughts but of which his eyes spoke openly.

But first came the Baryshnikov gala concert at the Kirov. The two young choreographers, Georgy Aleksidze and Mai Murdmaa, had created for him ballets to music by Mozart, Ravel, and Prokofiev. It might have seemed as though the young dancer had enviable prospects ahead of him. But everyone knew that, however successful, this programme might at best be repeated once or twice more and never again. The Kirov repertory was based on productions of a different order.

Then came Baryshnikov's last (for us) magical performance — of *Giselle*. In ballet history it occupies a place alongside Nijinsky's last Petersburg *Giselle*. Following both of these performances, their Albrechts were to be barred forever from appearing at the Maryinsky-Kirov, this alma mater of two great exiles.

At home, developments followed the usual pattern: the more enthusiastic the praise for Baryshnikov's genius in the West, the more bitterly the authorities condemned him, the more sweeping the ban on his name. A look in the 1981 edition of the standard Soviet encyclopedia of ballet is revealing. In the listings for those productions in which Baryshnikov originated the leading role, other names are given in his

place. We had already seen Rudolf Nureyev and Natalia Makarova wiped from the history books. Now everything was repeating itself. If at the time a balletomane had been woken up in the middle of the night and asked whom he must forget, his answer might well have been 'Mikhail Baryshnikov.'

Today, Baryshnikov's admirers remember and love the smiling boy who lightheartedly showered them with his radiant gift. Today he is wealthy — creatively, spiritually, and in all other ways. And he continues to painstakingly select only those works that will impart new tones to his iridescent palette. His talent is as forceful as ever; in fact it may be even more abundant than before. We may call his meeting with Balanchine a meeting of fellow countrymen, though of different generations. Misha Baryshnikov knew full well that in joining Balanchine's company he was subordinating himself to the powerful talent of the creator of *Apollo*, *Prodigal Son*, and *Theme and Variations* — these totally diverse works testifying to the dramatic power and virtuosity of the art of this great choreographer.

What lay in store for Baryshnikov in the West we may learn from the pages of this book of photographs. Today, here in Russia, we view the transformation of Baryshnikov's dancing style as the steps in his rise to fame. We think of him today, hazard guesses as to his future, while impressions of him in the past still live on in our minds.

Those who carefully leaf through the pages of this volume will certainly pause at the photograph of Natalia Makarova and Mikhail Baryshnikov dancing to Chopin, their leisurely pas de deux choreographed by Jerome Robbins. This is a dance of parting. Yet it is also a superb example of the renowned Petersburg school, its rich heritage readily glimpsed in the dancers' articulated, polished movements and in their lasting and as yet unsurpassed poetic beauty.

—*Vera Krasovskaya, 1998*

PHOTO CREDITS

© Nina Alovert: pp. 109, 132, 138–139, 141, 142–143, 154, 160, 162, 163, 166, 168, 169. © Stephanie Berger: pp. 296, 298, 299, 302–303, 304, 305, 306–307, 308–309, 311, 312–313, 316–317, end page 3. © Tom Brazil: pp. 172–173, 174, 177, 178–179, 181, 182, 189, 190–191, 194–195, 196–197, 198–199, 203, 205, 208, 210–211, 213, 214–215, 216, 217, 219, 225, 227, 242, 243, 245, 250, 257, 259, 260, 262–263, 265, 290, 292–293, 294, 295, 300–301. © Steven Caras: pp. 266, 267. © Mark Enguerand: pp. 111, 112. © Gary Friedman: pp. 252, 253, 254, 255, 272, 273, 275. © Beverley Gallegos: p. 115. © Lois Greenfield: pp. 156–157. © Paul Kolnik: pp. 94, 97, 116, 117, 118–119, 123, 124–125, 126–127, 128, 130, 146, 148–149, 151, 232, 235, 236, 237, 246. © Annie Leibovitz: pp. 206–207. © Francette Levieux: pp. 268, 271. © Serge Lido/Sipa Press: p. 90. © Dina Makarova: end page 2, pp. 2, 5, 72–73, 75, 76–77. © Colette Masson/Enguerand: pp. 14, 15, 68, 69, 88, 89, 108, 113, 121, 147, 184, 185, 187, 220, 221, 222–223, 228, 231, 238, 314, 315, 319, end page 4, back cover. © Herbert Migdoll: front cover pp. 11, 12, 66, 96, 99, 101, 102, 104, 106, 107, 135. © Mira: end page 1, p. 152. © Jacques Moatti/Sipa Press: pp. 240 top left and bot. left and right, 241 top left and right and bot. left. © Paul Pasquarello: pp. 240 top right, 241 bot. right. © Beatriz Schiller: p. 85. © Yasuhiko Shirota: pp. 276, 278. © Vladimir Sichov/Sipa Press: p. 158. © Martha Swope/TimePix: pp. 192, 200. © Robert Trippet/Sipa Press: p. 170. © Jack Vartoogian: pp. 6, 8–9, 70–71, 79, 81, 82–83, 93, 137, 144, 164–165, 248–249, 280. © Linda Vartoogian: pp. 10, 13, 80, 86–87, 103. © Robert Whitman: pp. 282, 285, 286, 287, 289.

The Prodigal Son, *Theme and Variations*, *Coppélia*, *Rubies*, *Apollo*, *Harlequinade*, and *Who Cares?*, choreography by George Balanchine © The George Balanchine Trust. BALANCHINE is a trademark of The George Balanchine Trust. *Duo Concertant*, choreography by George Balanchine © Kay Mazzo.

Introduction Copyright © 2002 by Joan Acocella
Afterword Copyright © 1998 by Vera Krasovskaya
Afterword translation Copyright © 2001 by Amanda Calvert
Chronology and Annotated Captions Copyright © 2002 by Robert Greskovic and Valery Golovitser

Published by Bloomsbury, New York and London
Distributed to the trade by Holtzbrinck Publishers

Parts of the Introduction by Joan Acocella appeared, in somewhat different form, in the *New Yorker* in 1998.

Library of Congress Cataloging-in-Publication Data
Baryshnikov in black and white: Mikhail Baryshnikov / introduction by Joan Acocella
p. cm

ISBN 1-58234-186-9

1. Baryshnikov, Mikhail, 1948 - Portraits.
2. Ballet dancers - Russia (Federation) — Pictorial works. I. Title: Baryshnikov. II. Acocella, Joan.

GV1785.B348 B37 2002
792.8′ 092--dc21
2001056573

First U.S. Edition 2002

10 9 8 7 6 5 4 3 2 1

Design by 2×4

Printed and bound in Italy by Artegrafica S.p.A., Verona

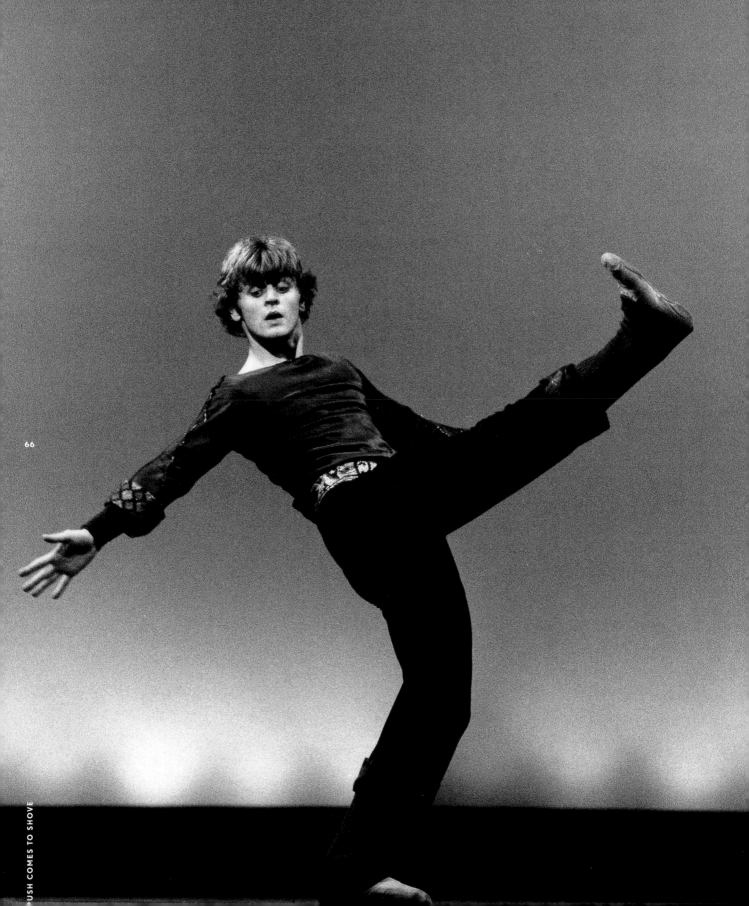

NINETEEN SEVENTY SIX

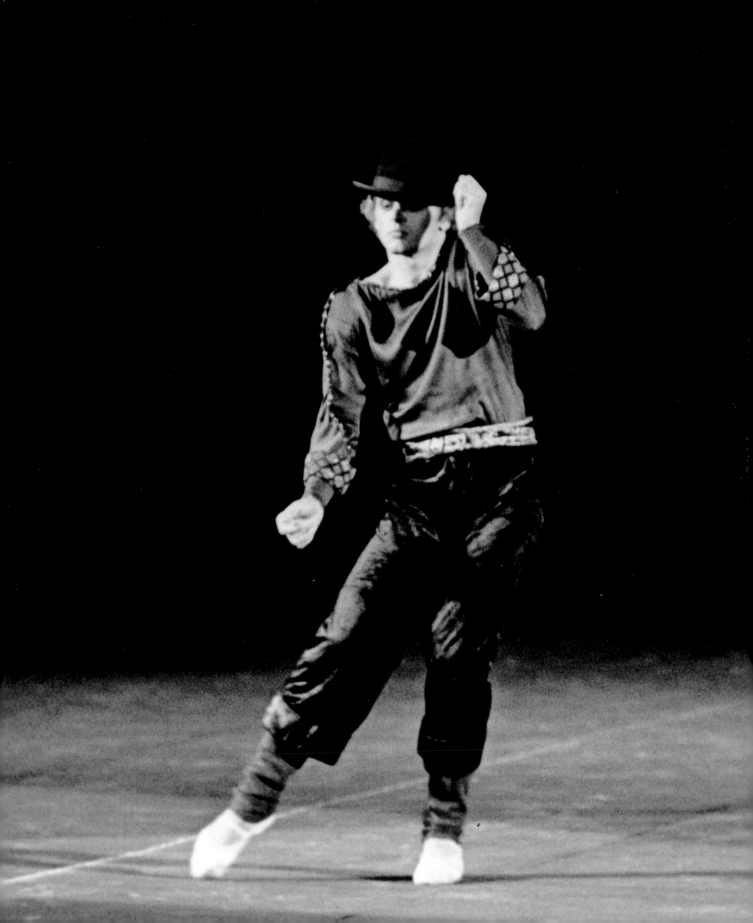

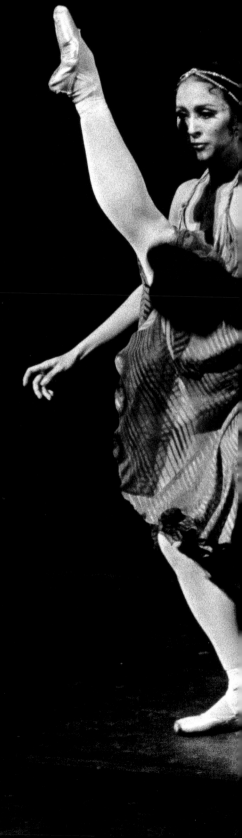

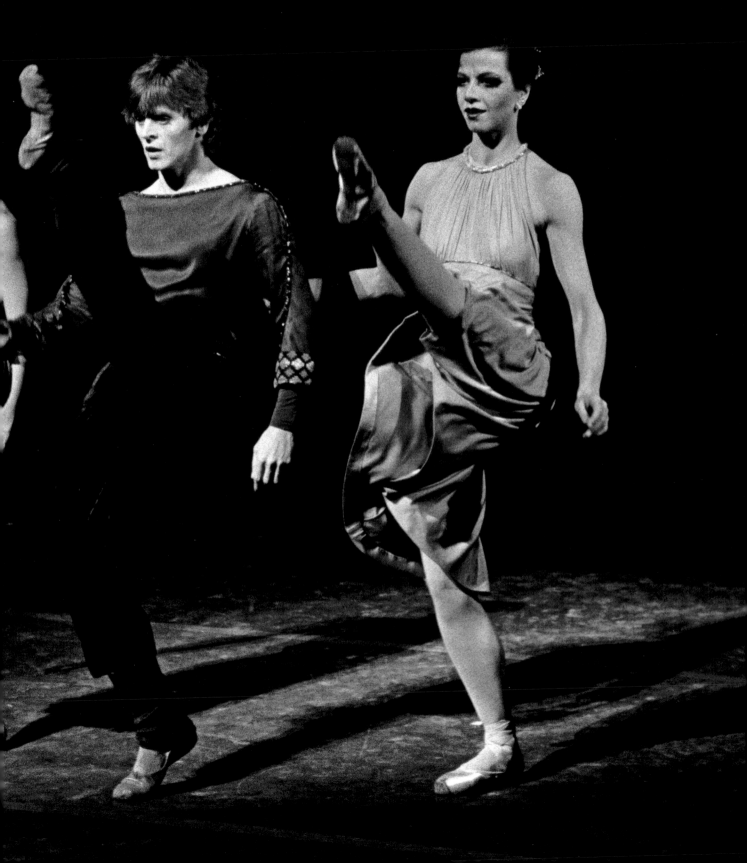

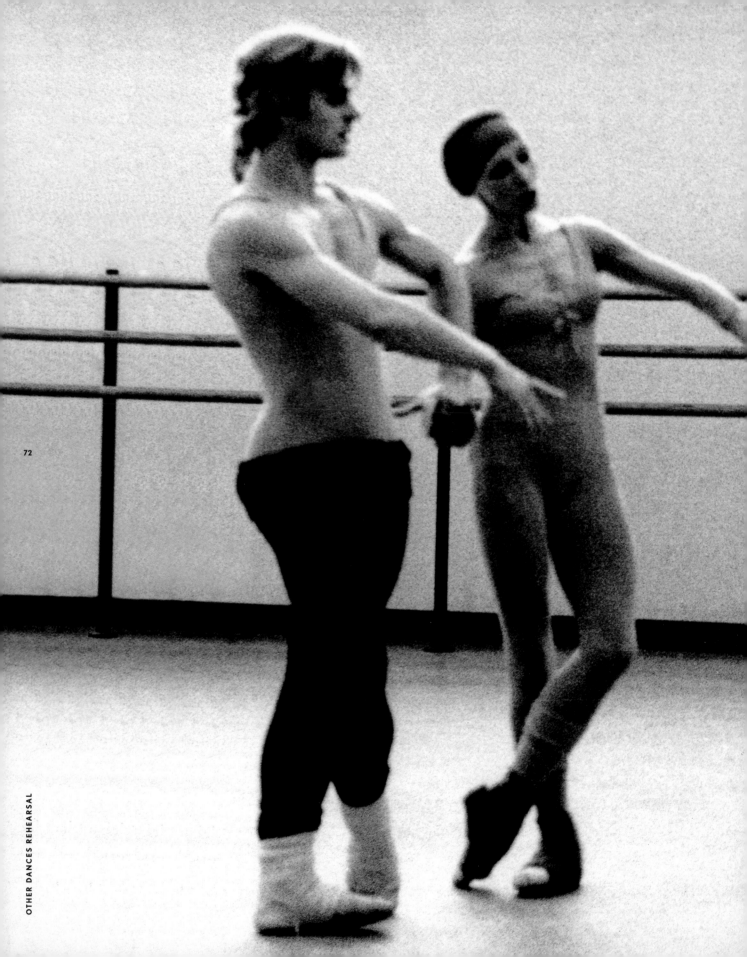

74

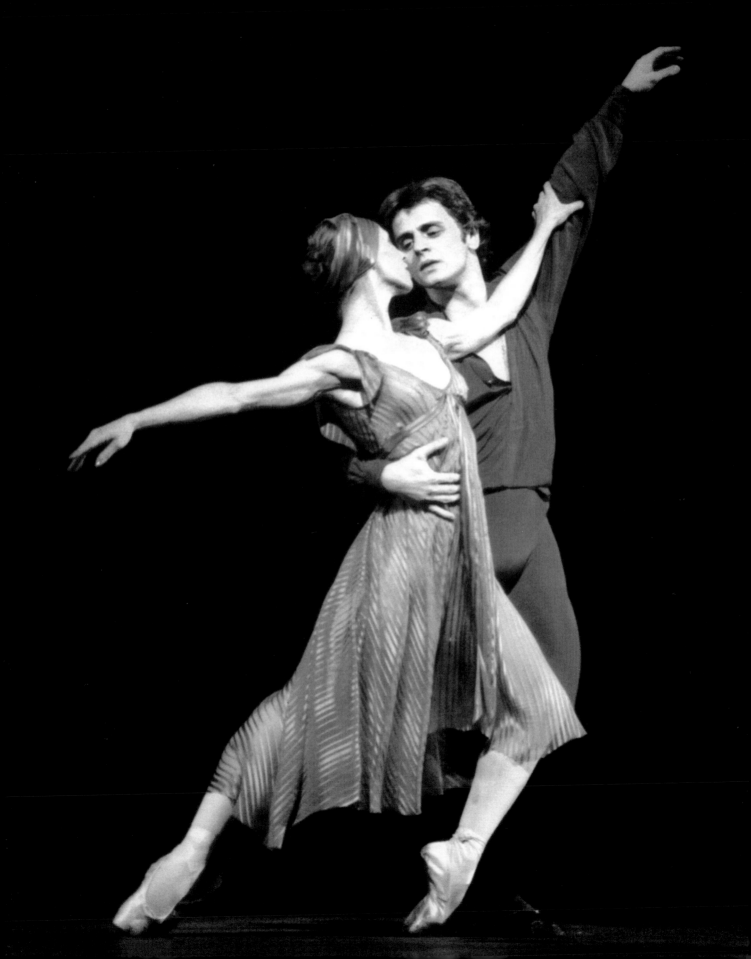

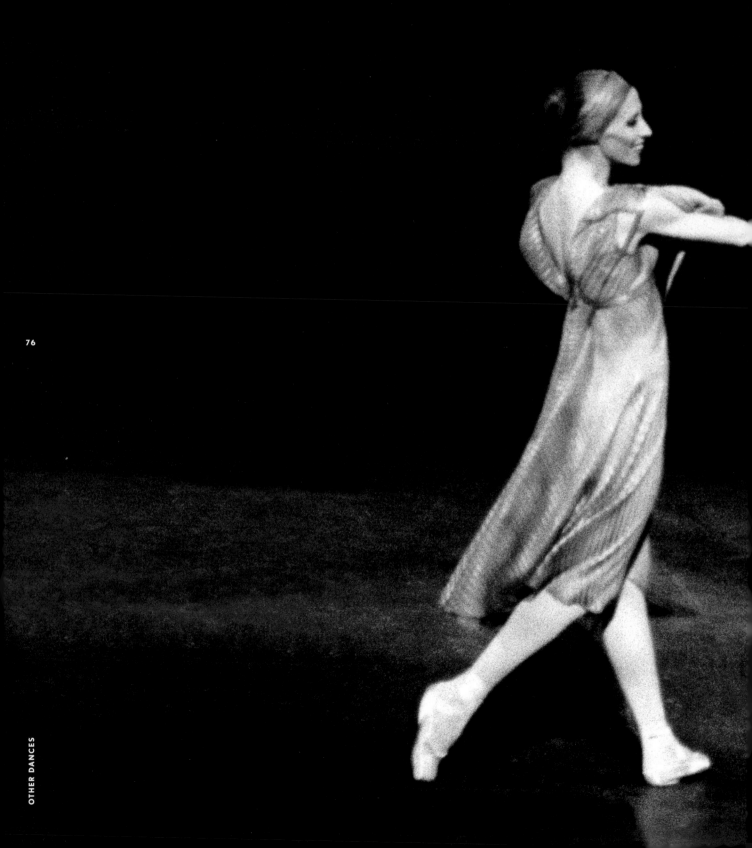

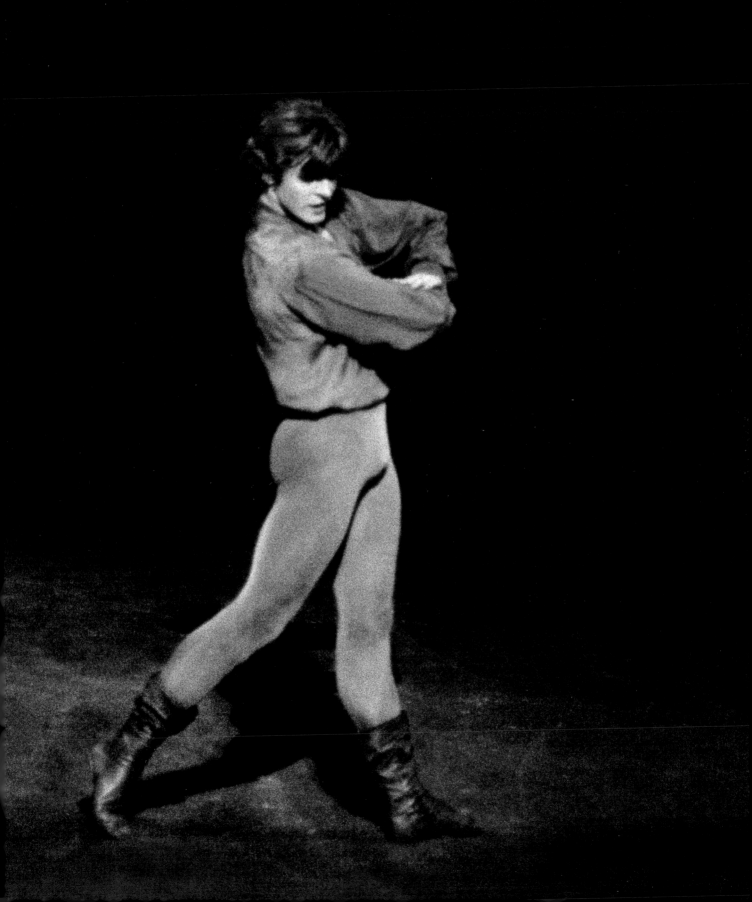

PAS DE 'DUKE'

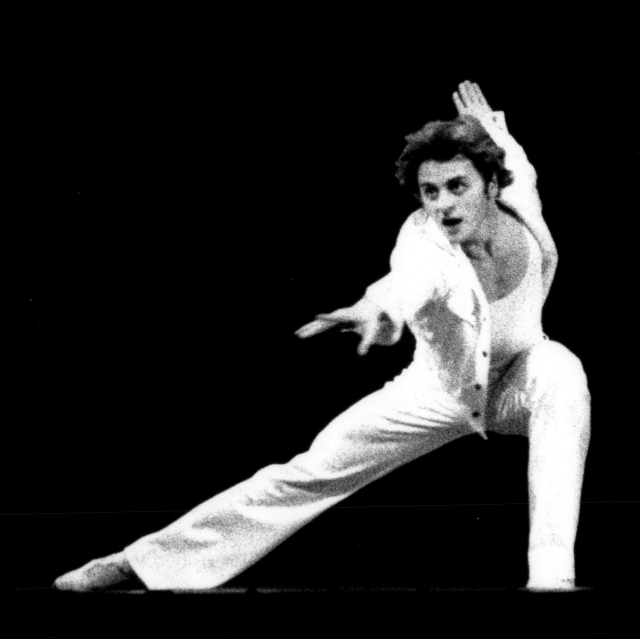

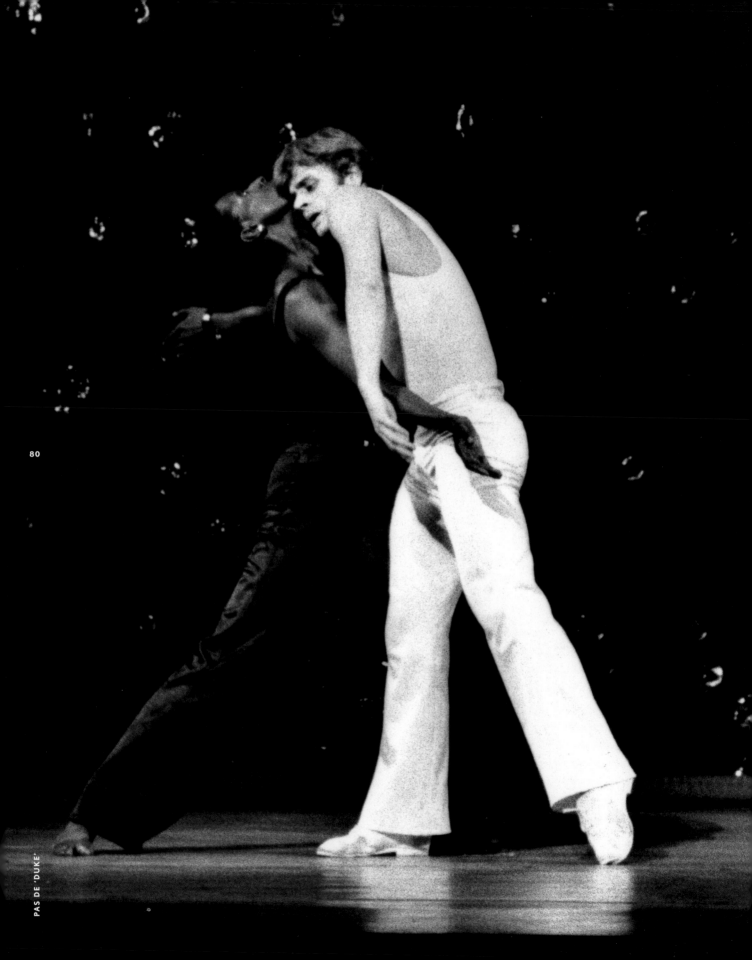

80

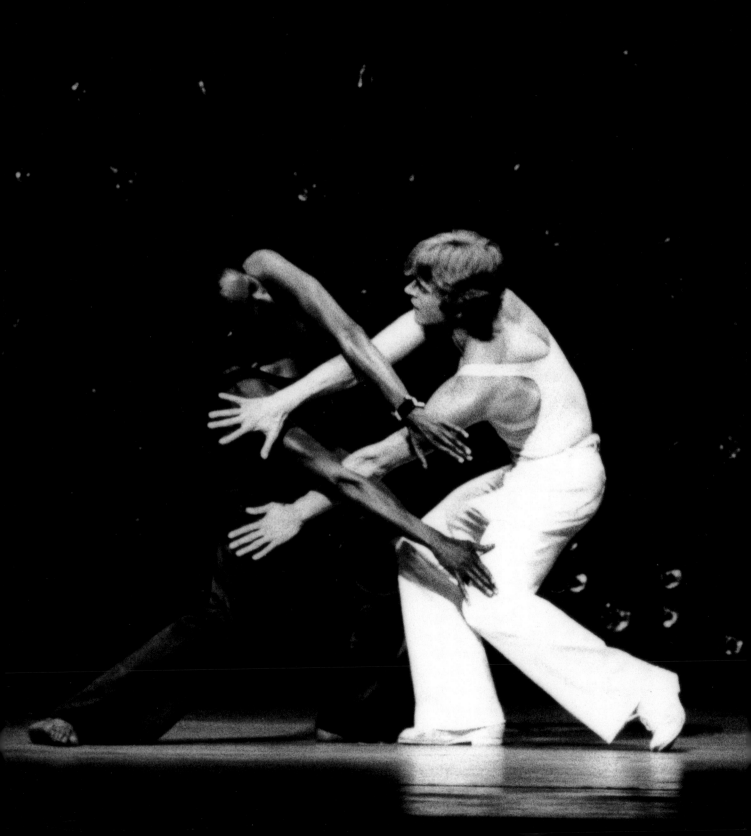

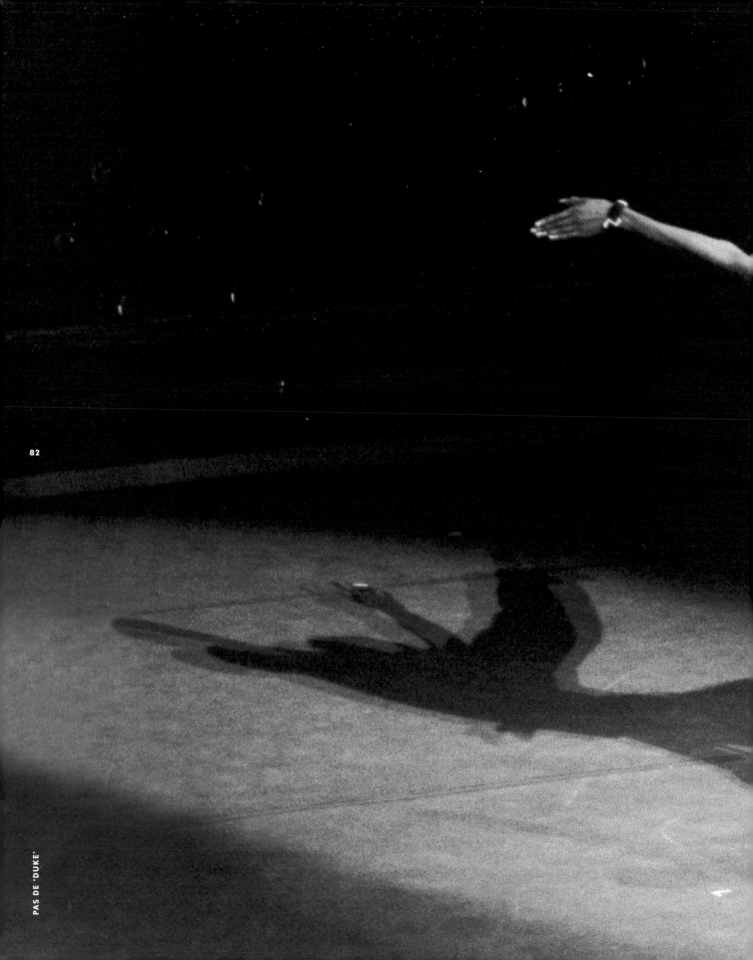

82

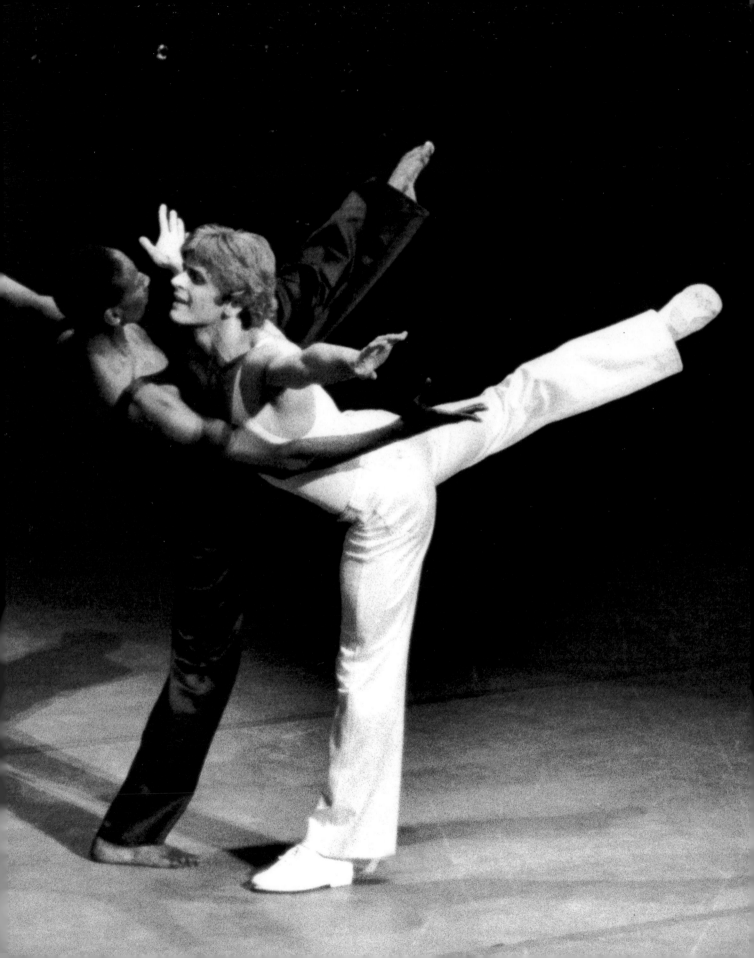

84

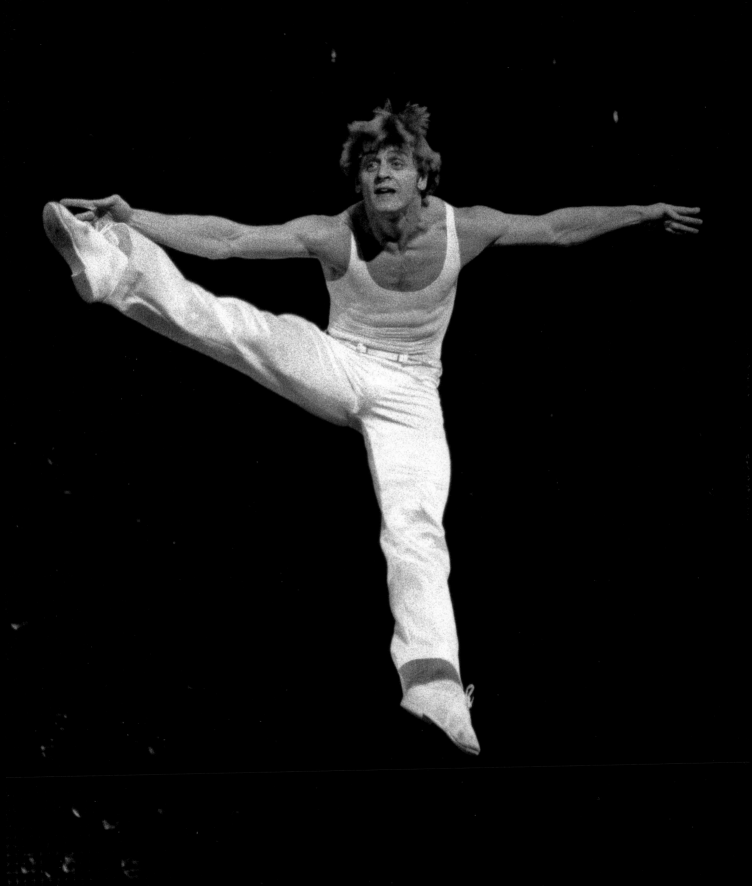

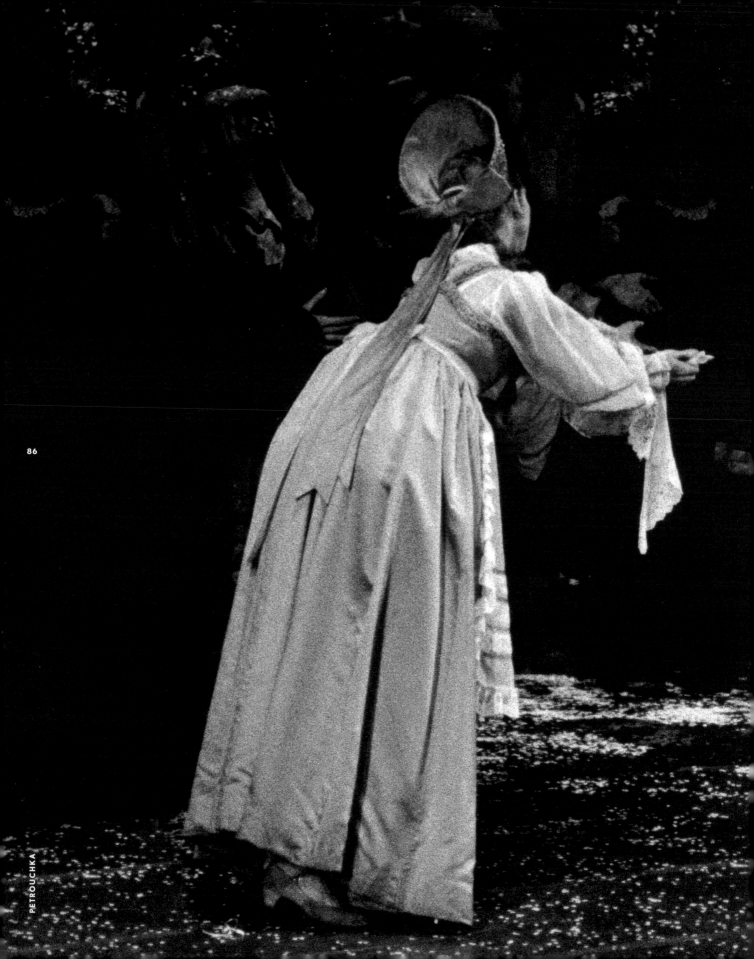

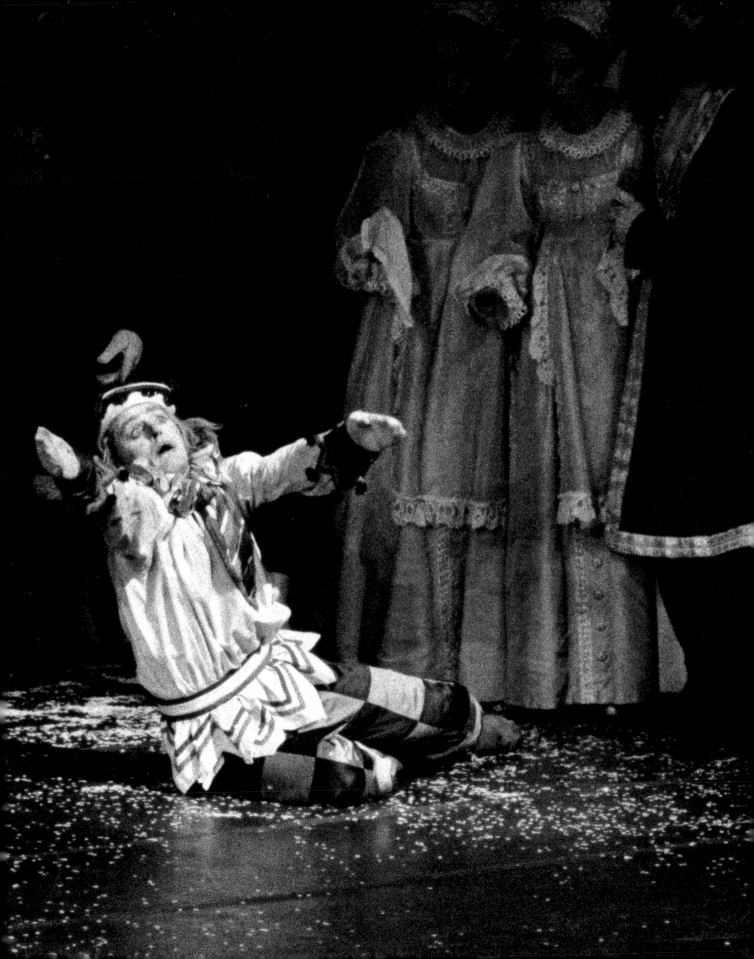

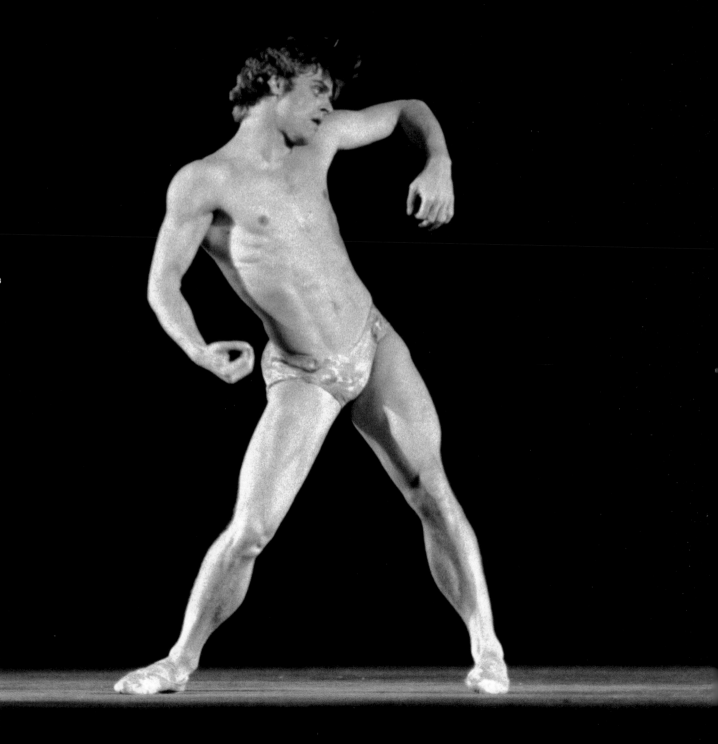

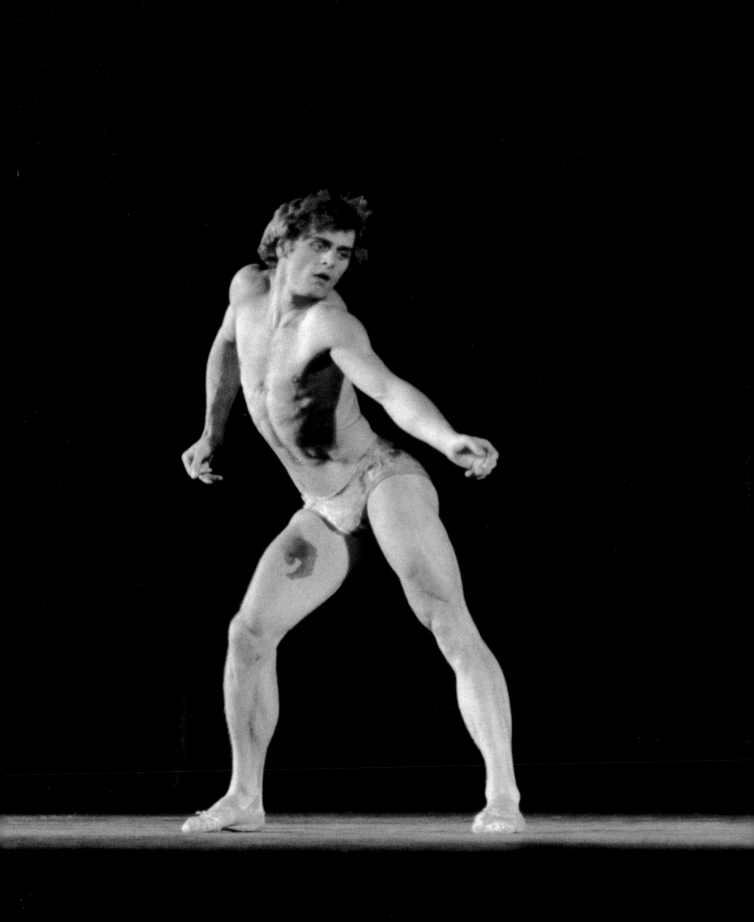

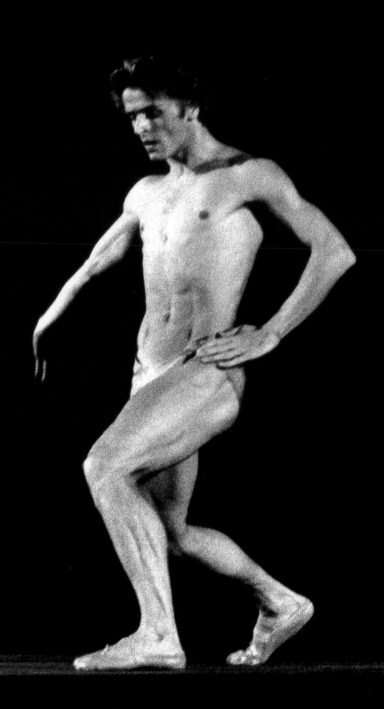

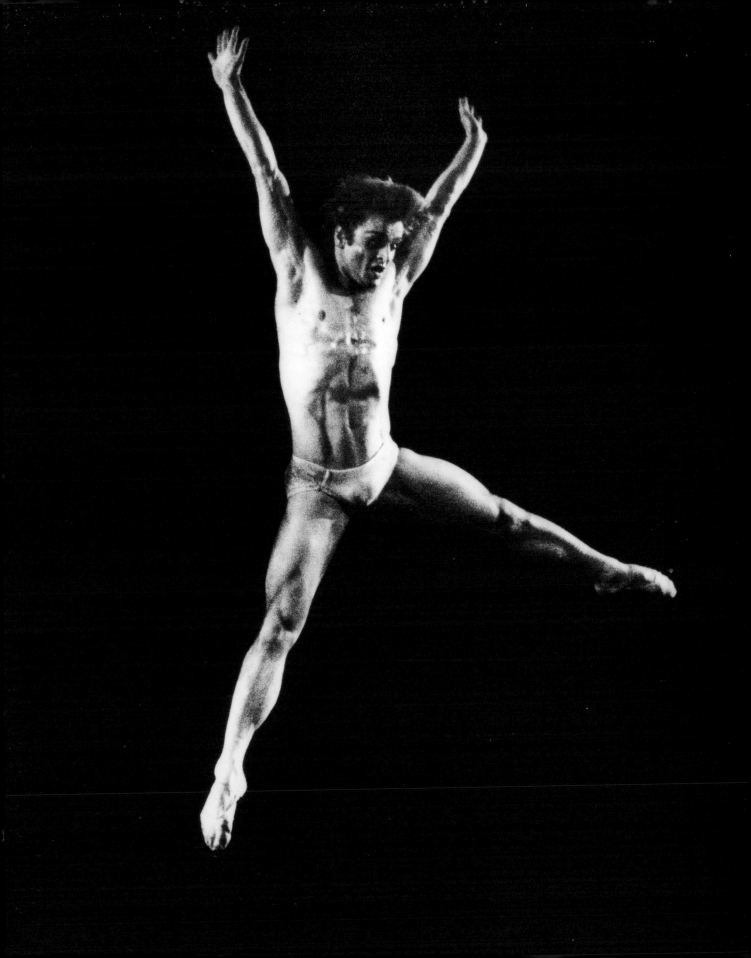

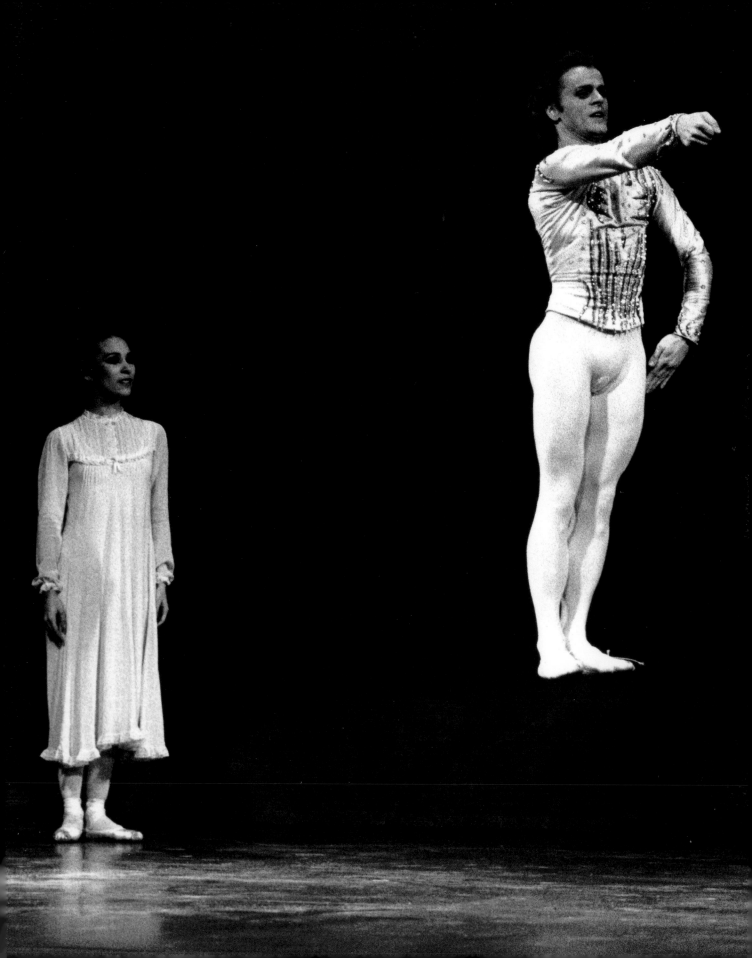

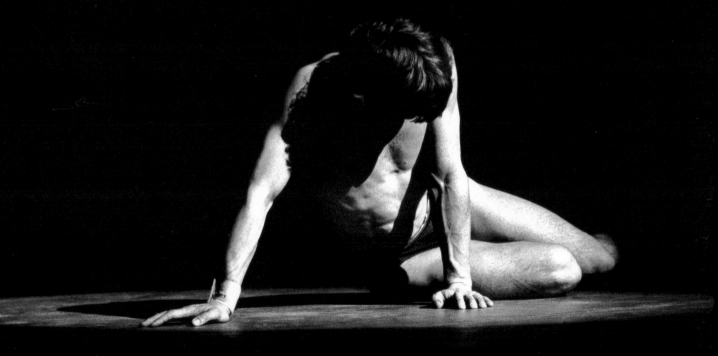

NINETEEN SEVENTY SEVEN

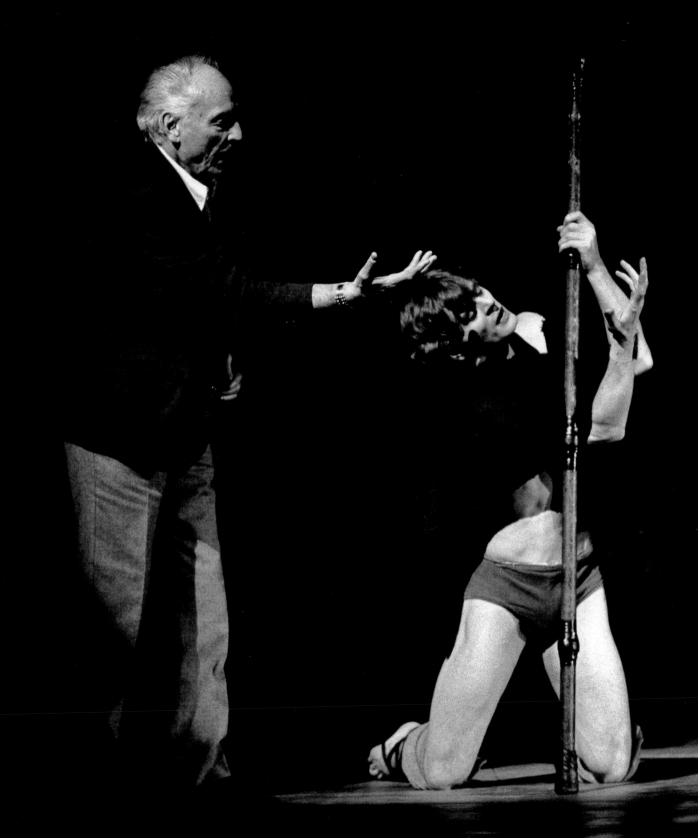

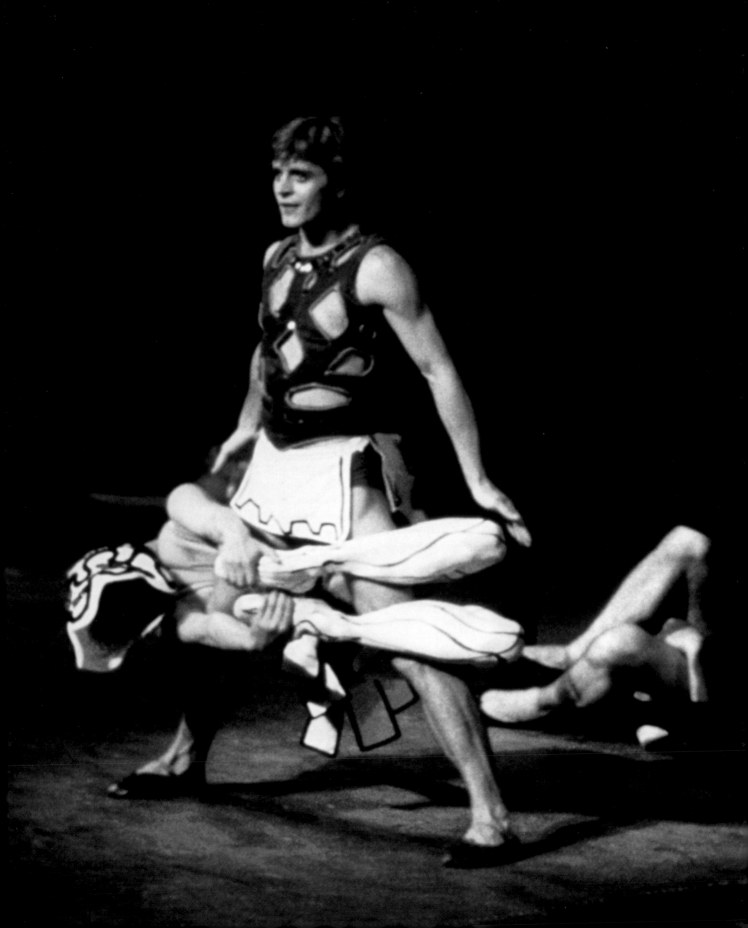

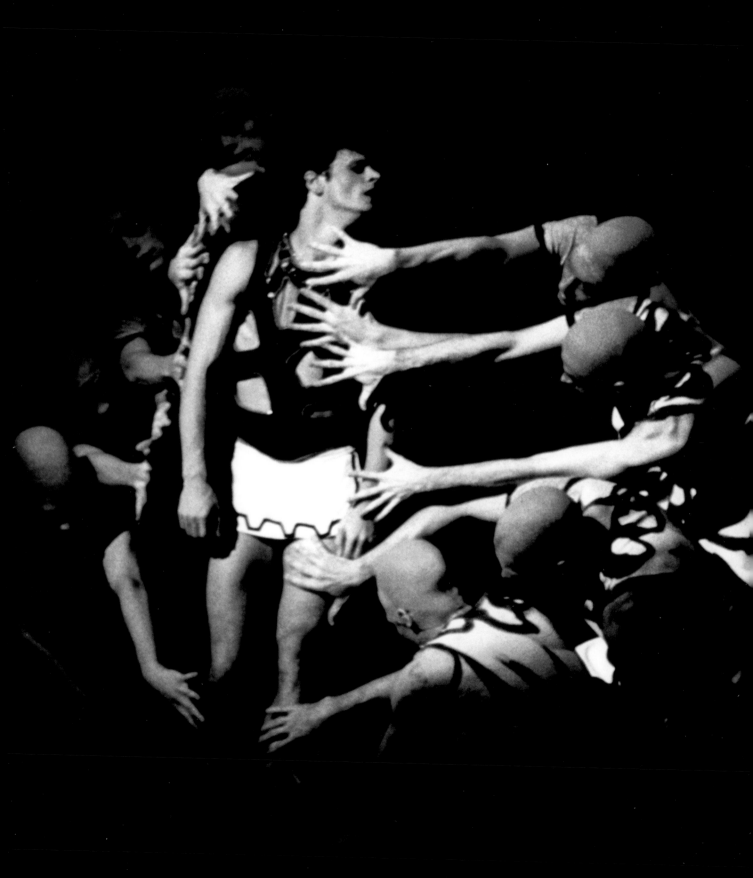

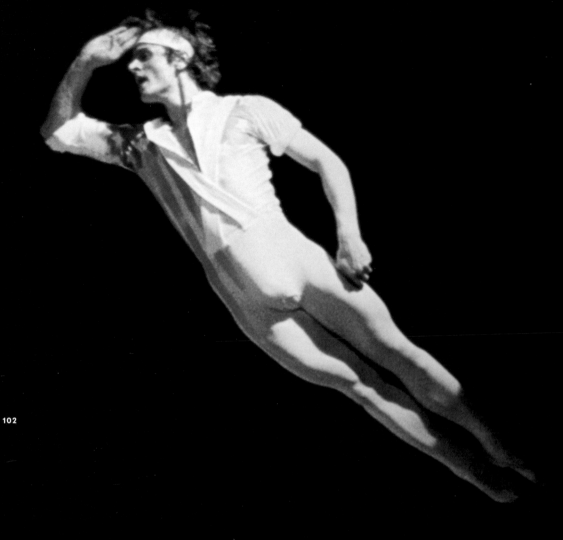

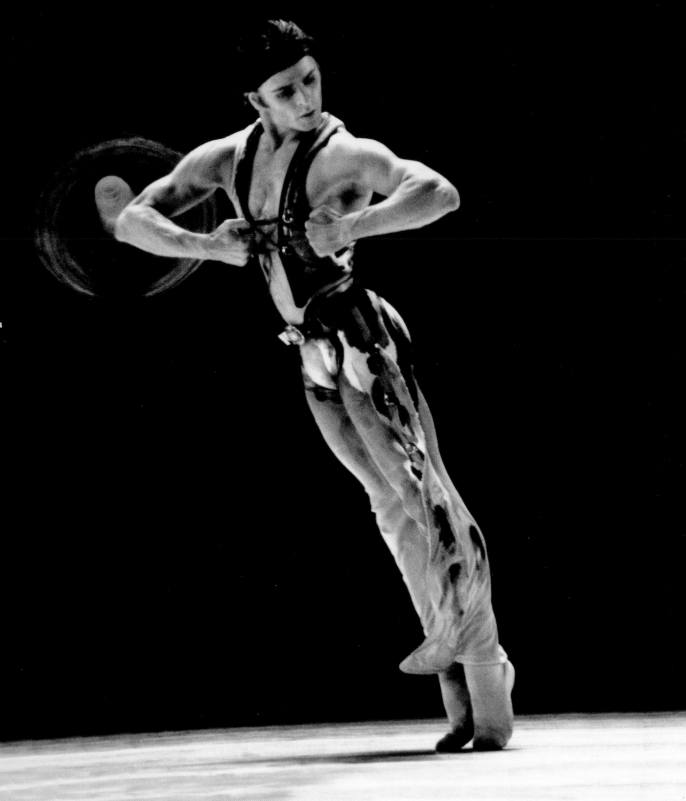

NINETEEN SEVENTY EIGHT

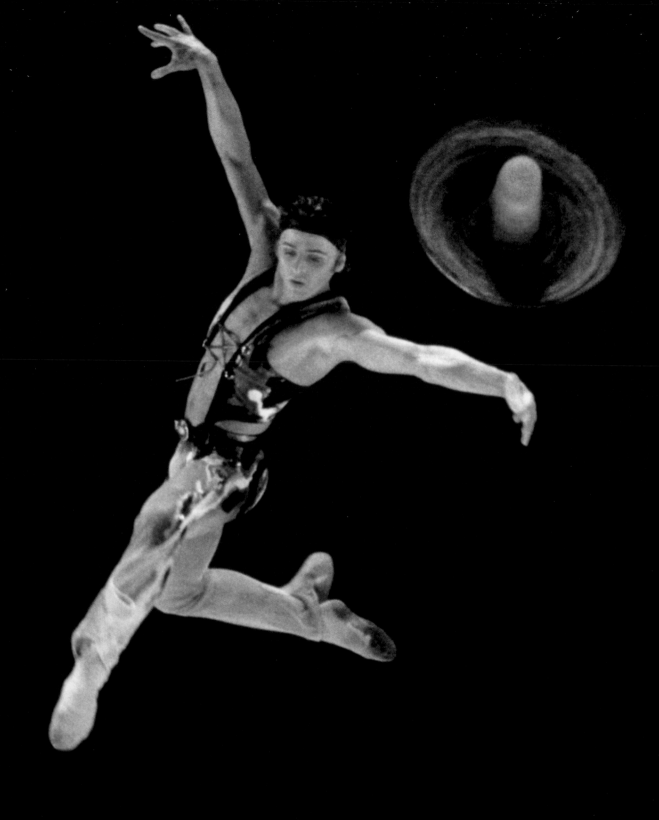

106

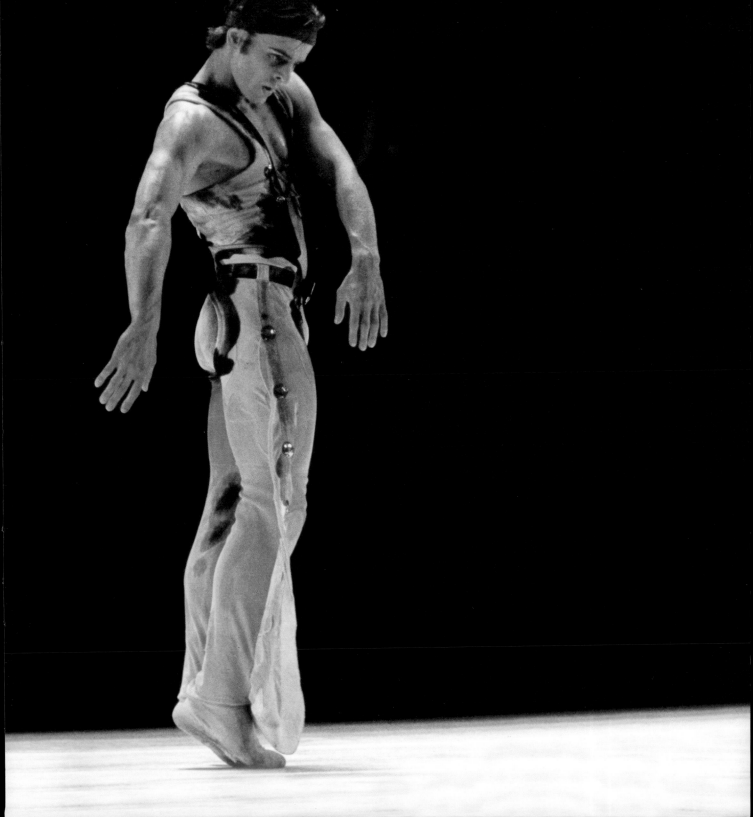

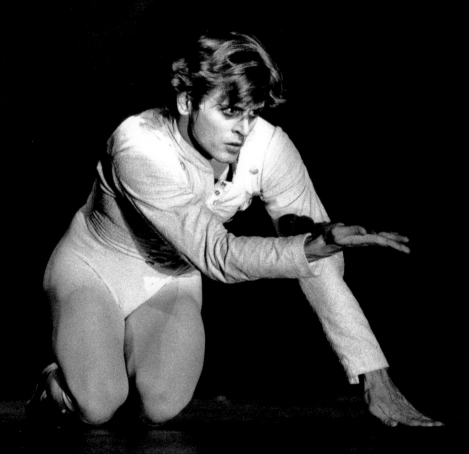

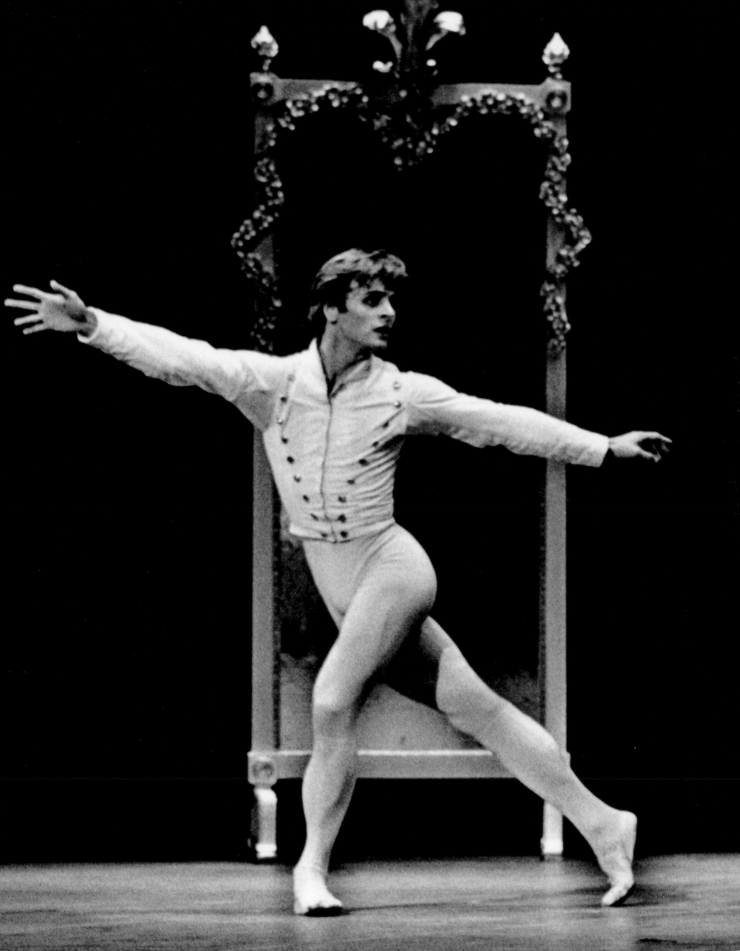

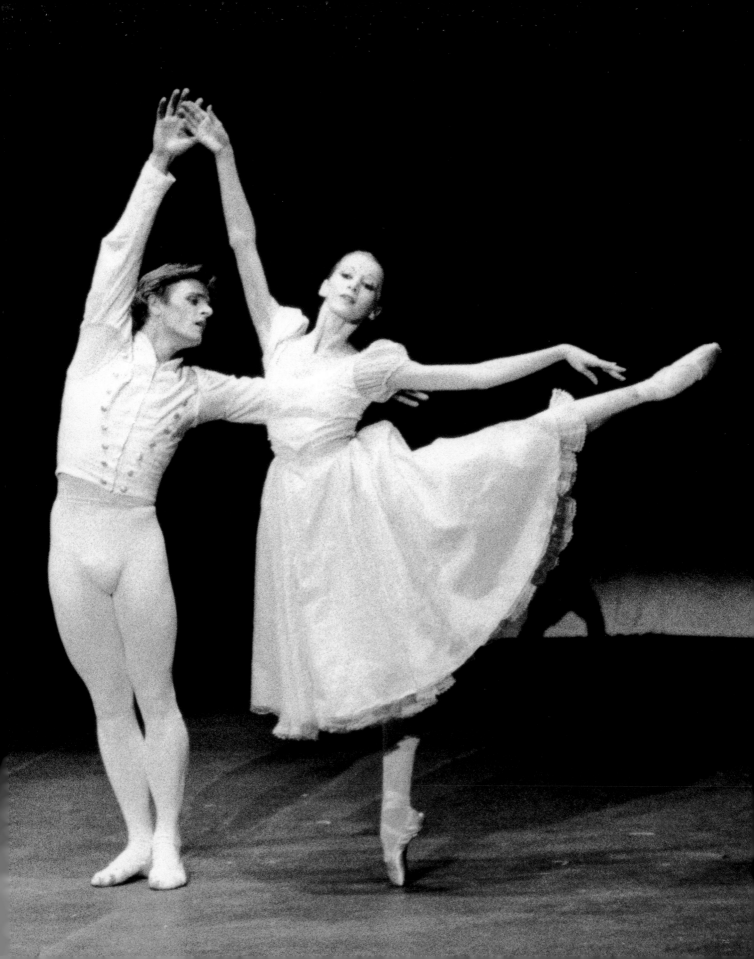

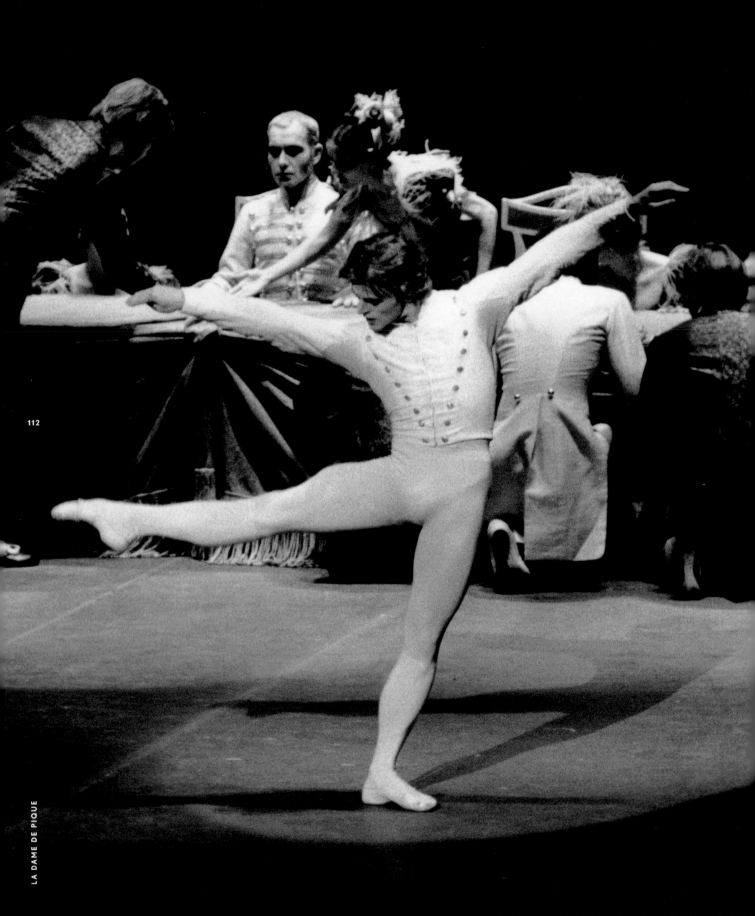

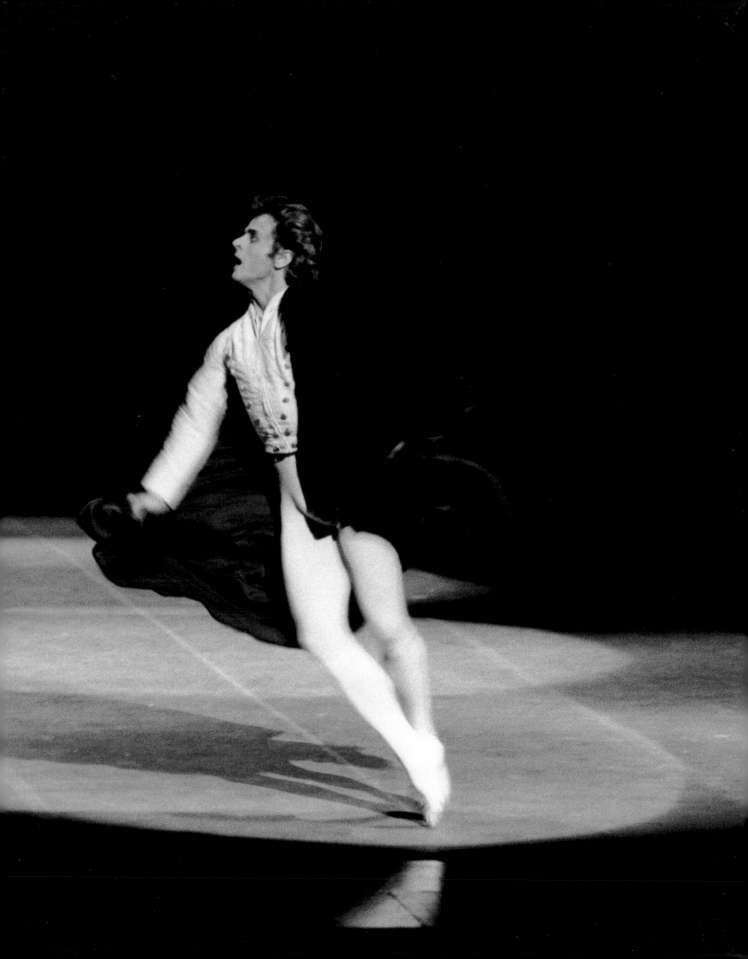

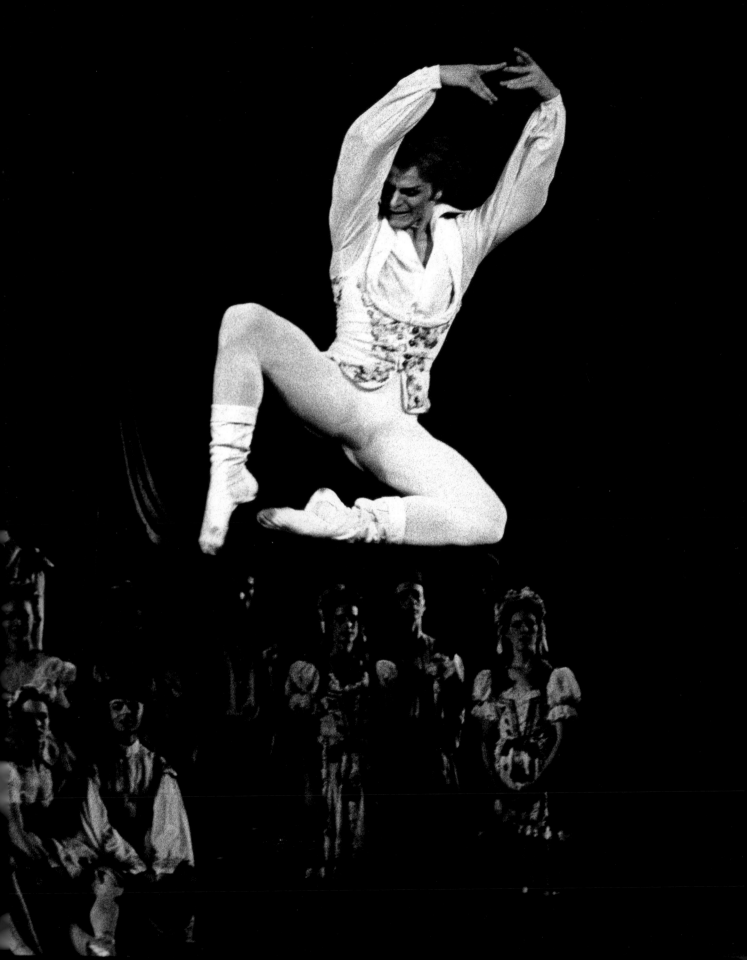

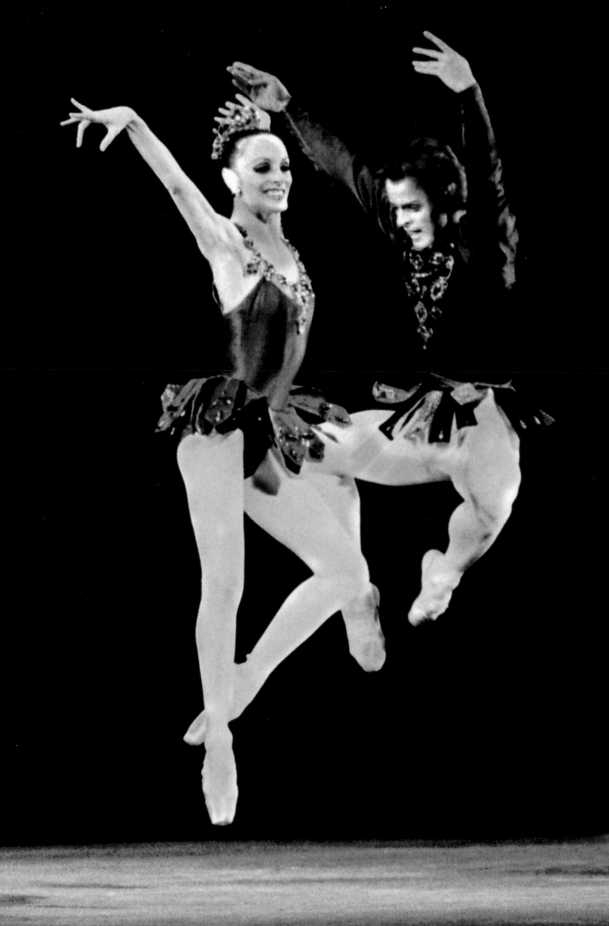

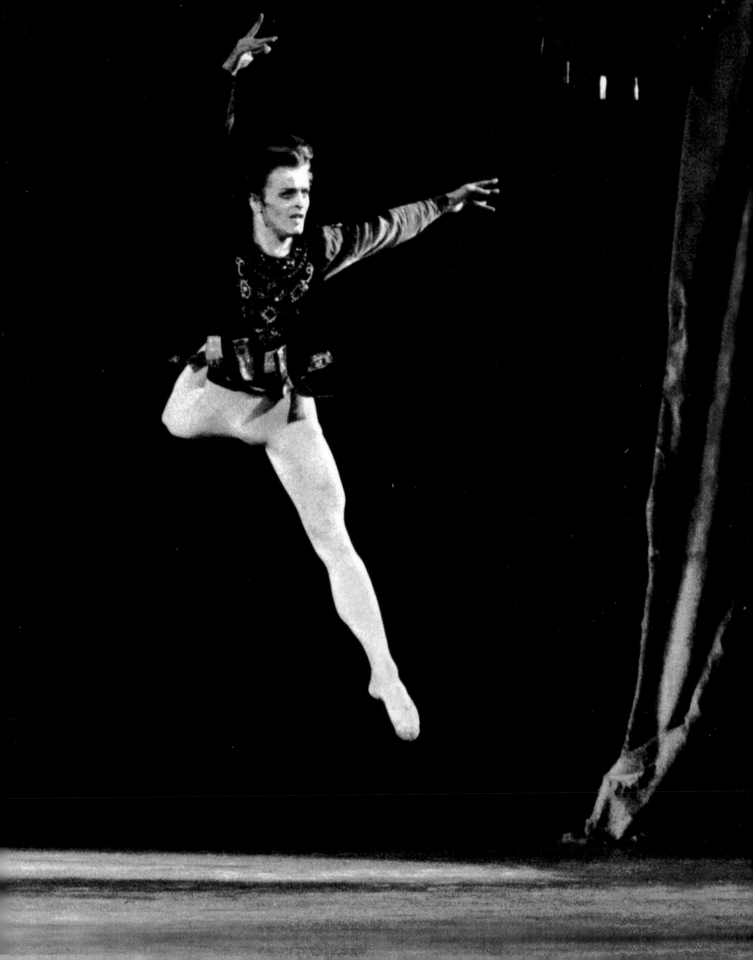

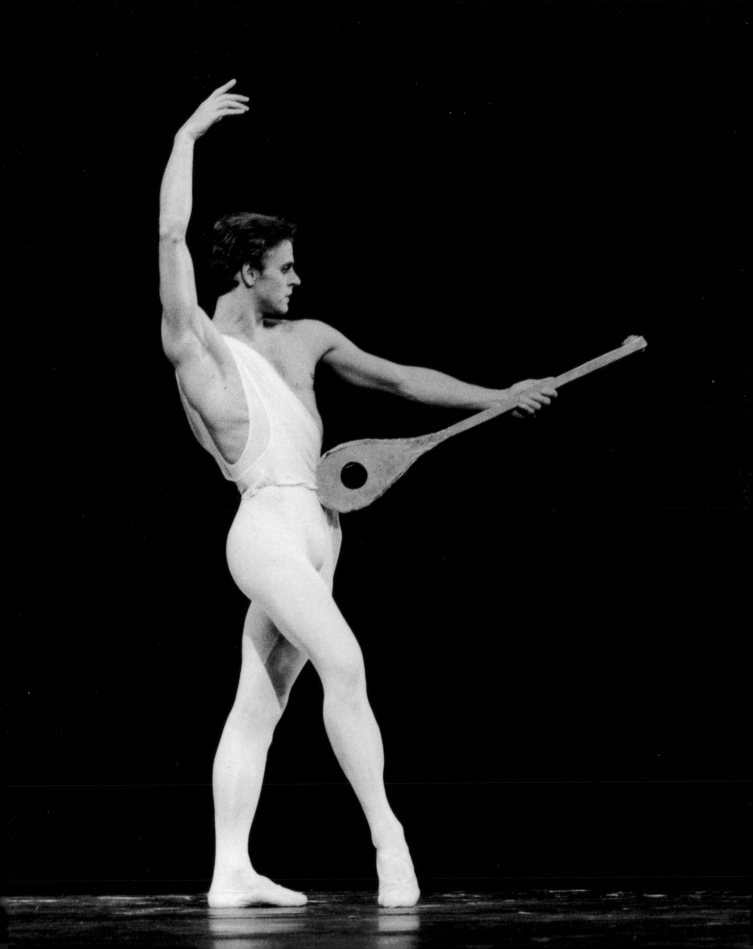

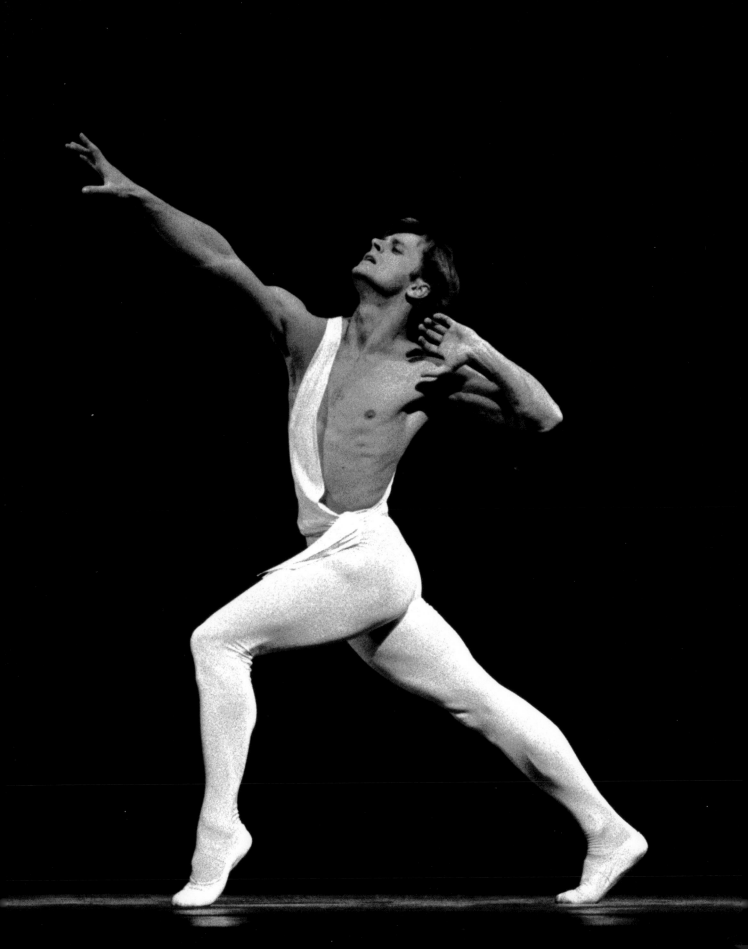

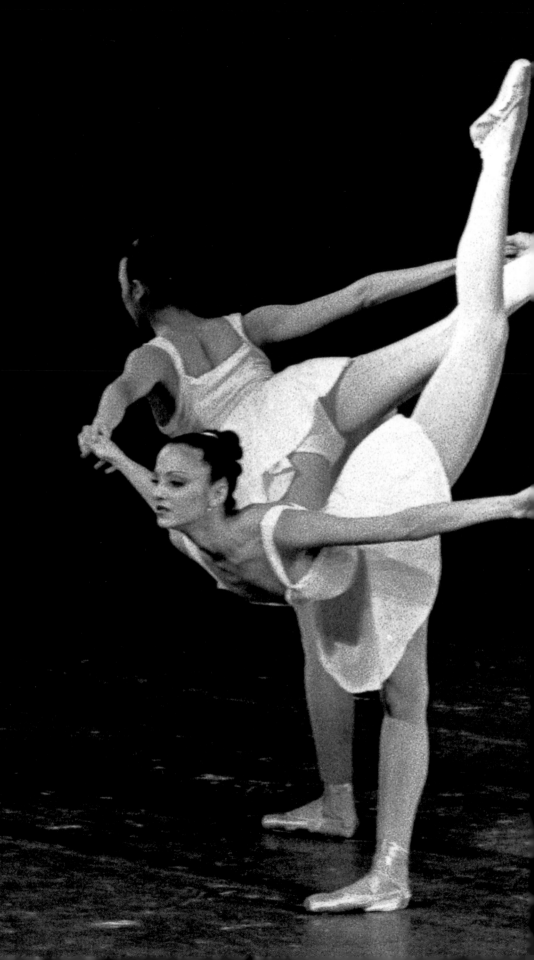

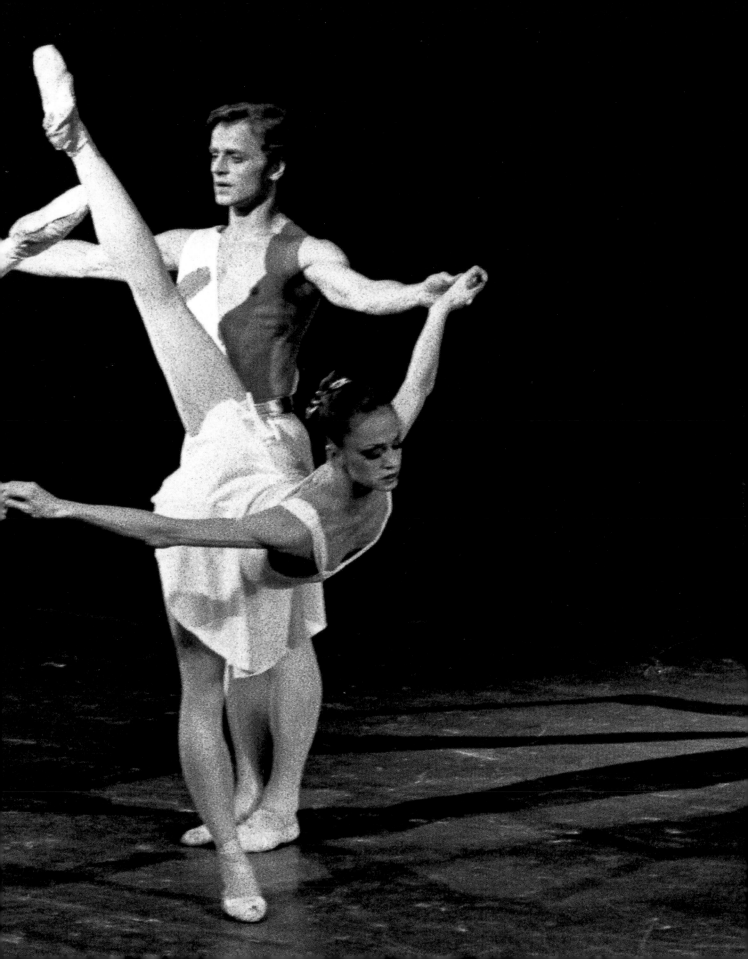

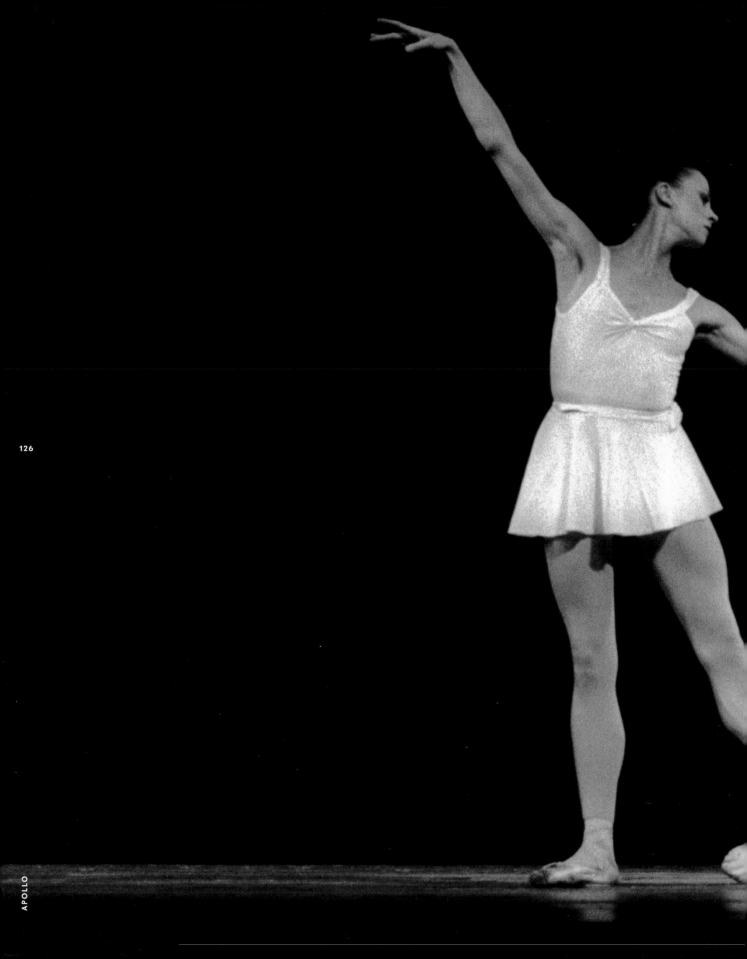

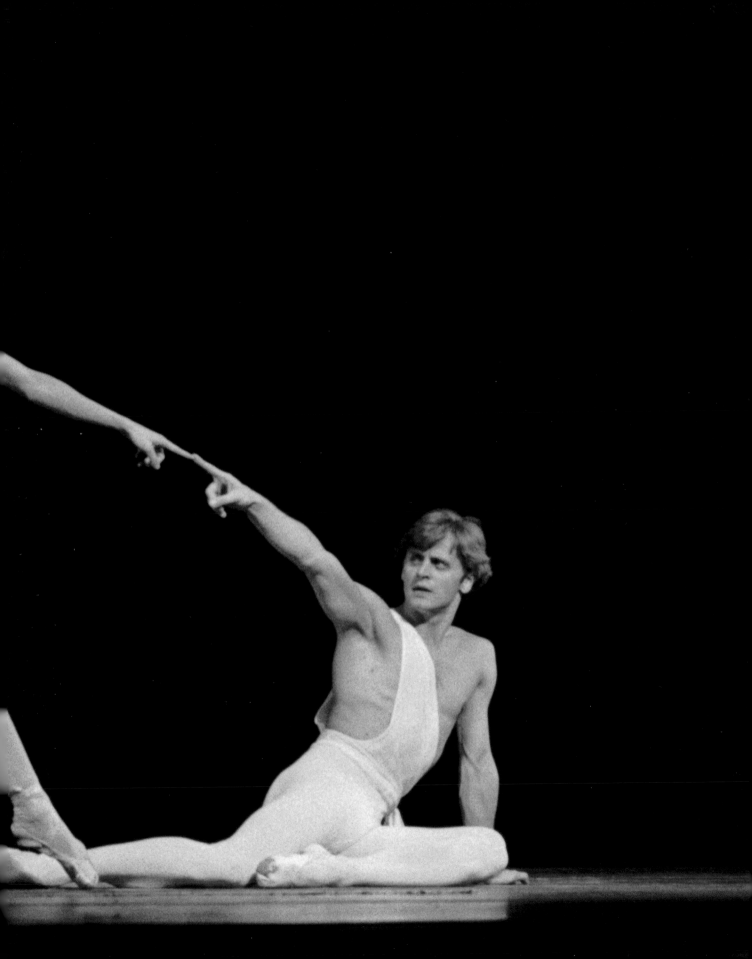

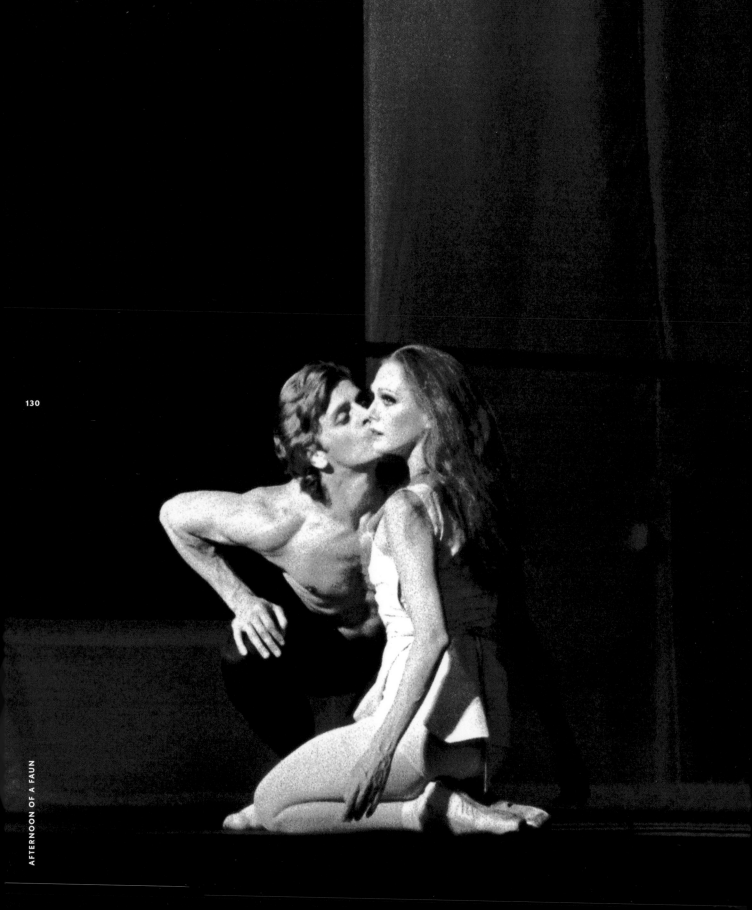

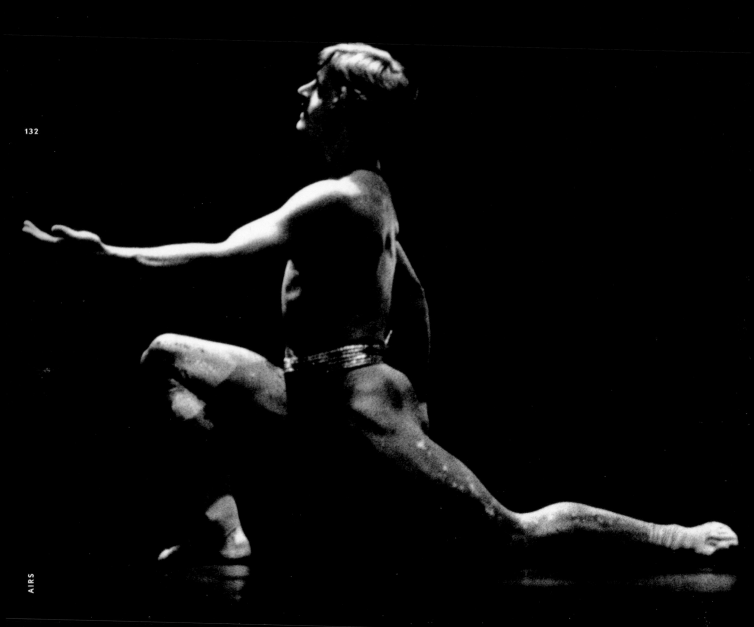

NINETEEN SEVENTY NINE

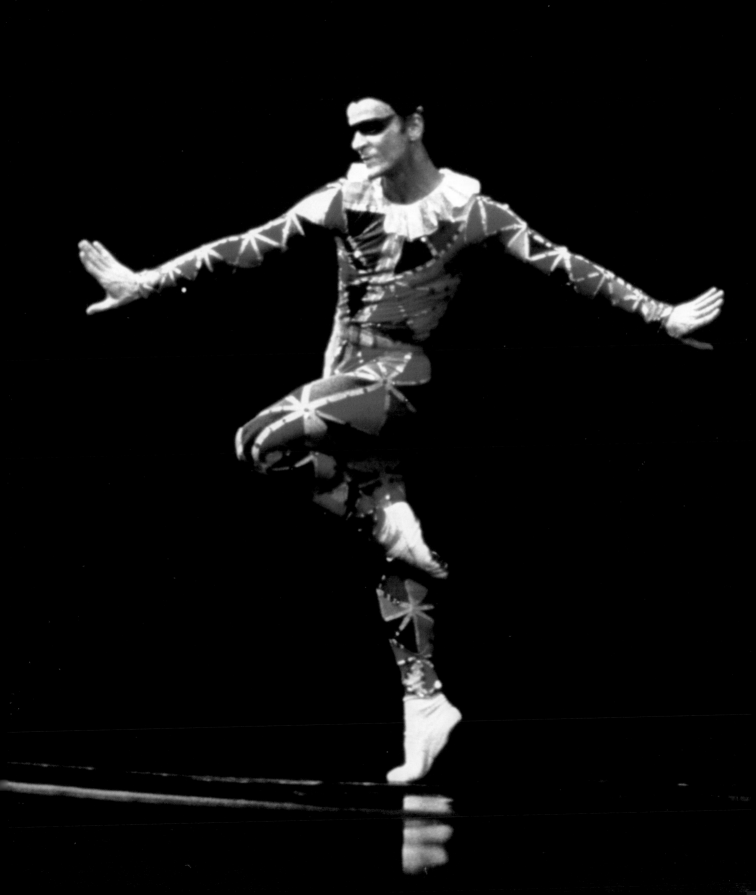

REHEARSAL WITH PAUL TAYLOR

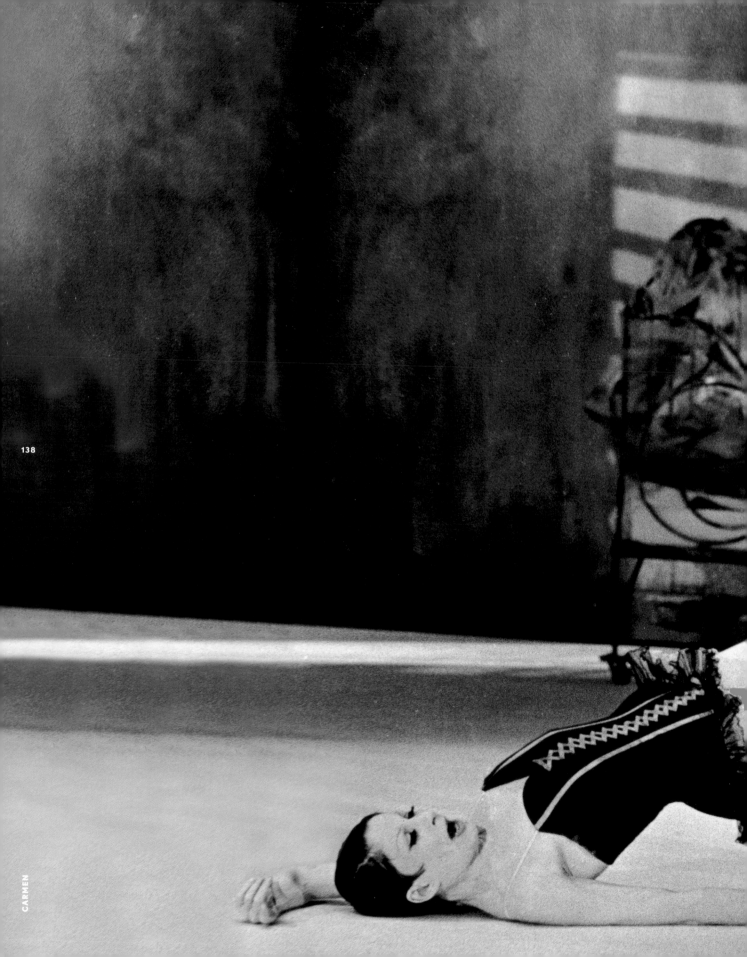

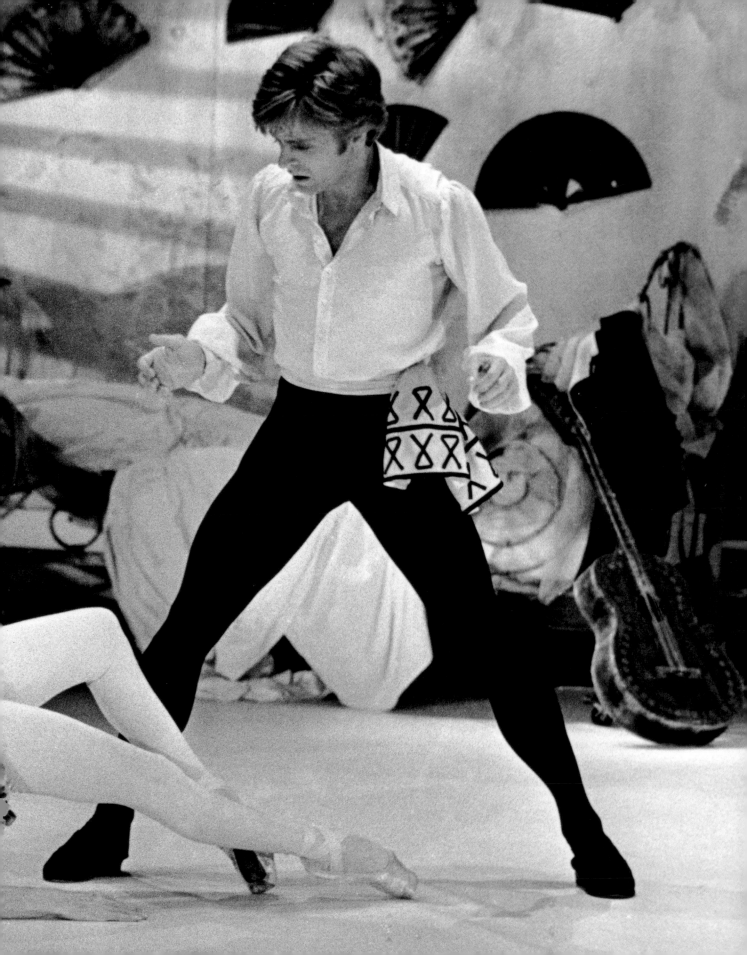

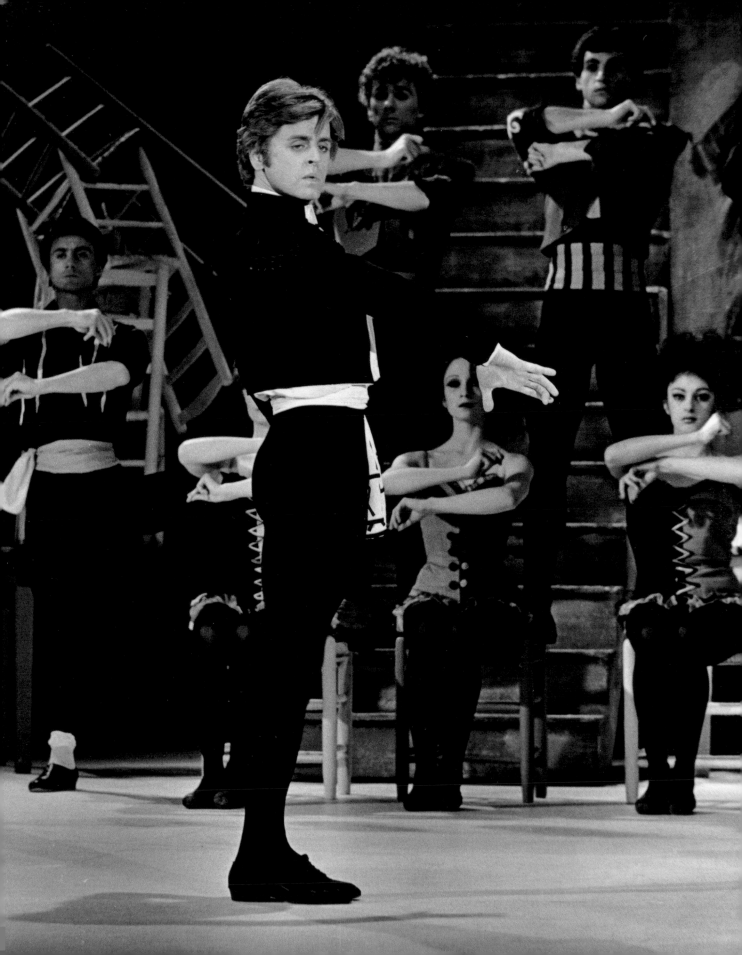

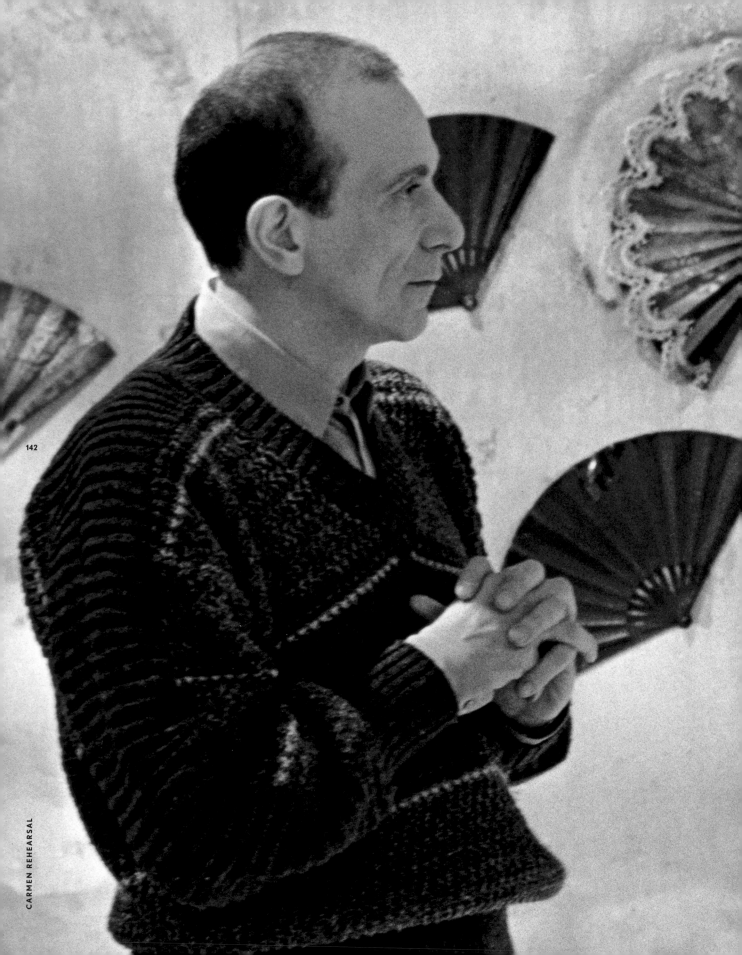

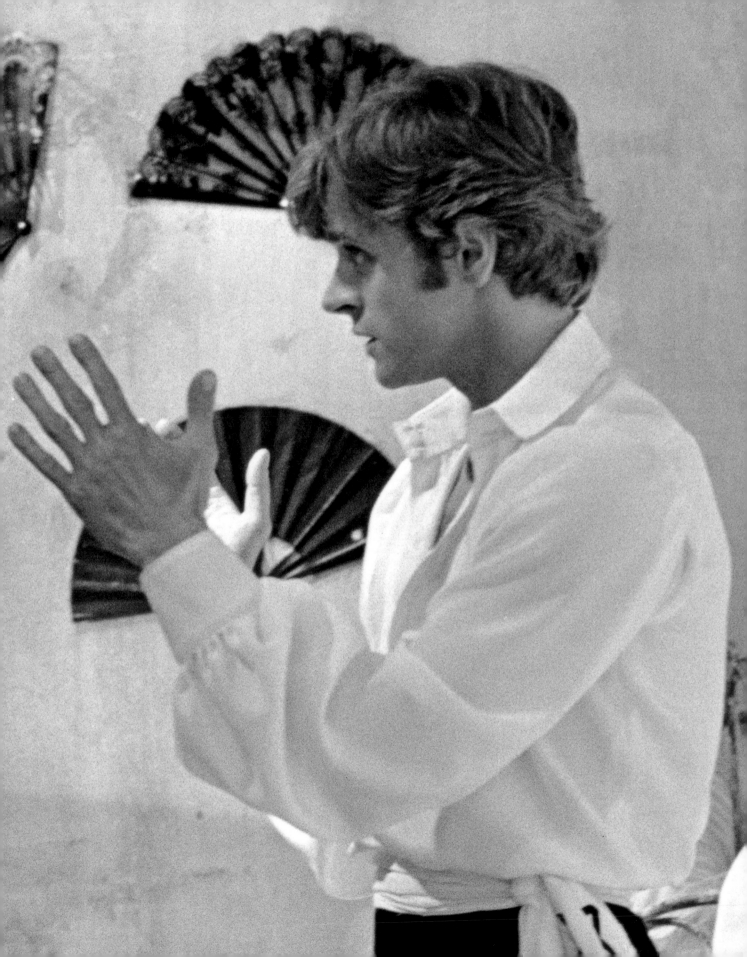

144

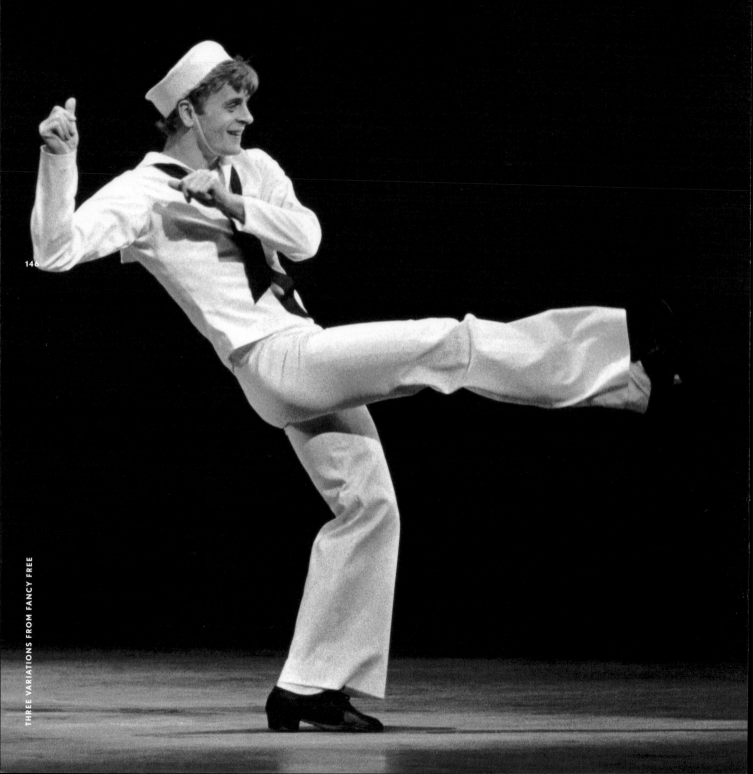

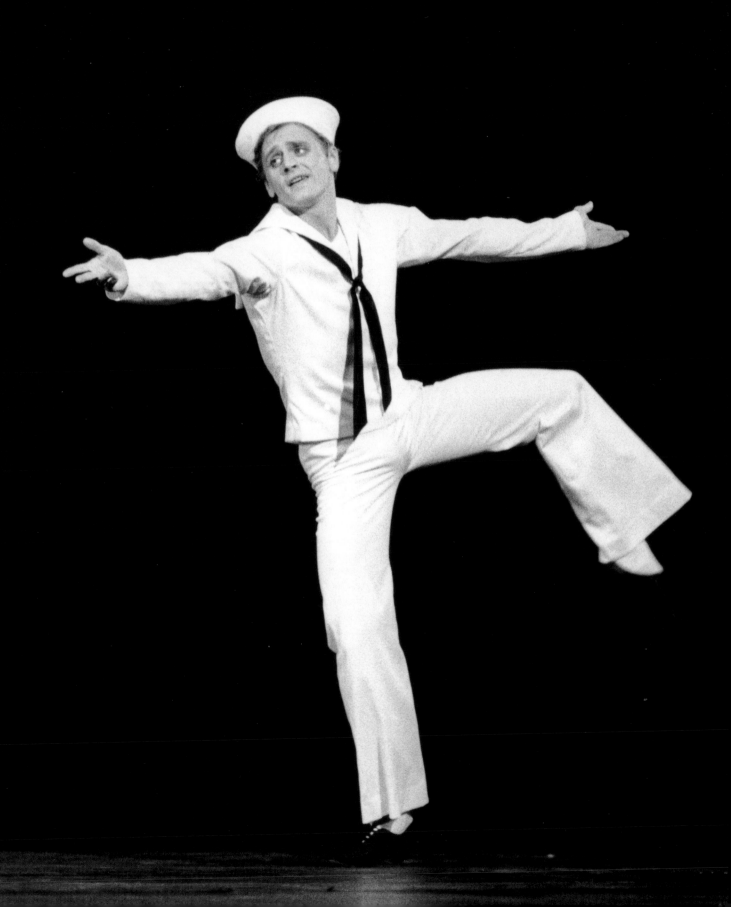

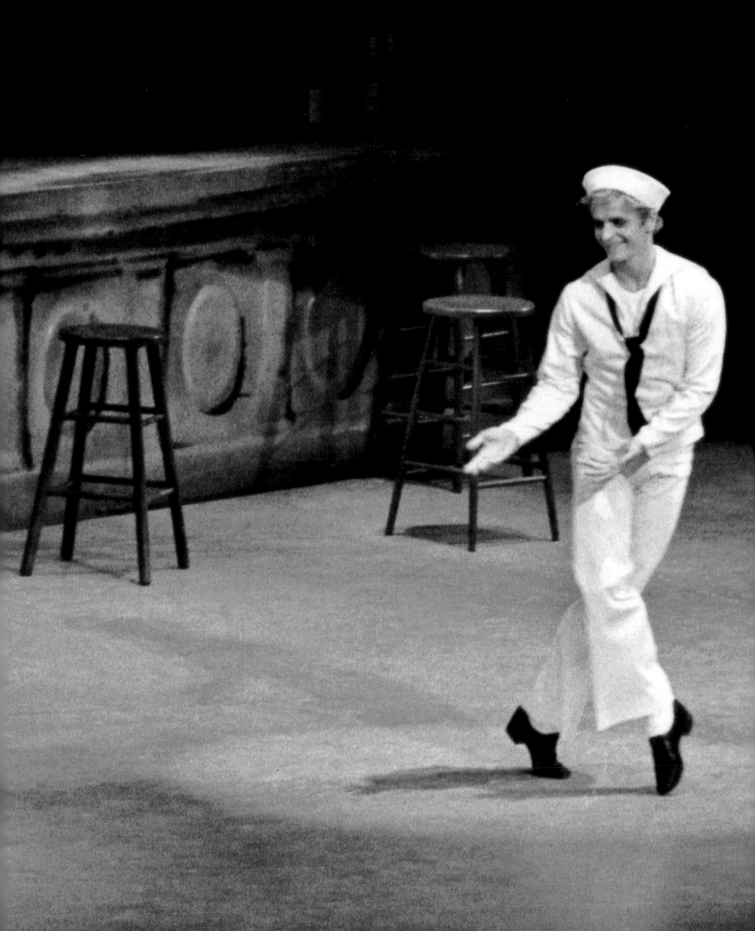

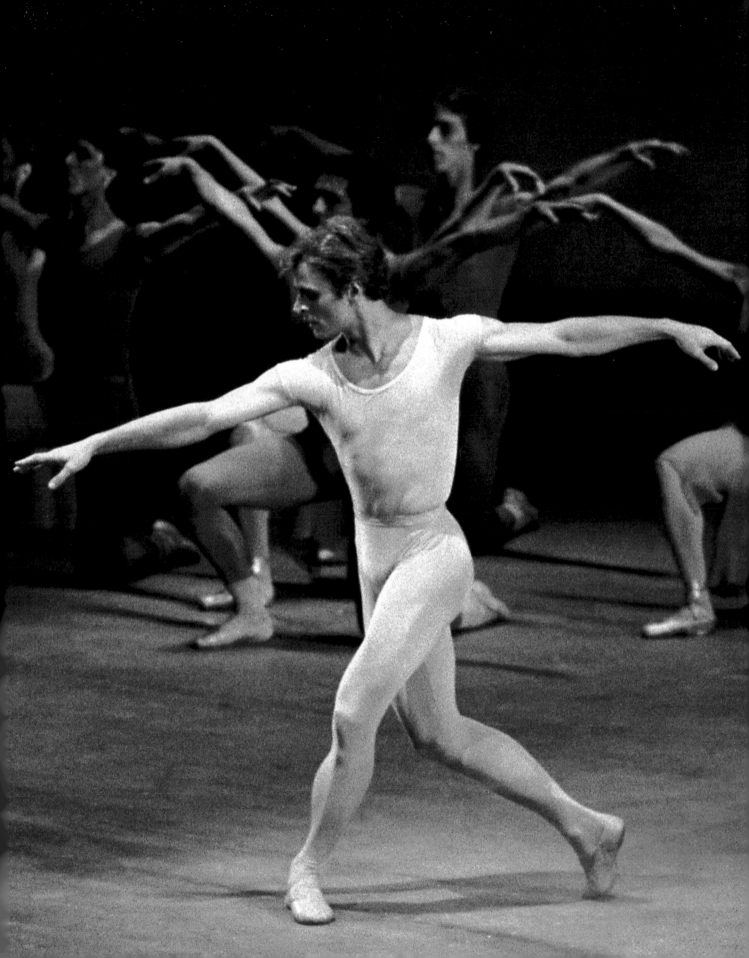

NINETEEN EIGHTY

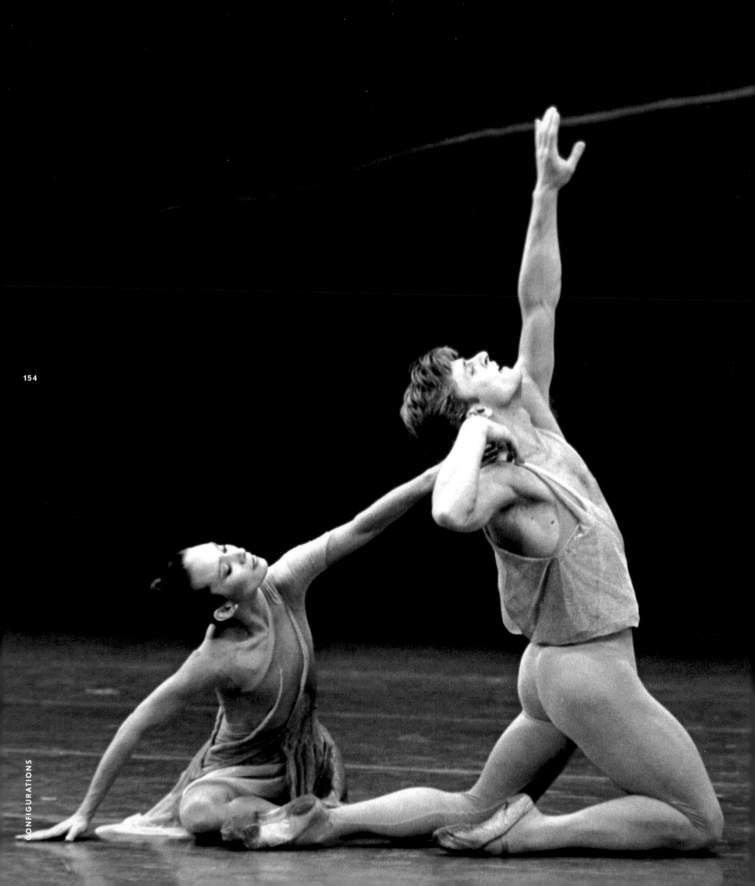

NINETEEN EIGHTY ONE

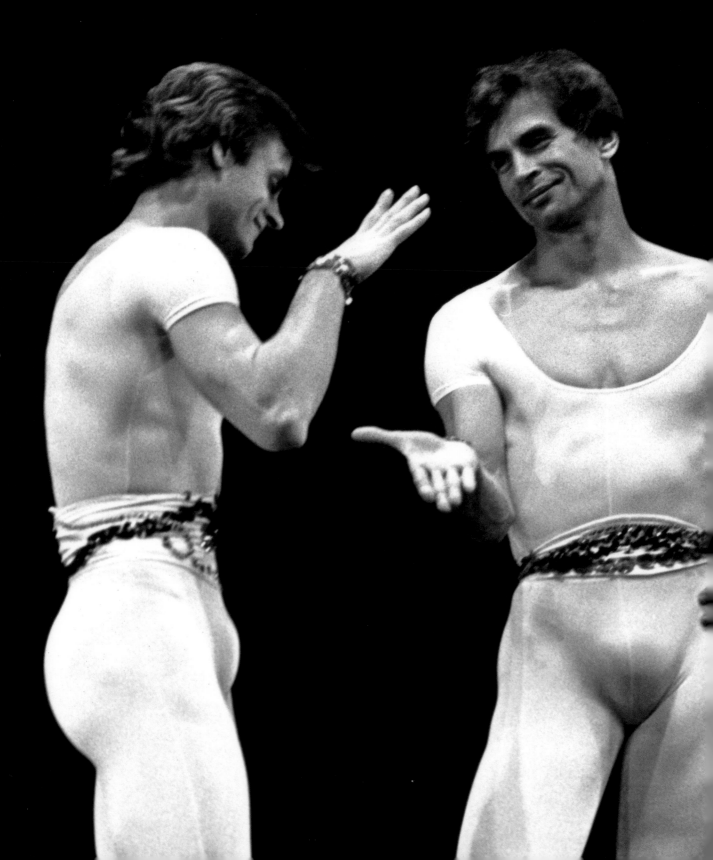

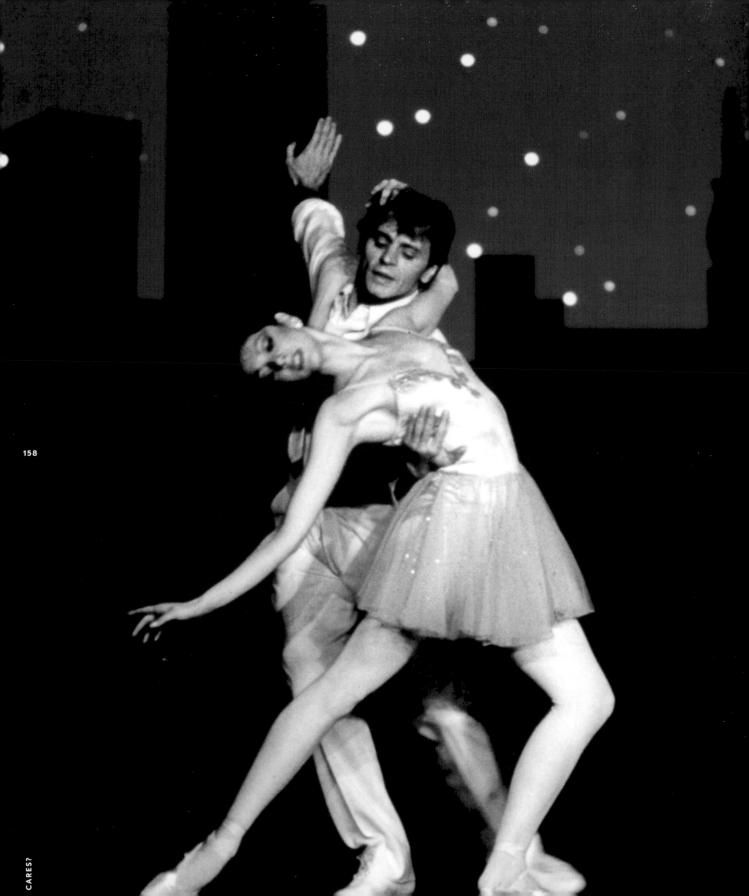

NINETEEN EIGHTY TWO

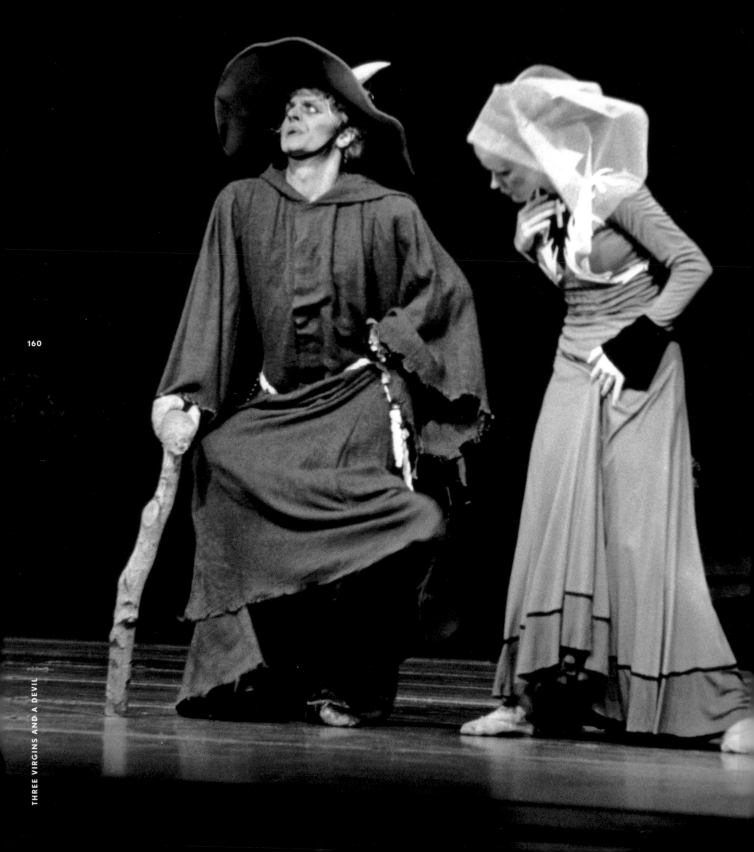

NINETEEN EIGHTY THREE

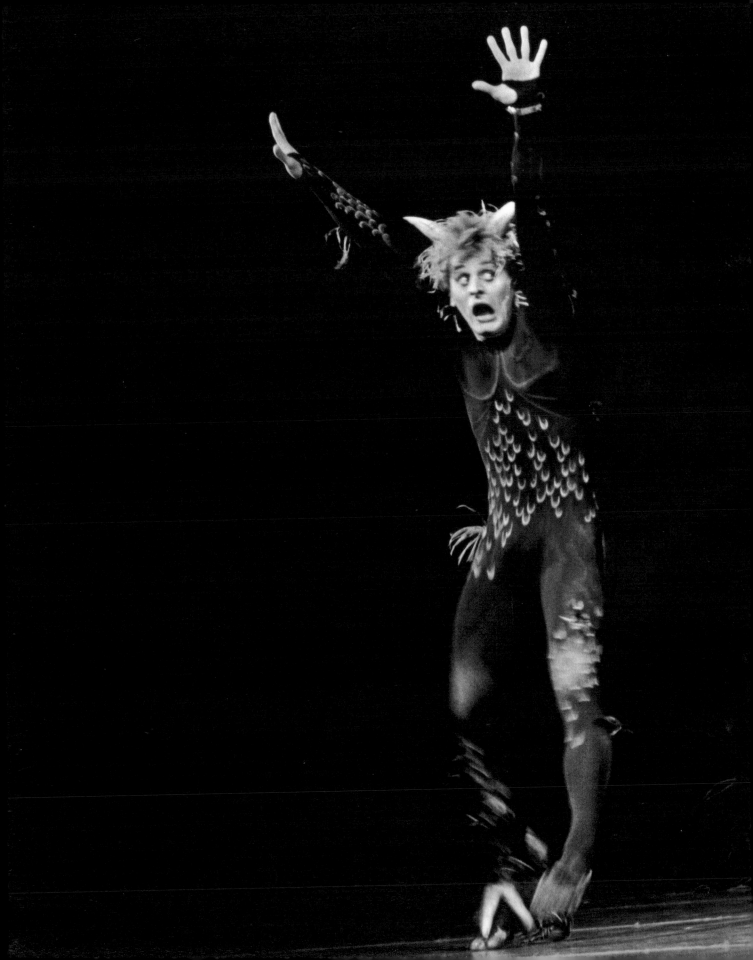

164

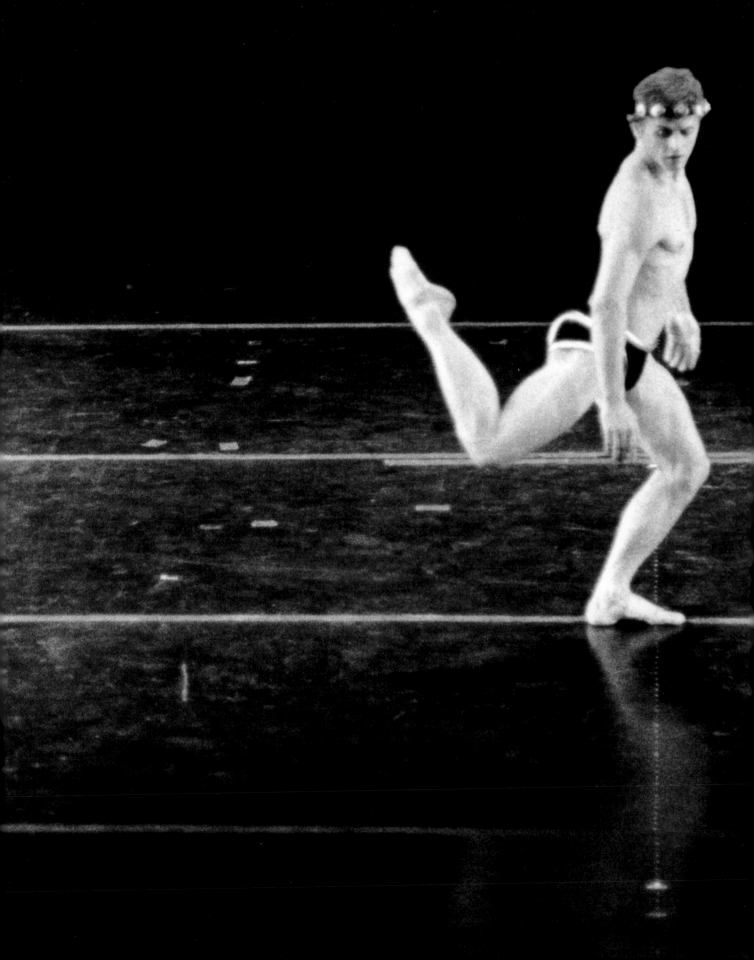

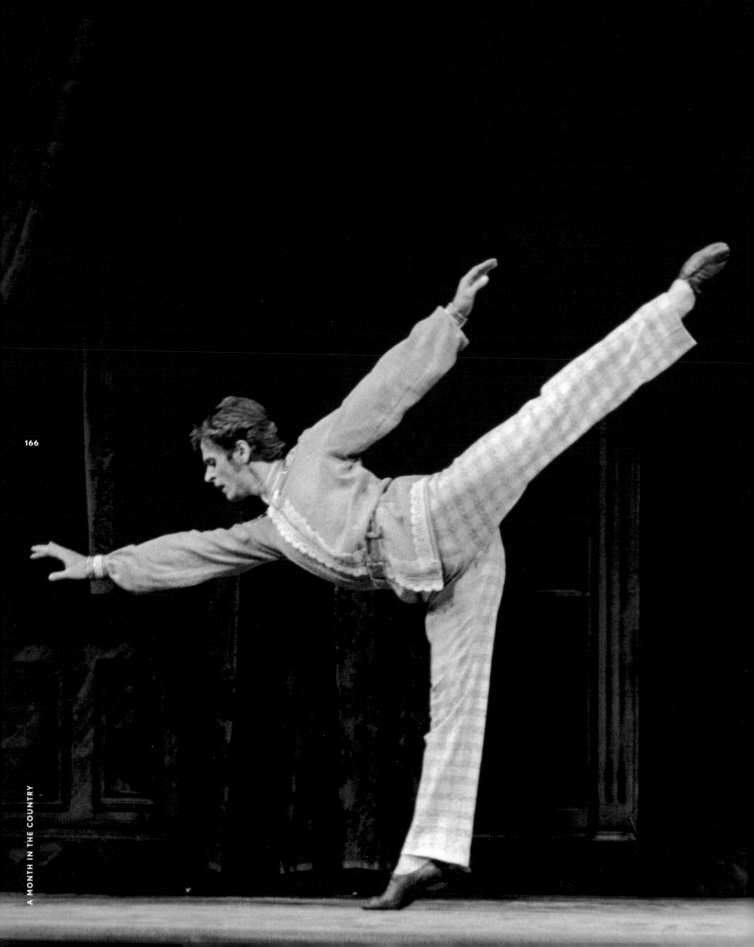

NINETEEN EIGHTY FIVE

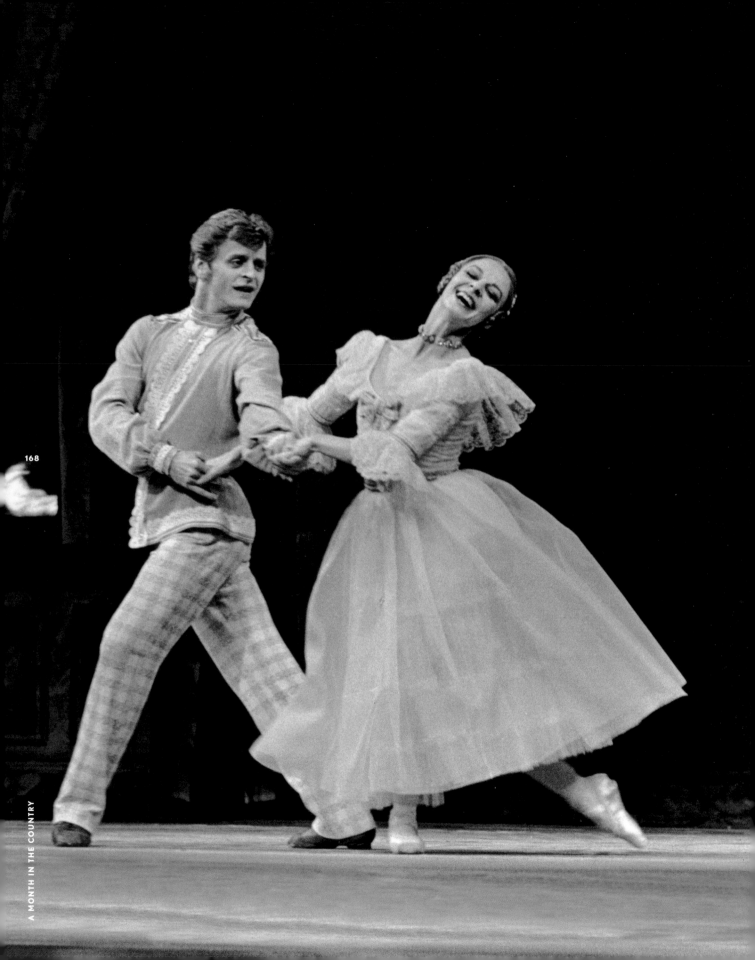

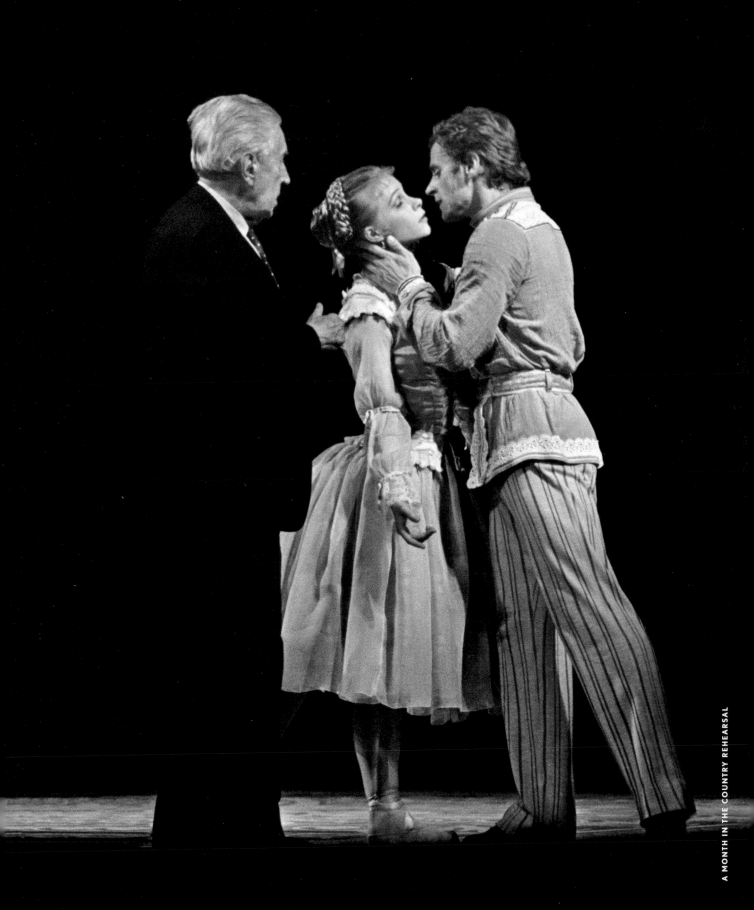

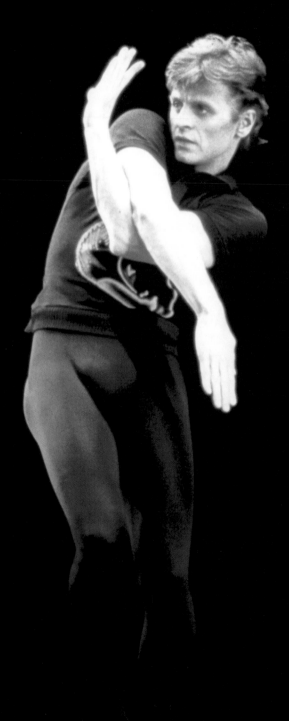

NINETEEN EIGHTY SIX

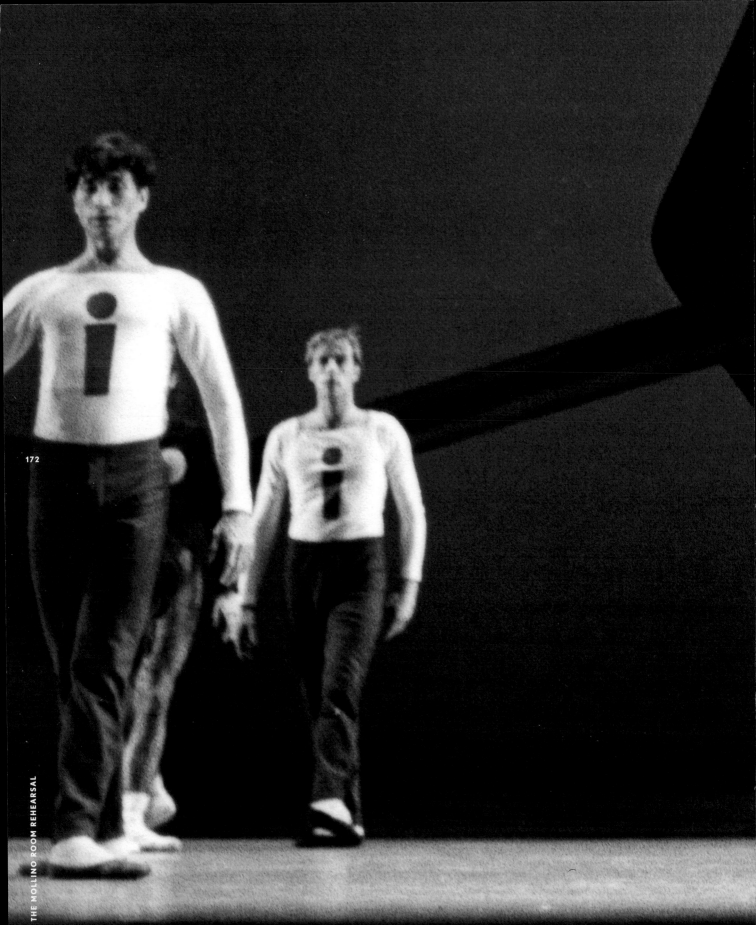

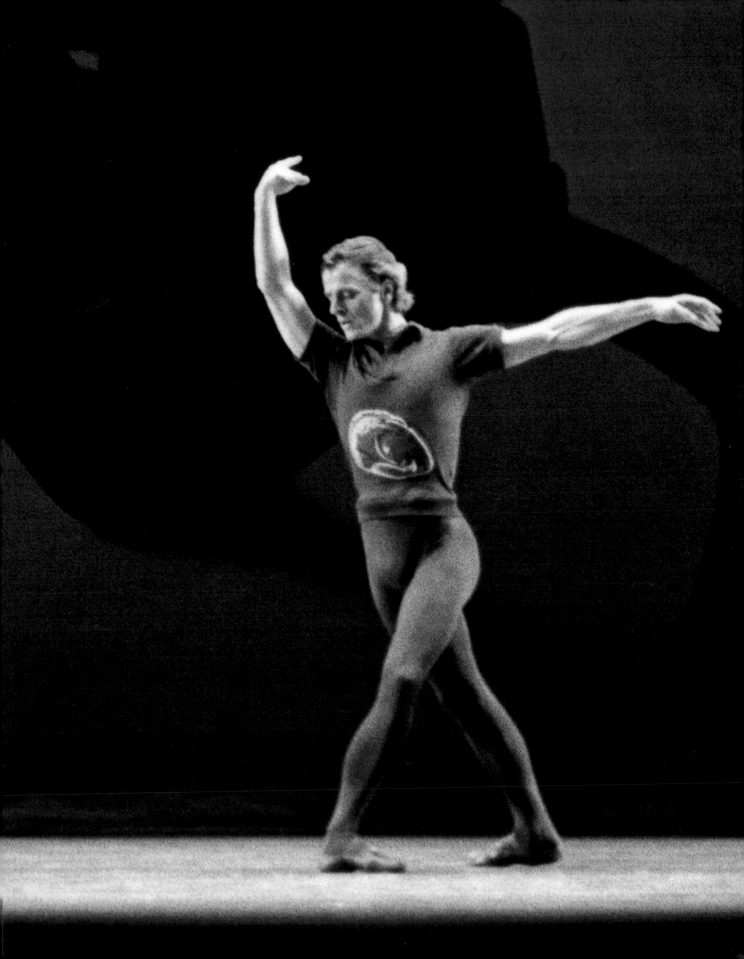

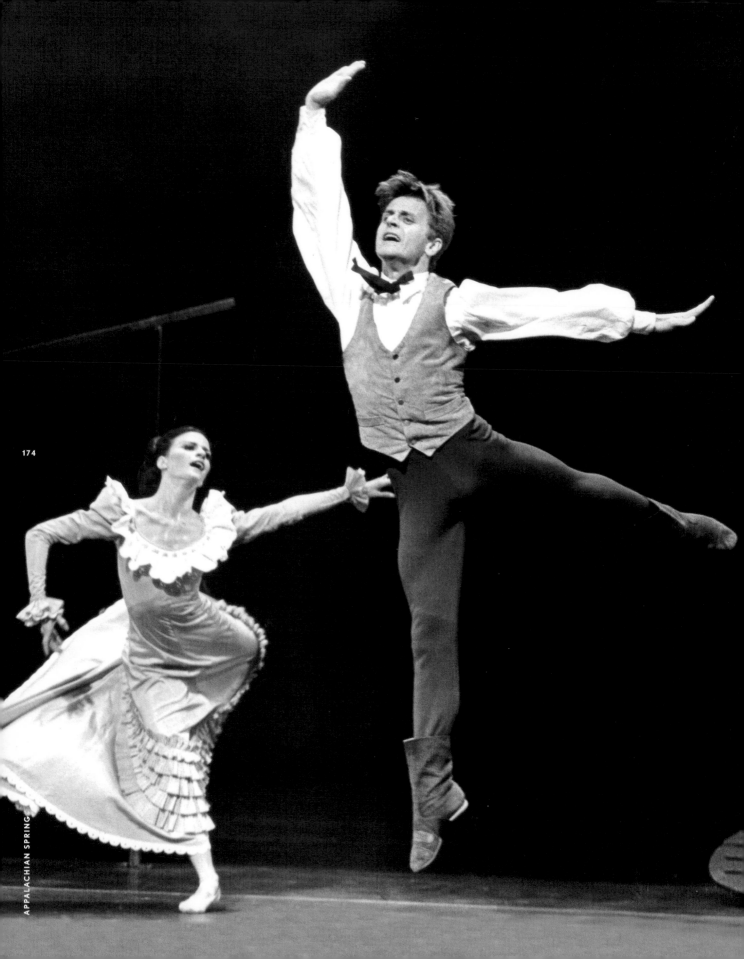

NINETEEN EIGHTY SEVEN

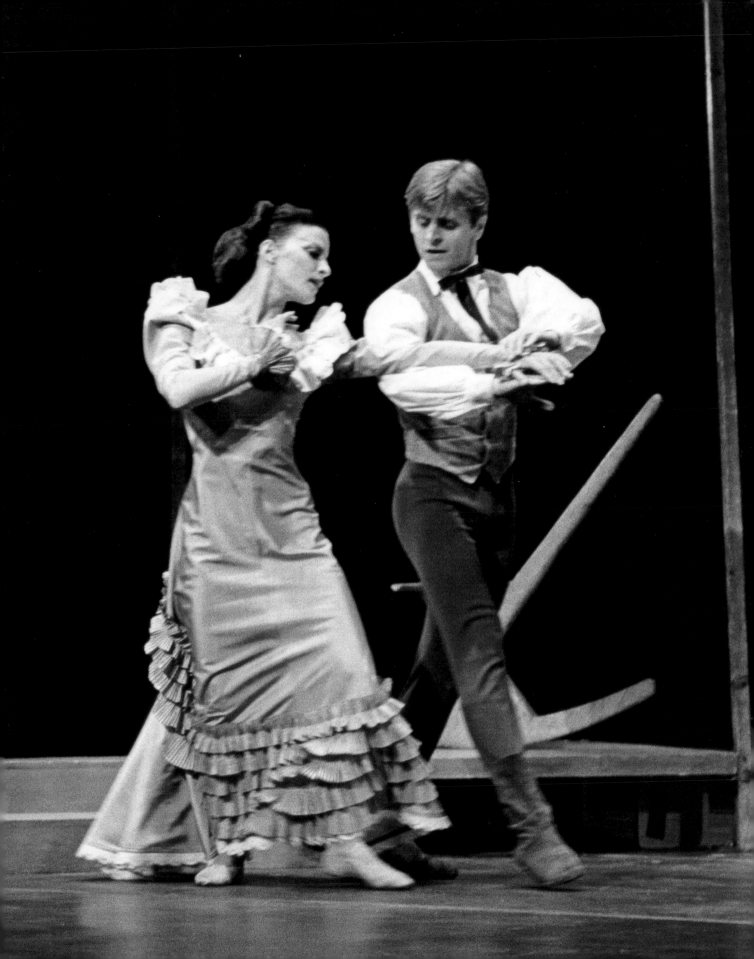

178

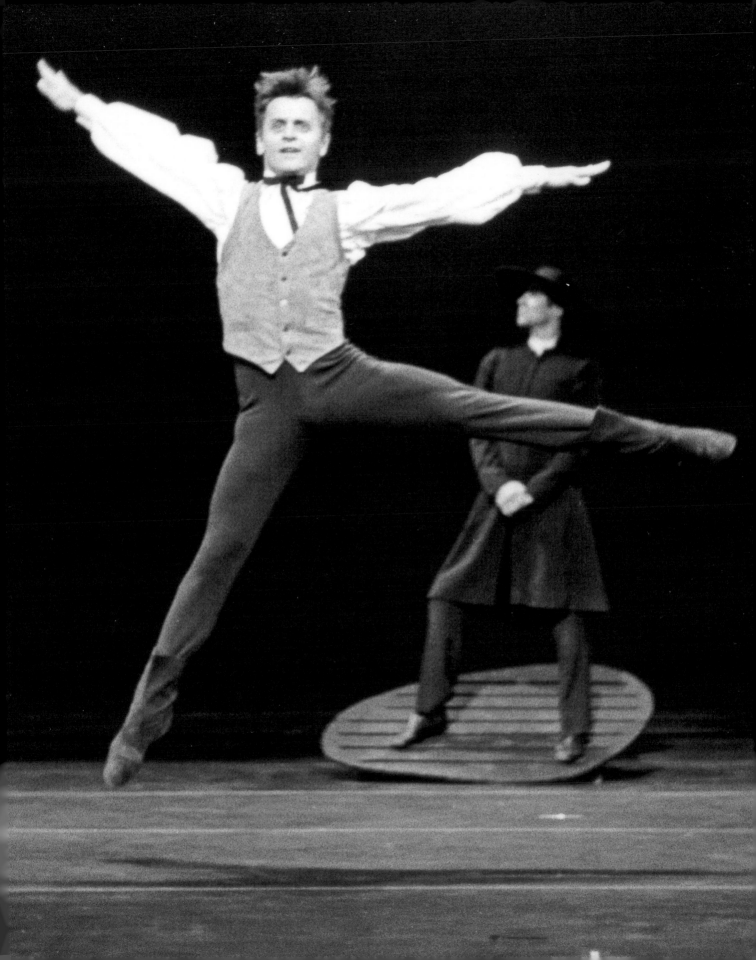

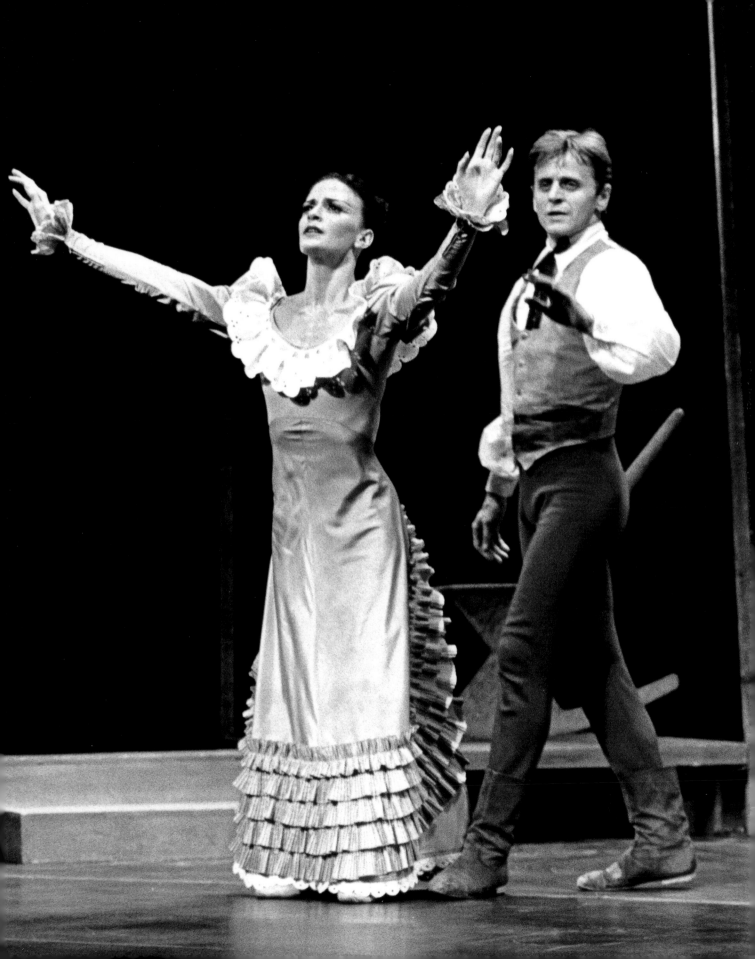

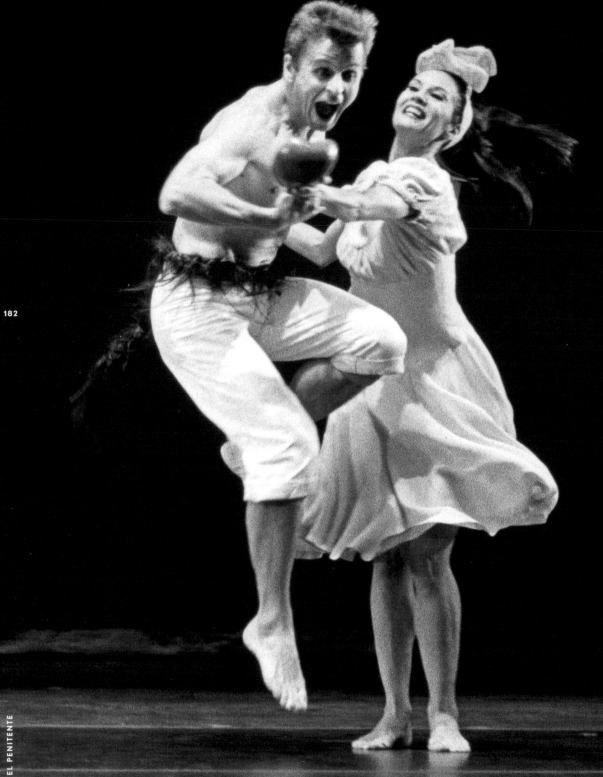

NINETEEN EIGHTY EIGHT

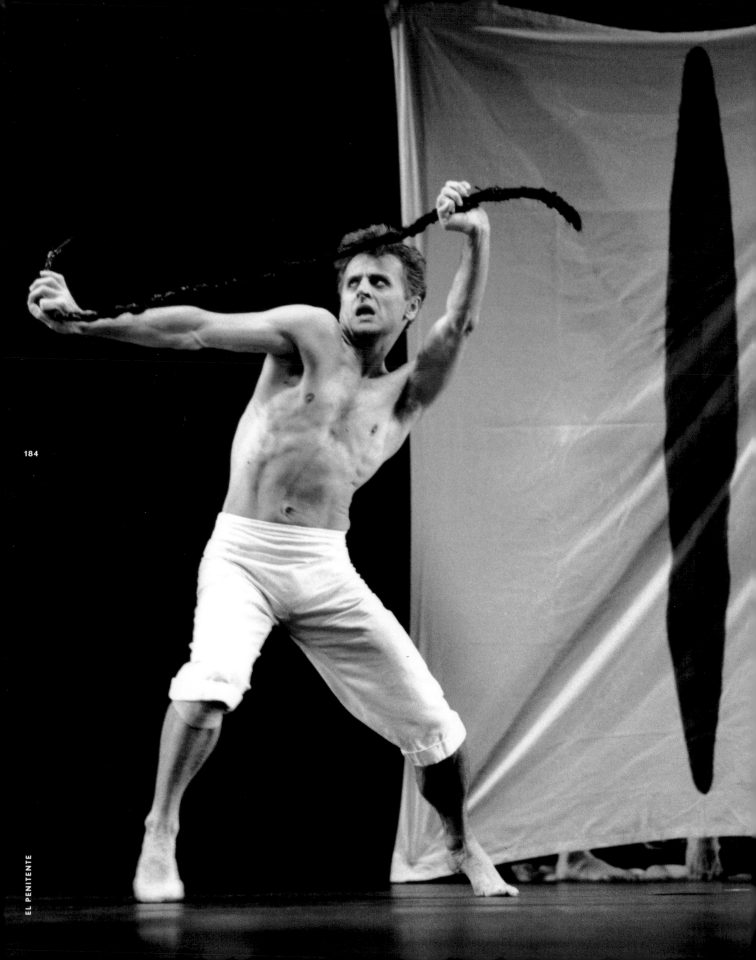

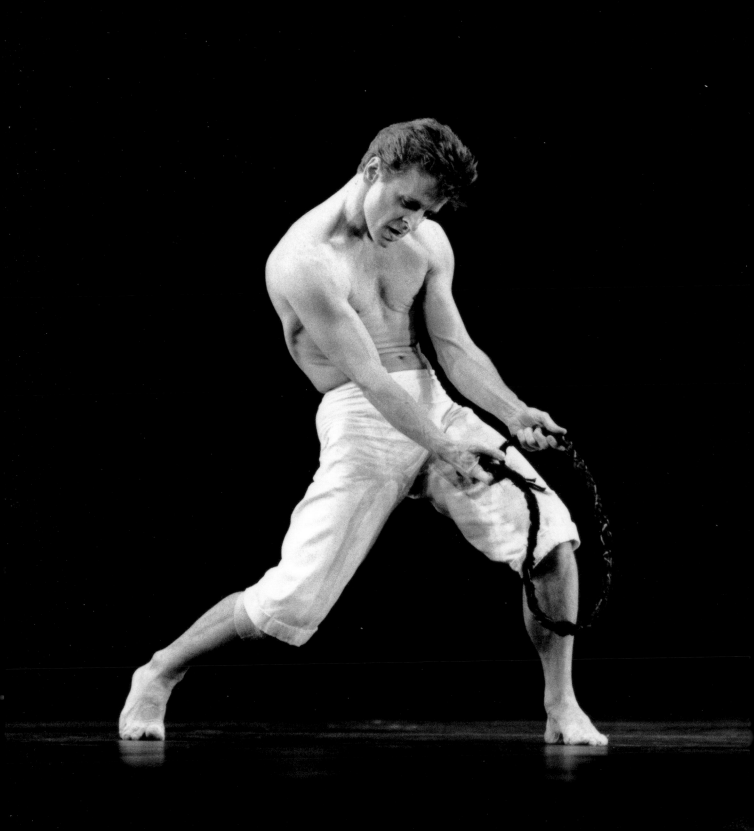

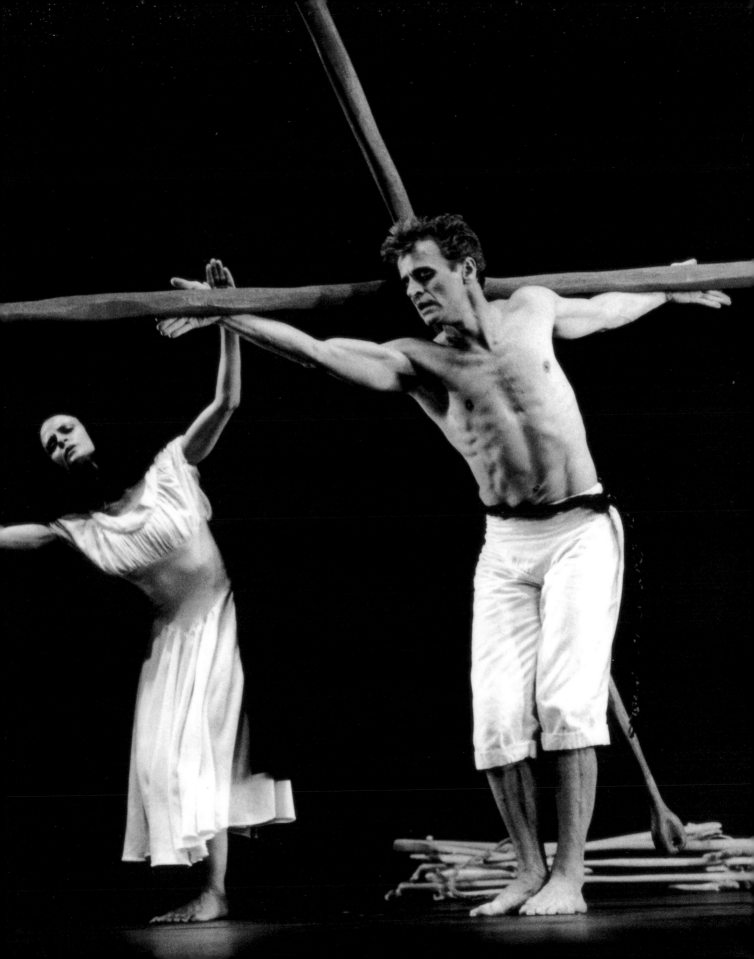

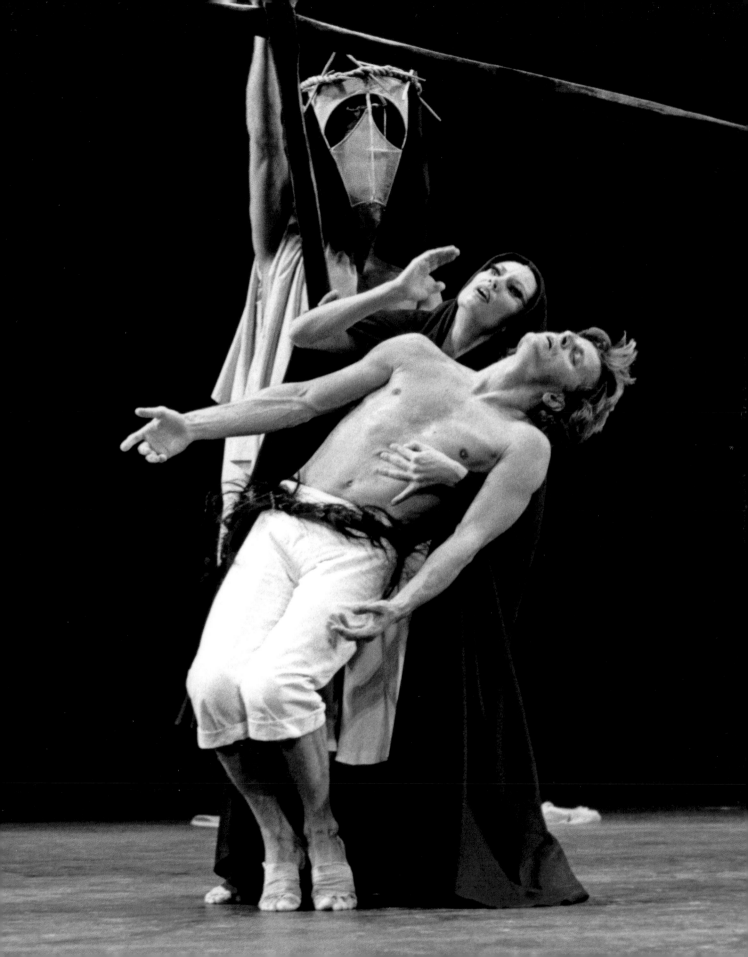

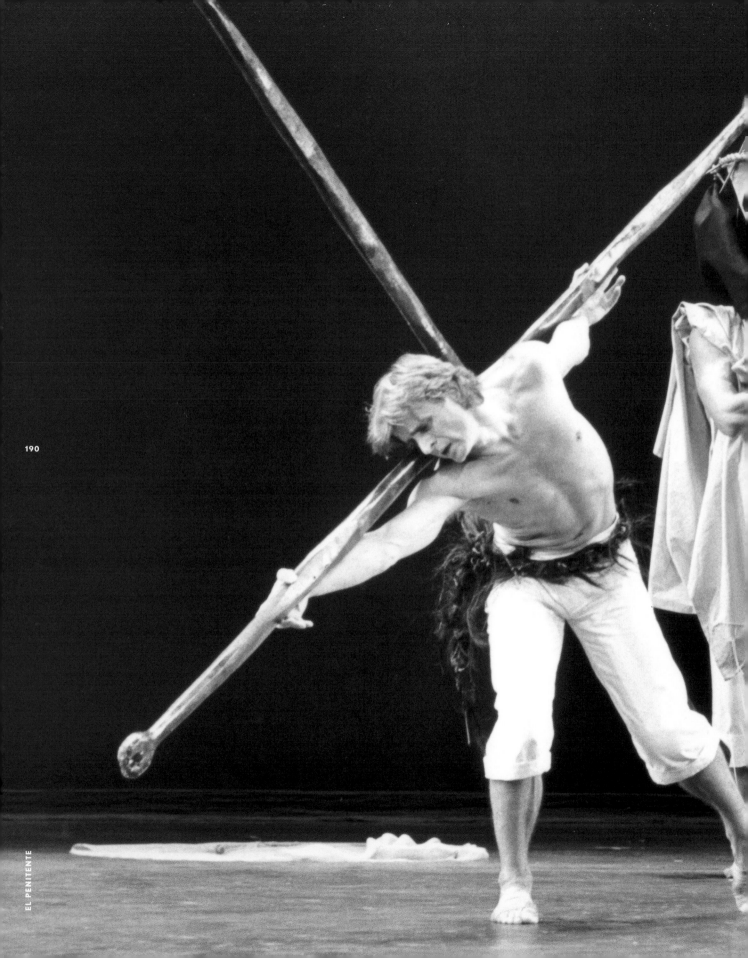

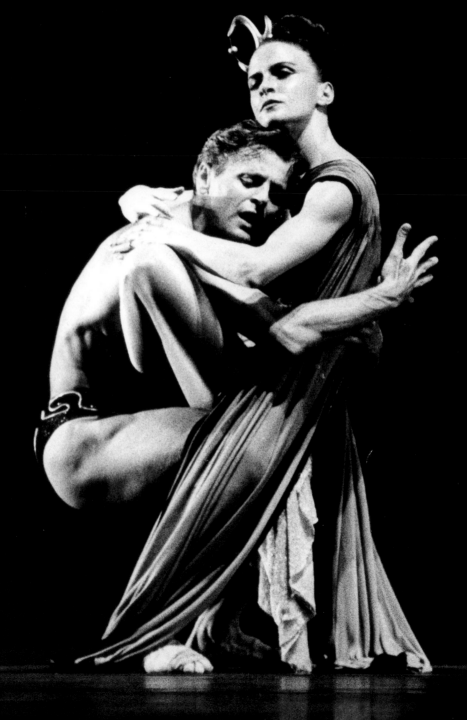

NINETEEN EIGHTY NINE

194

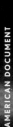

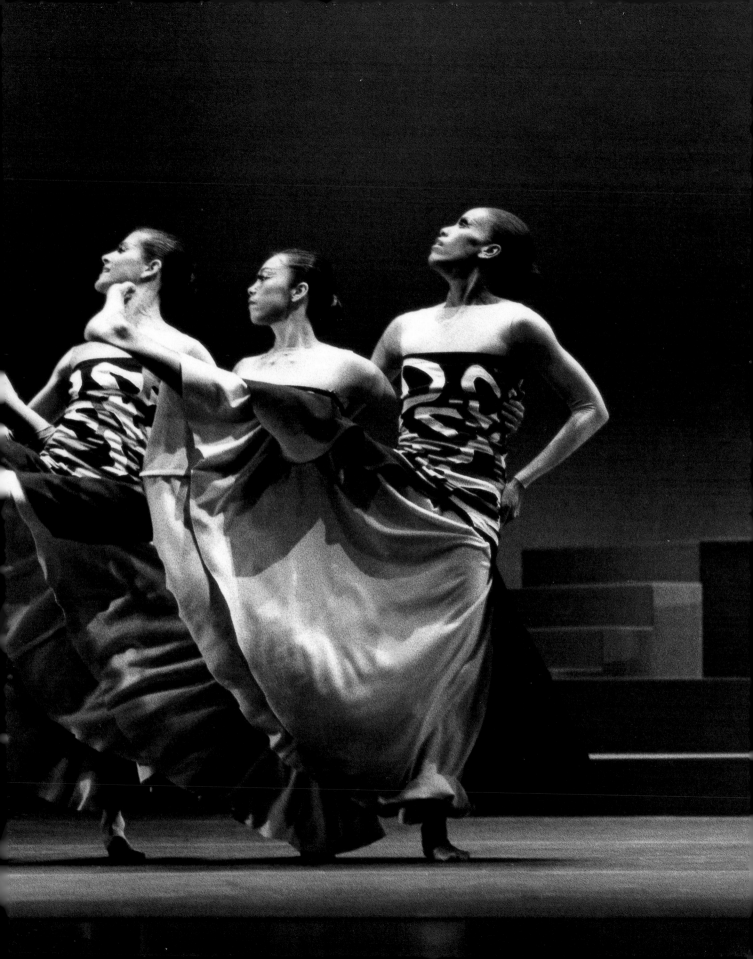

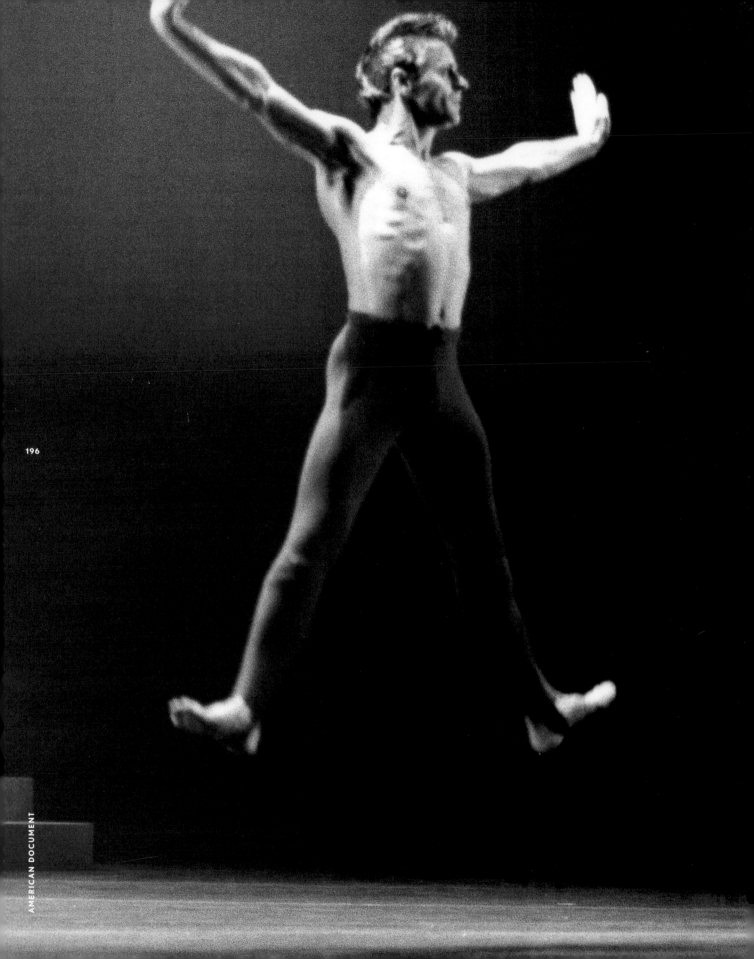

196

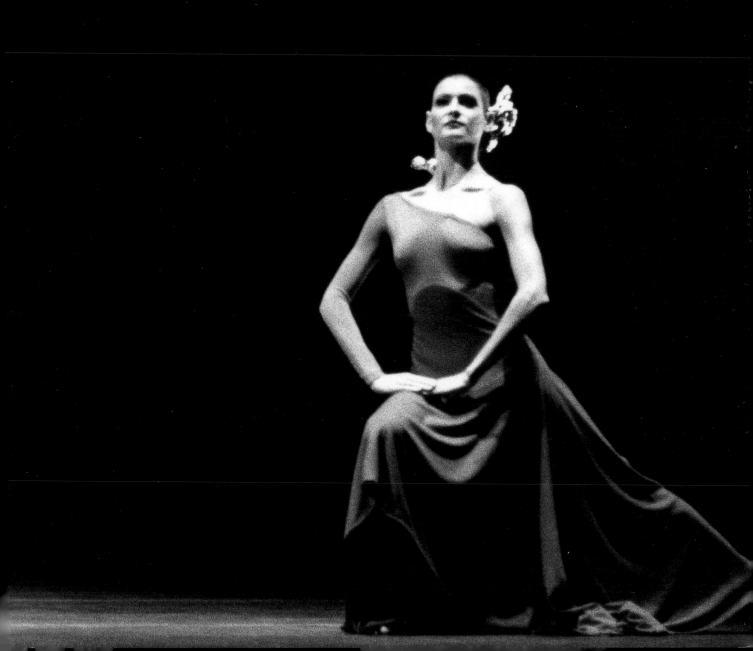

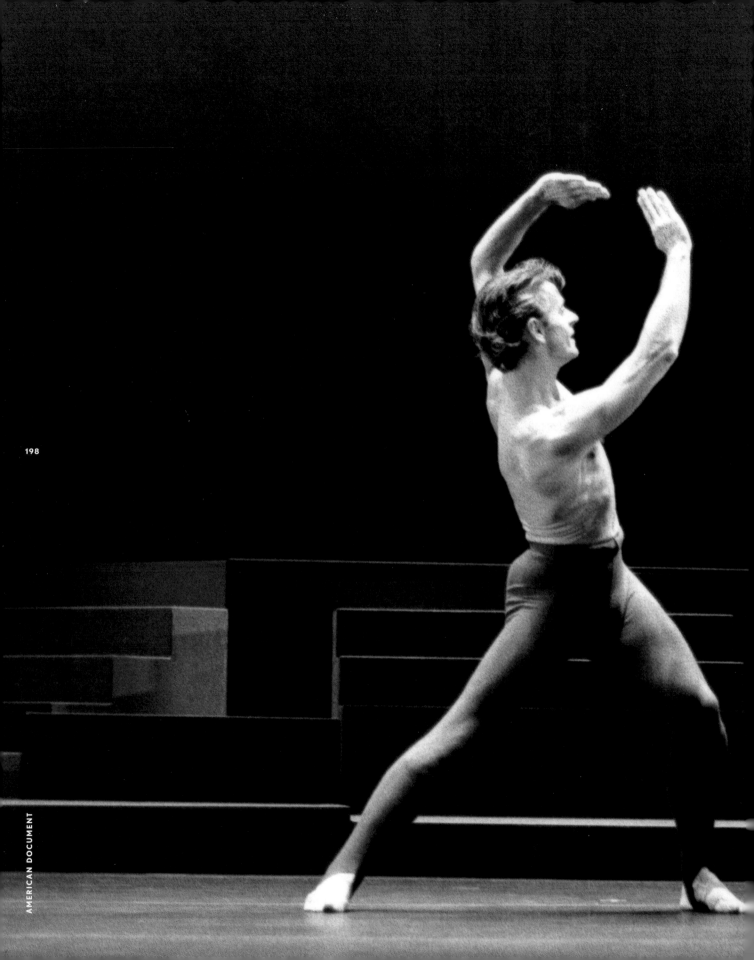

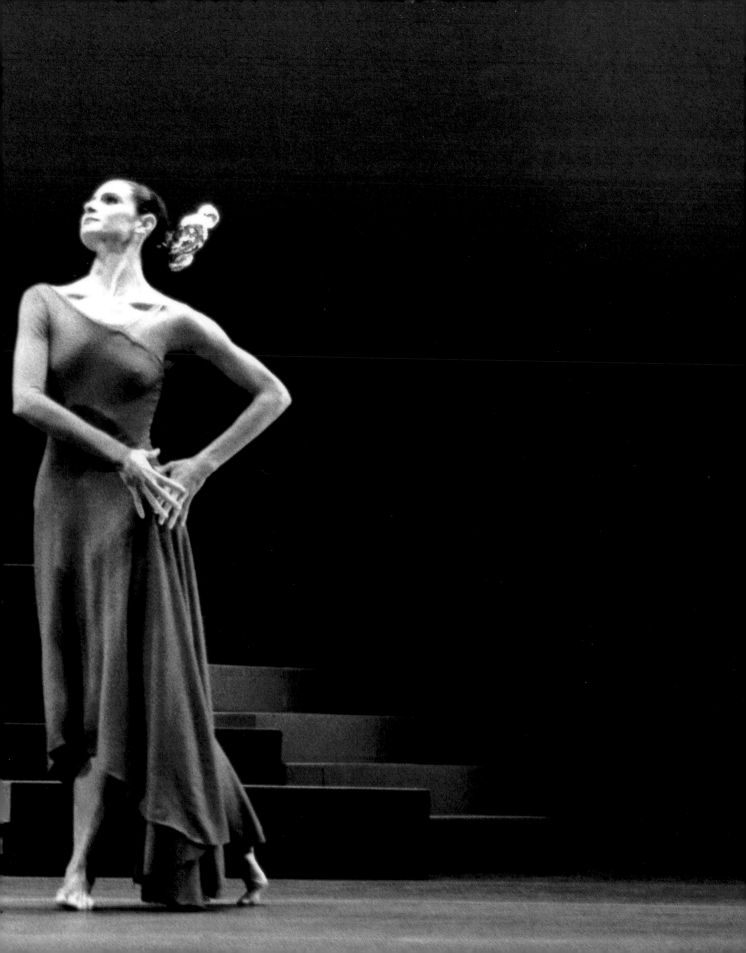

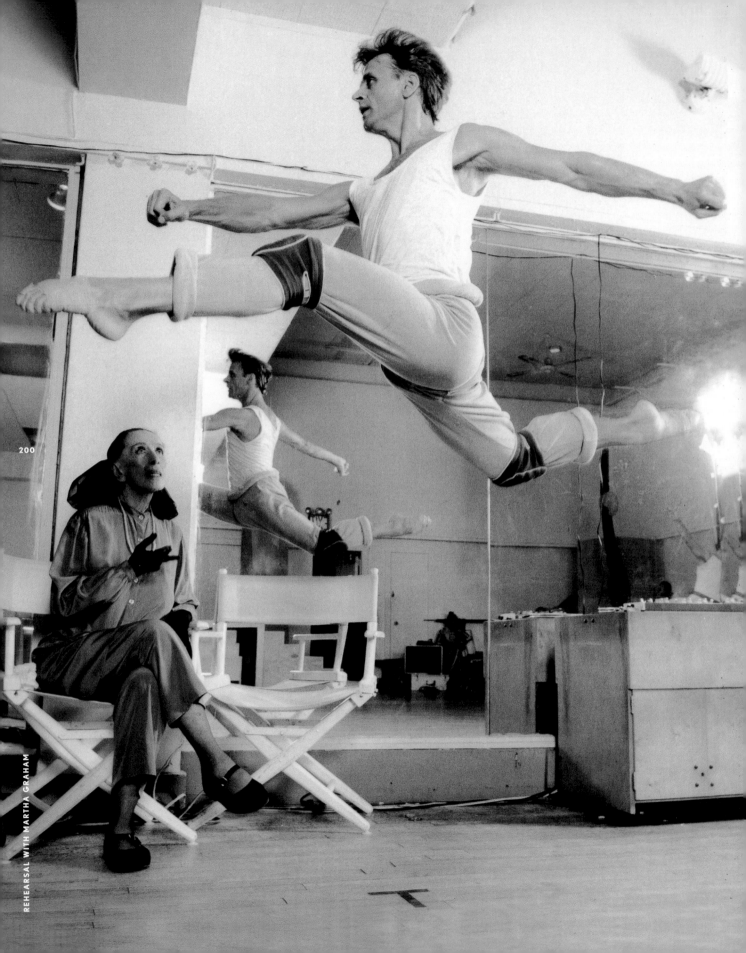

REHEARSAL WITH MARTHA GRAHAM

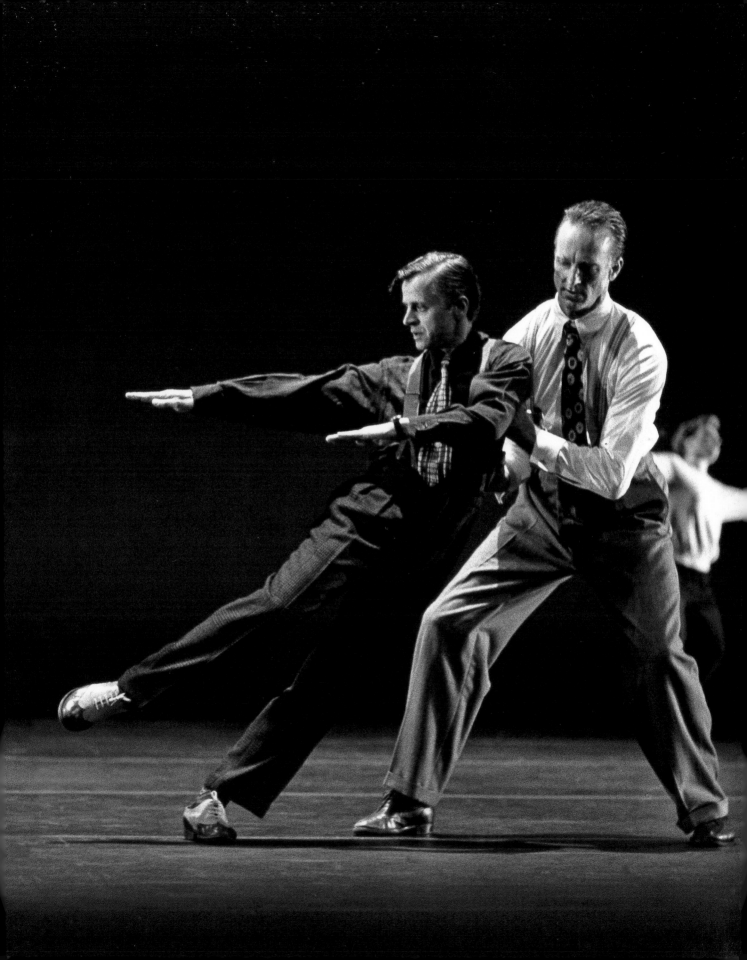

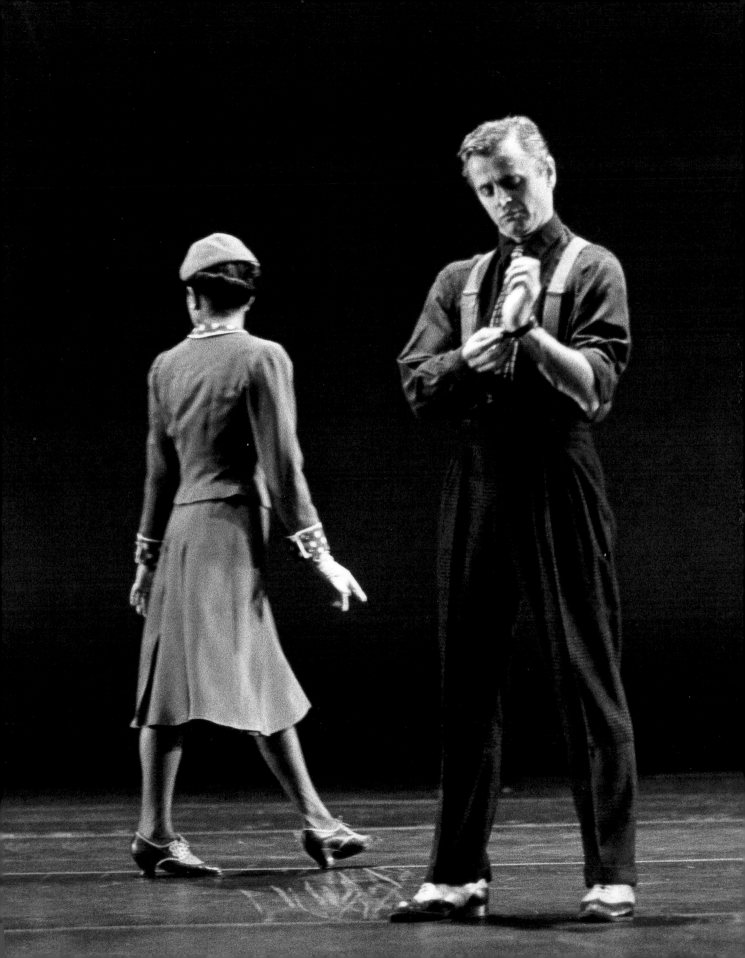

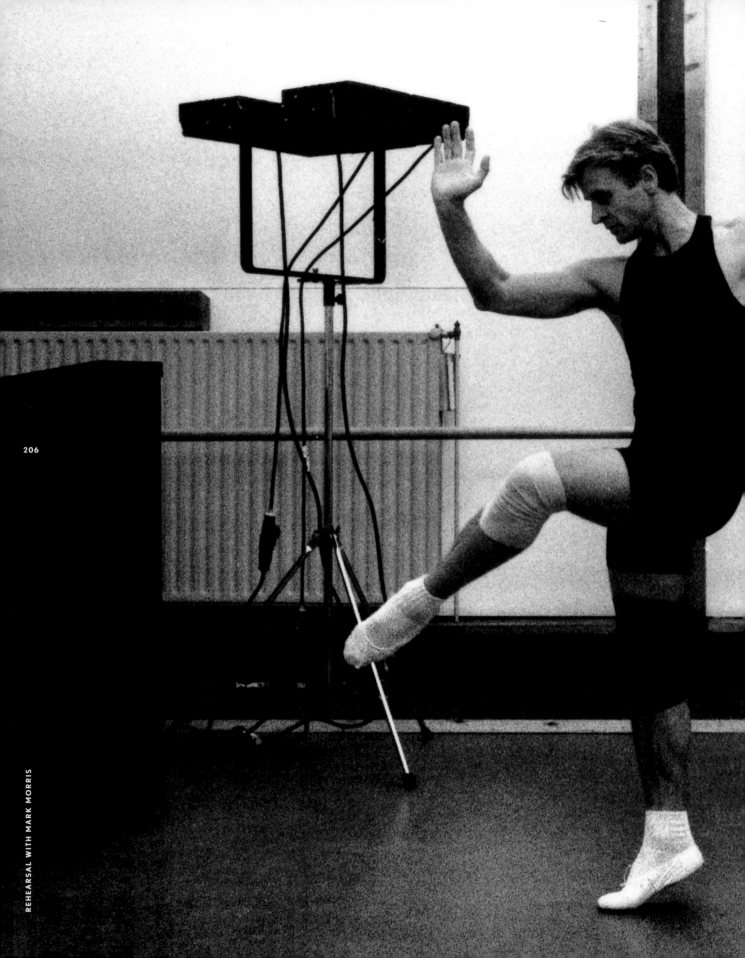

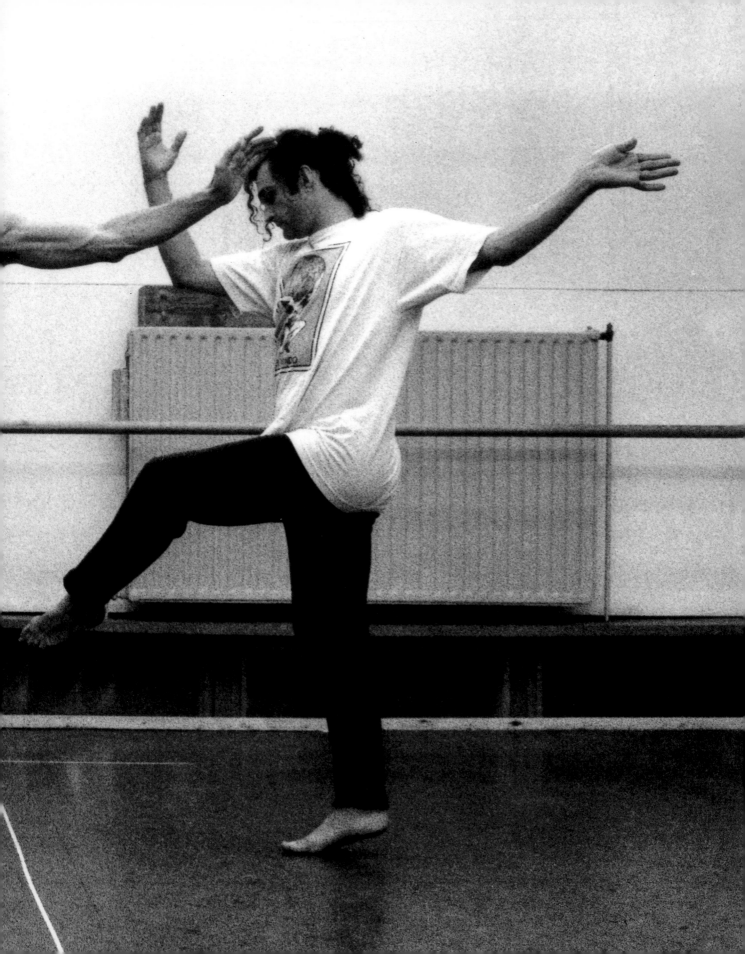

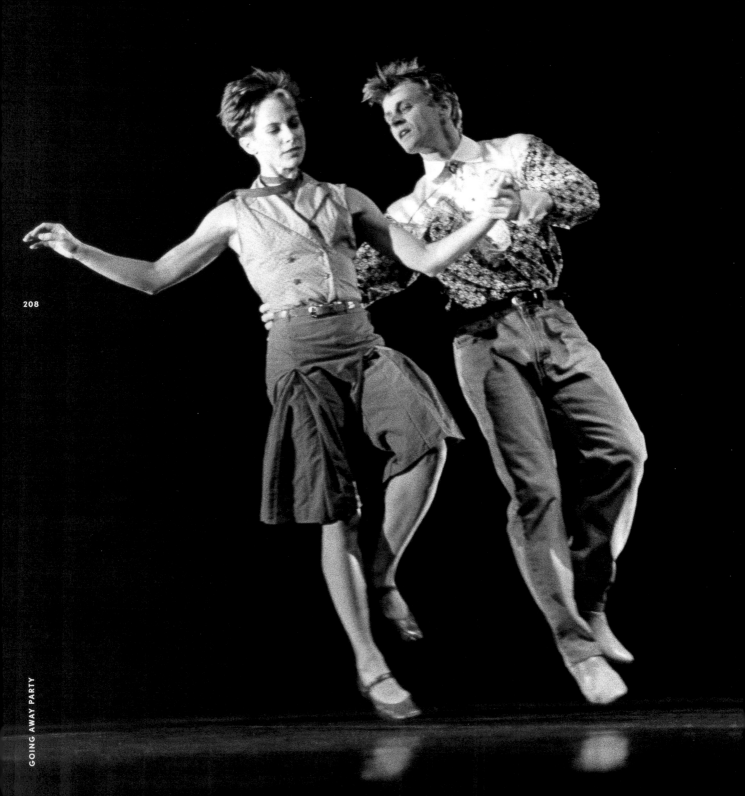

208

NINETEEN NINETY

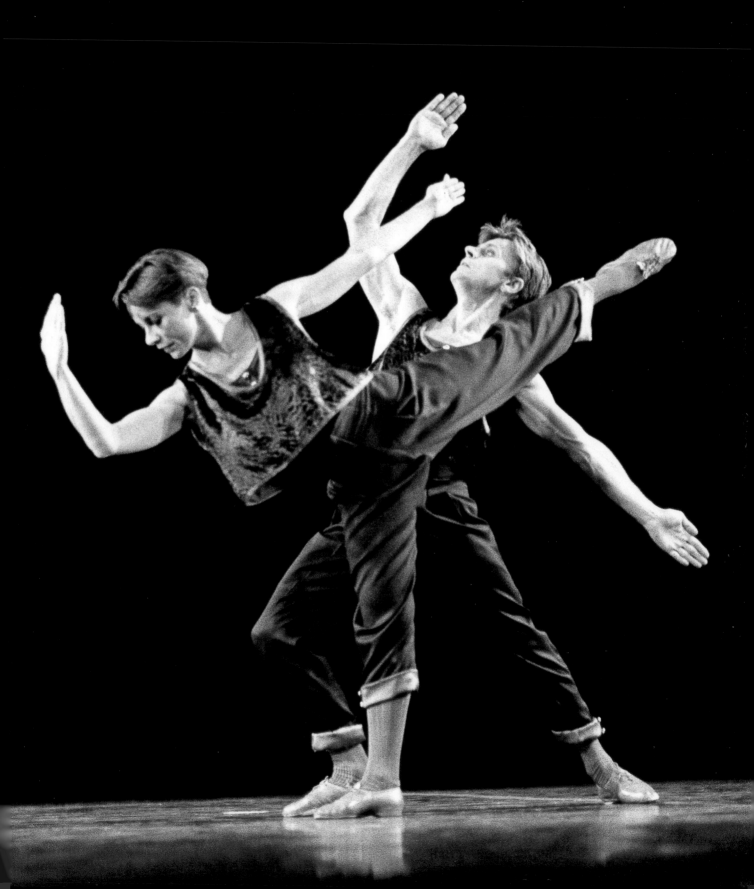

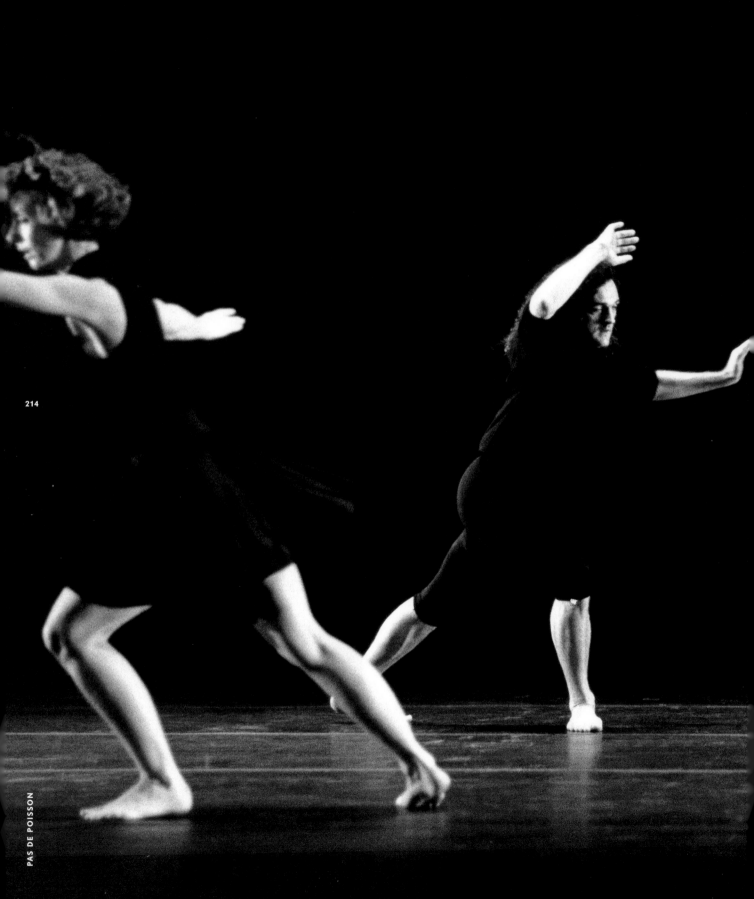

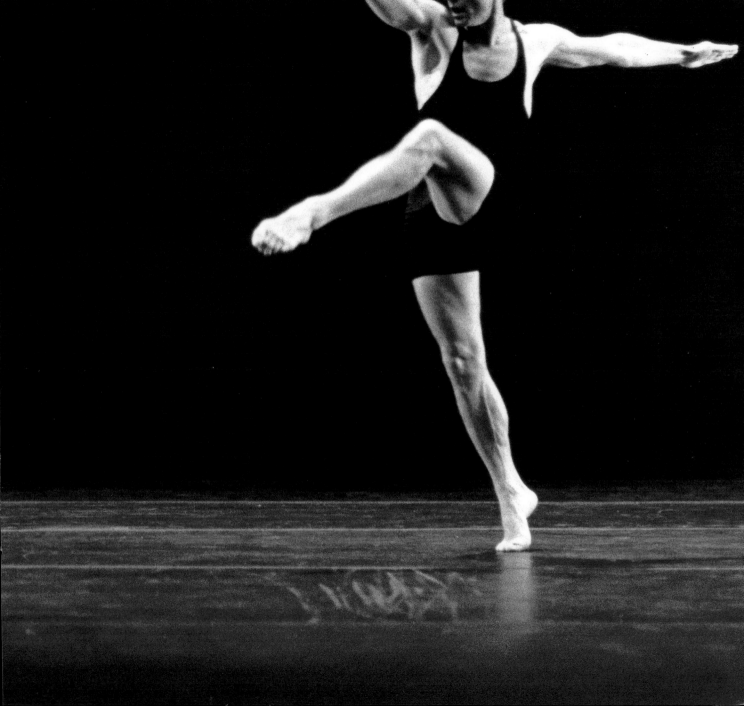

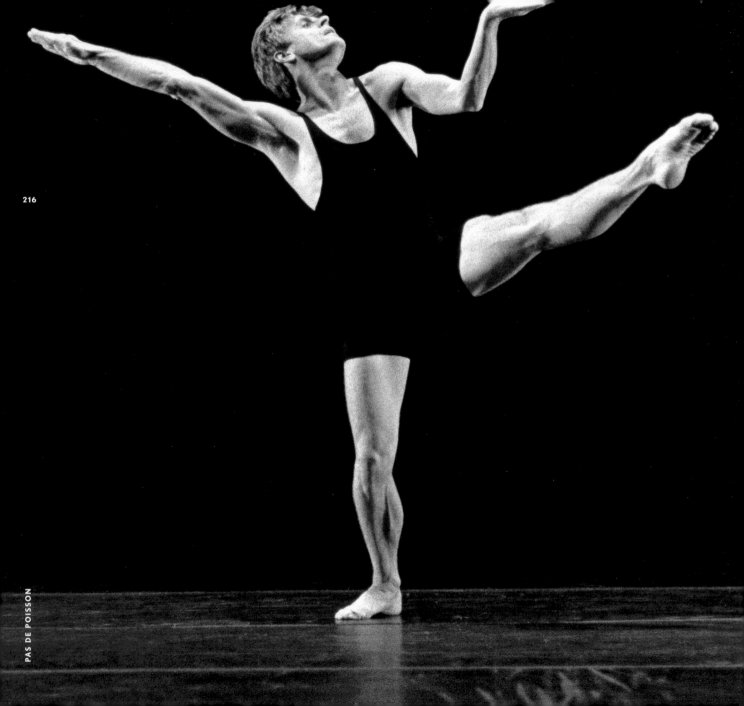

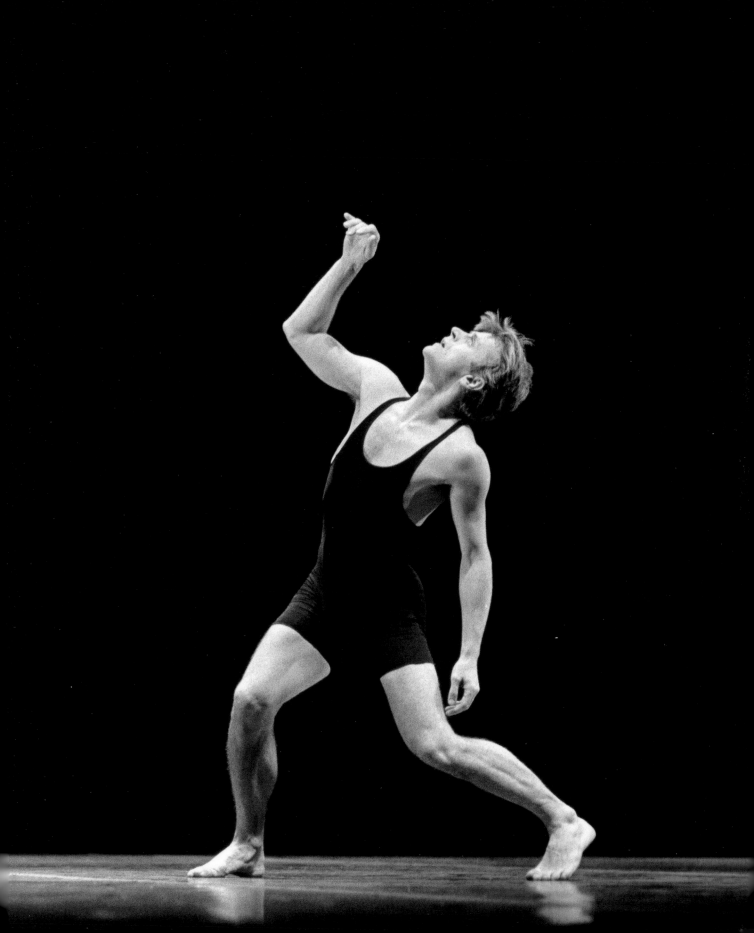

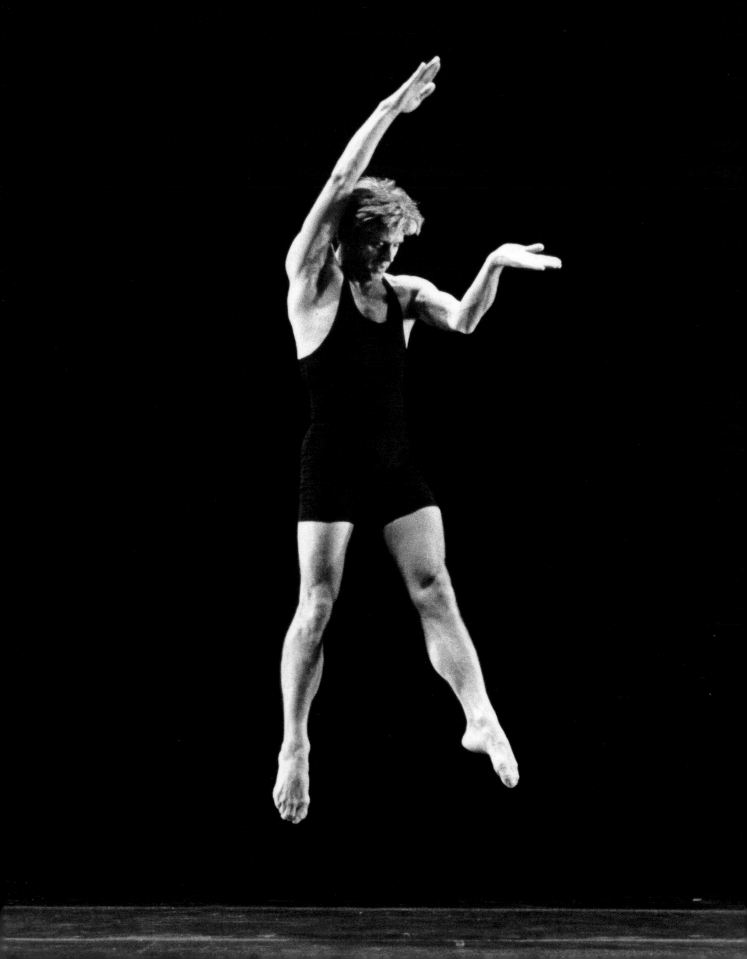

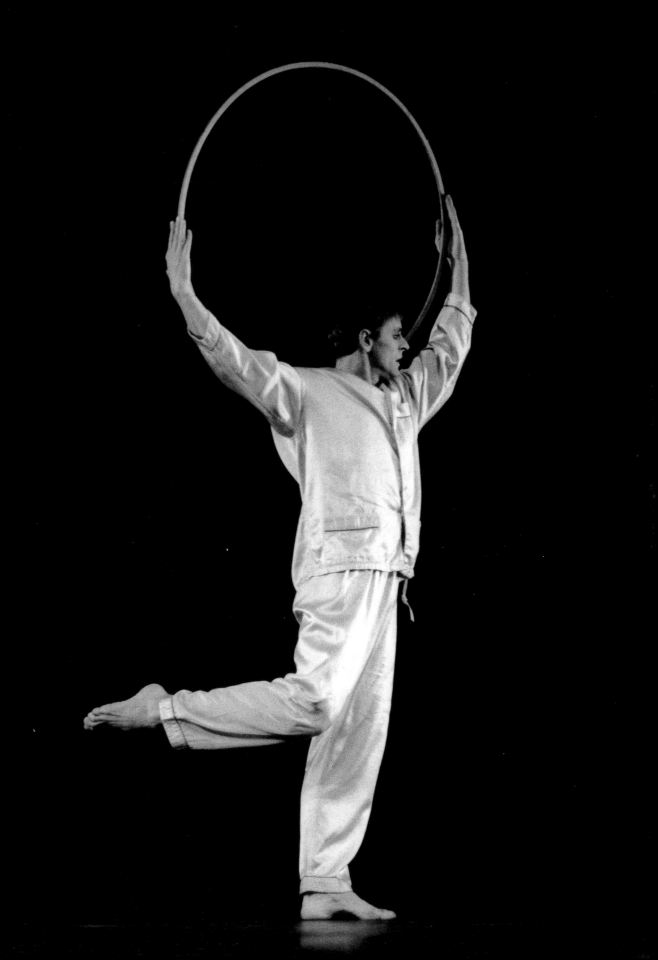

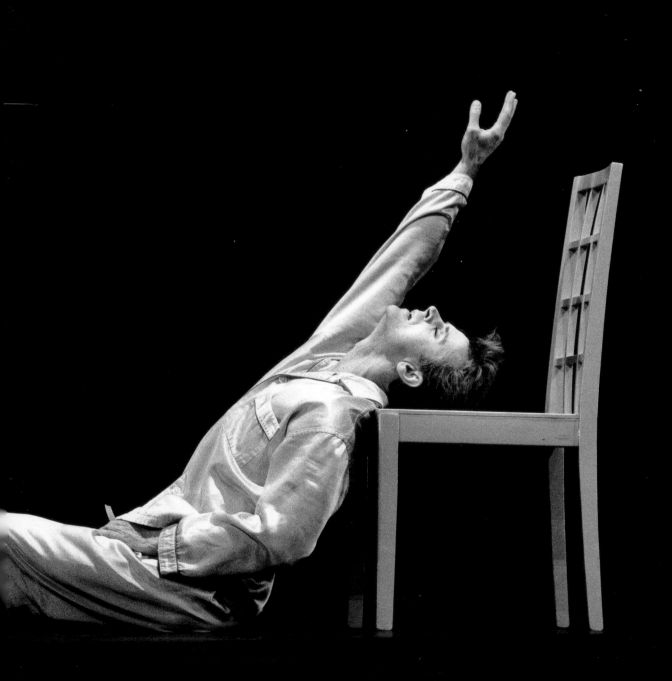

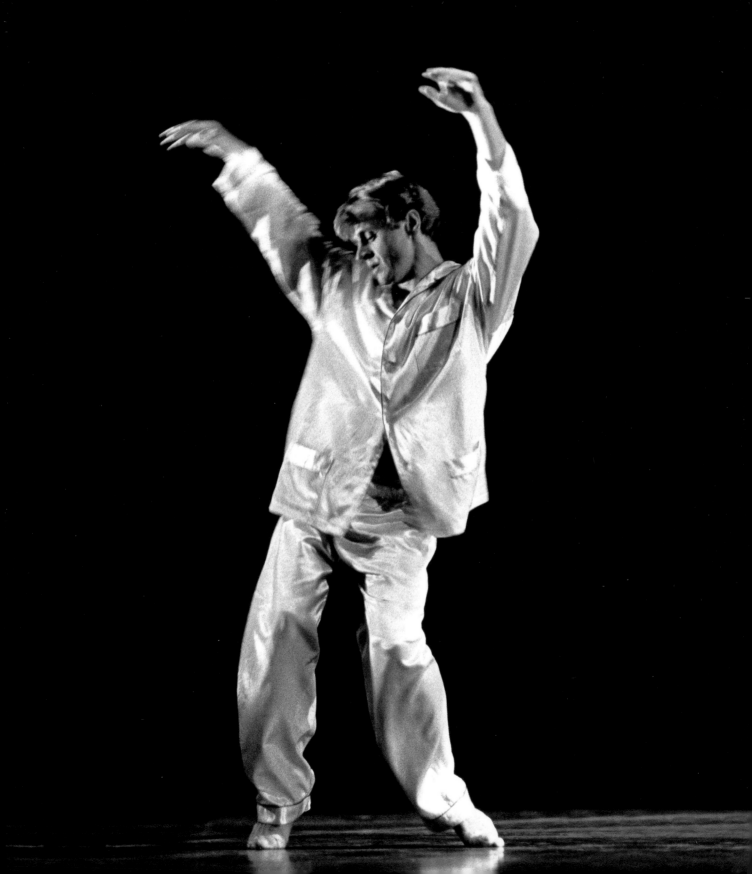

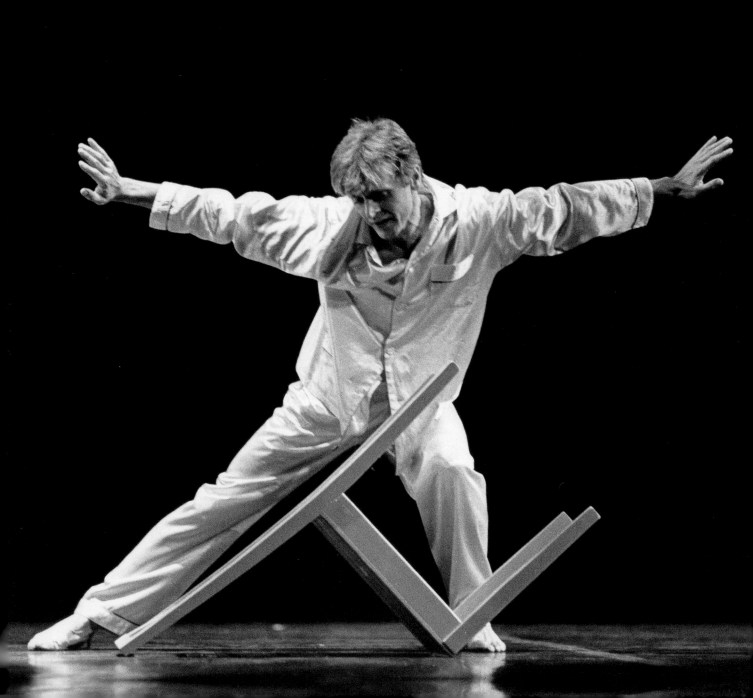

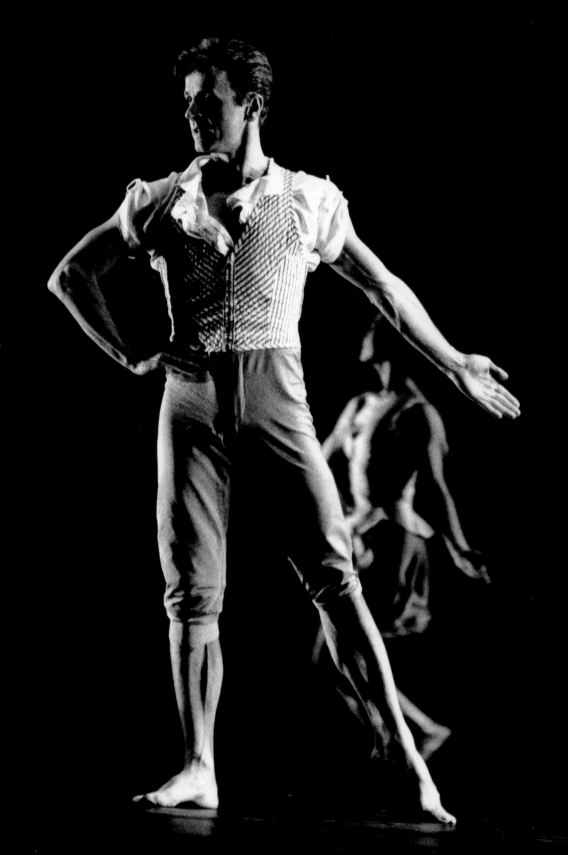

NINETEEN NINETY ONE

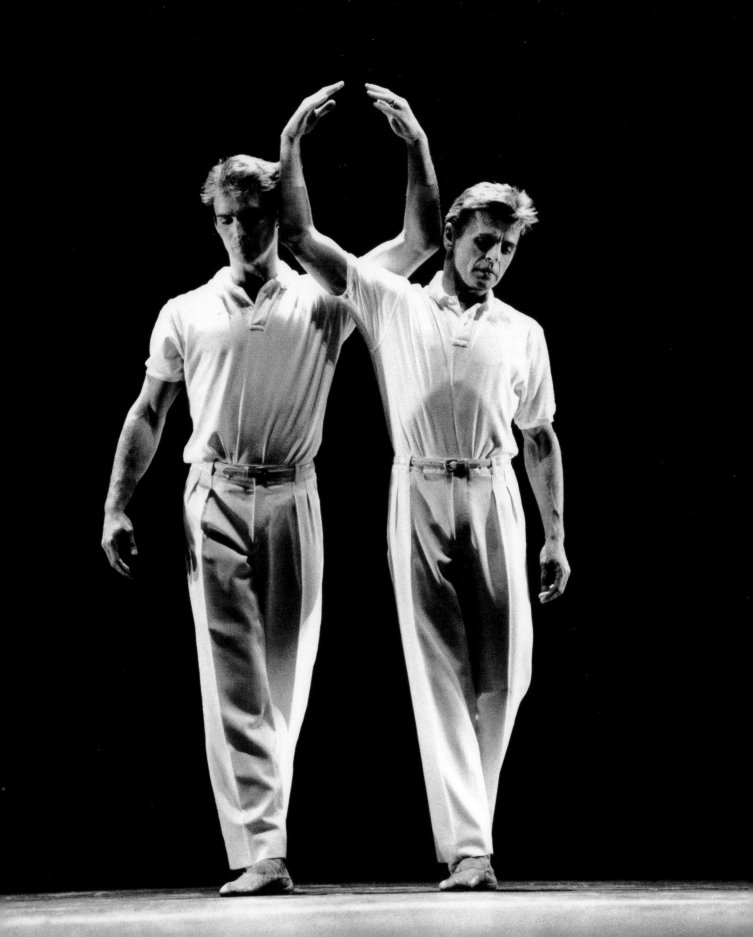

232

NINETEEN NINETY TWO

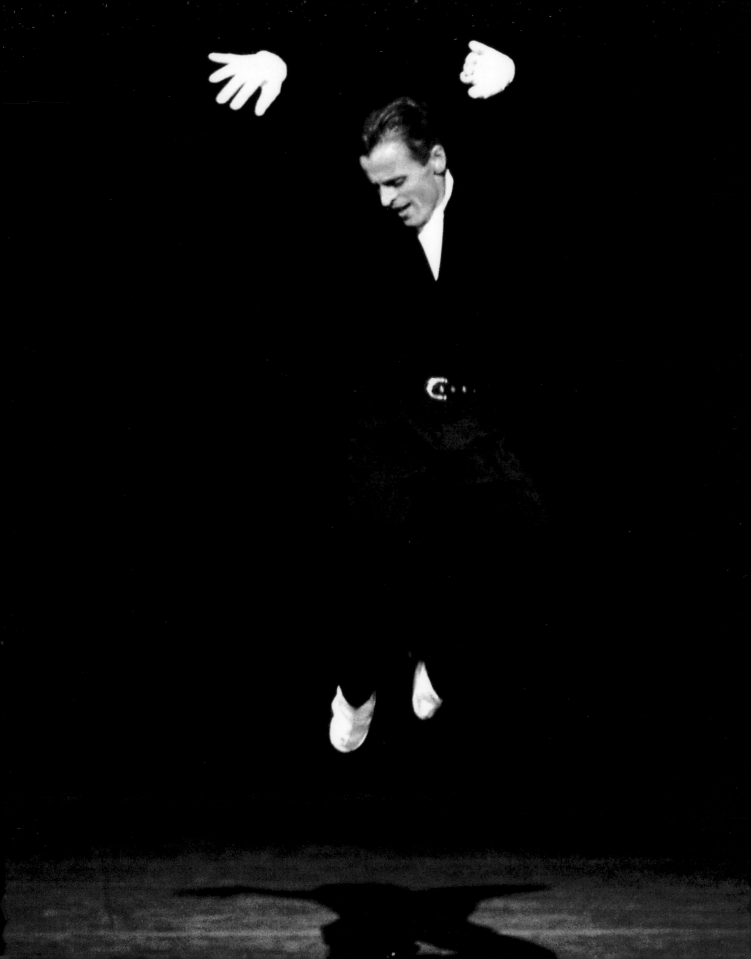

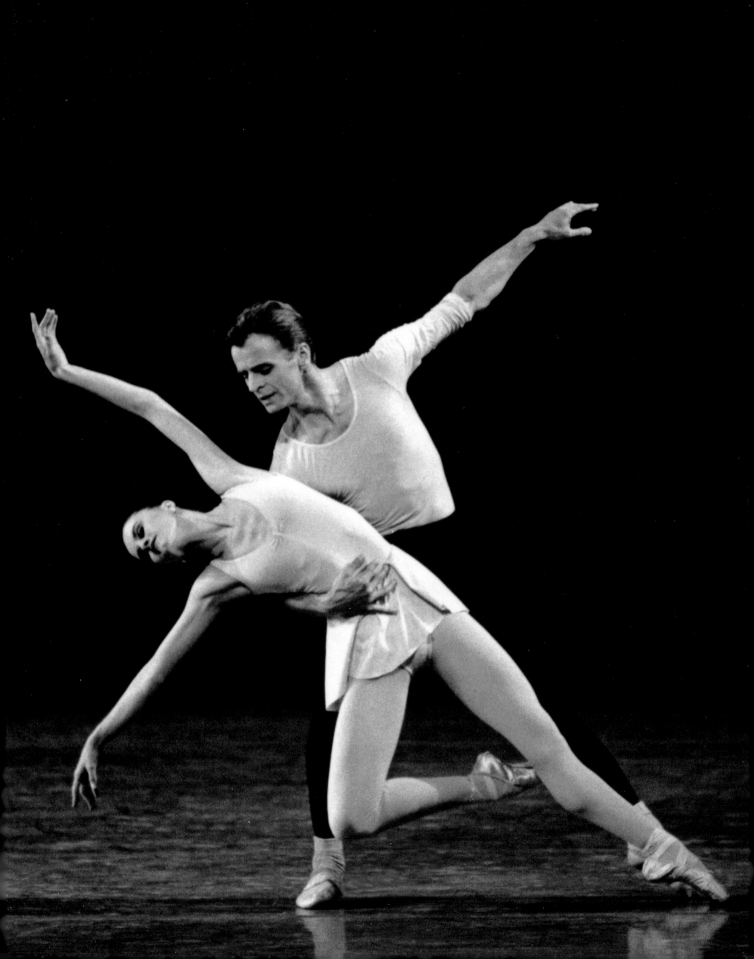

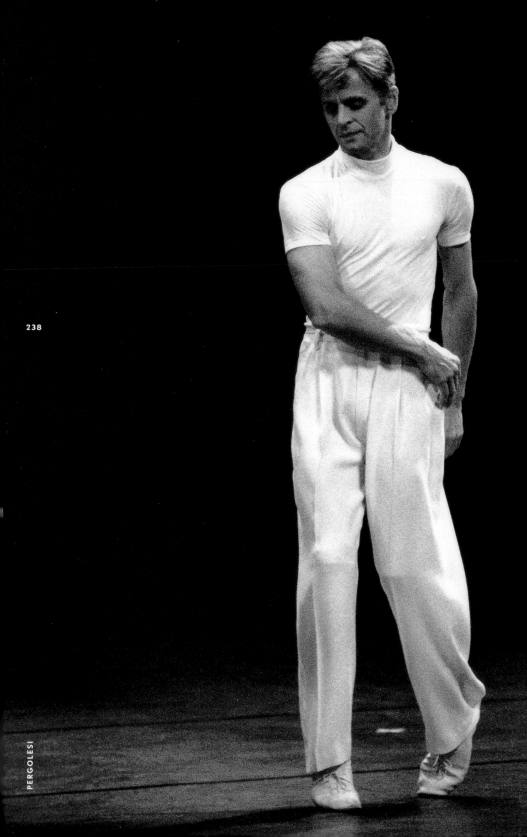

NINETEEN NINETY THREE

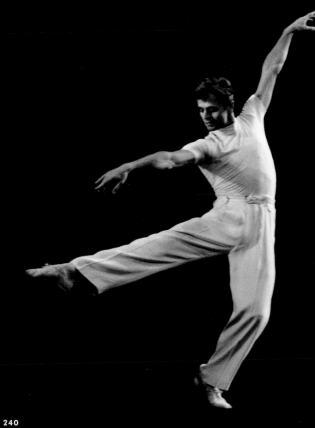

240

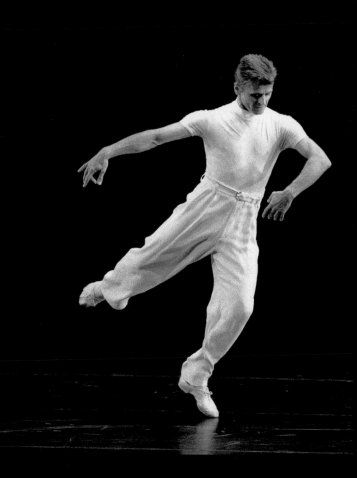

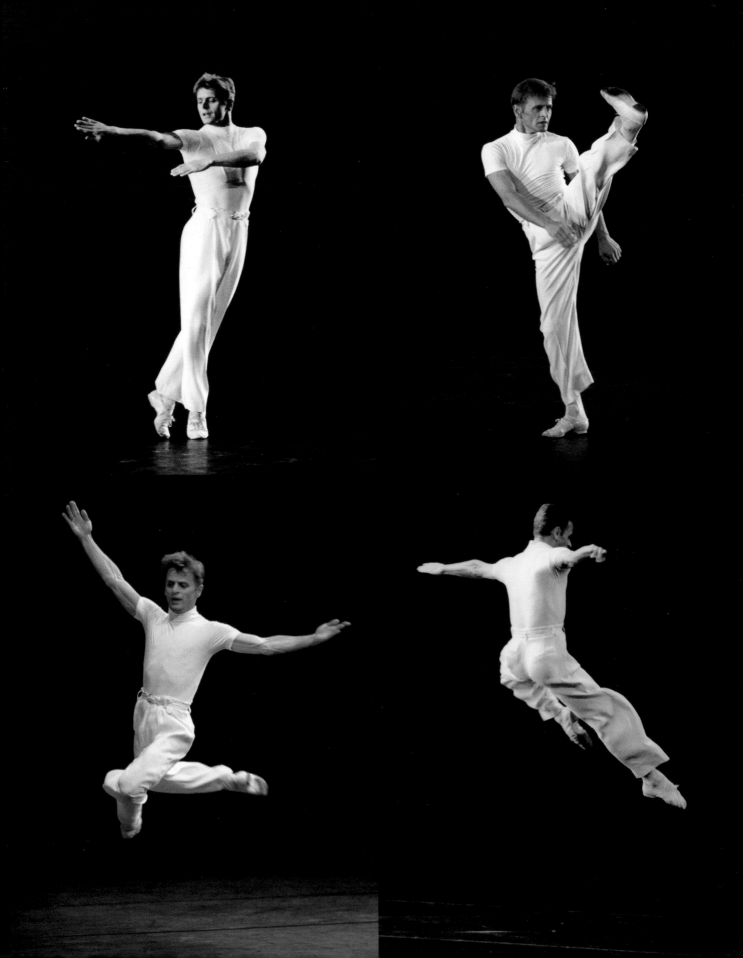

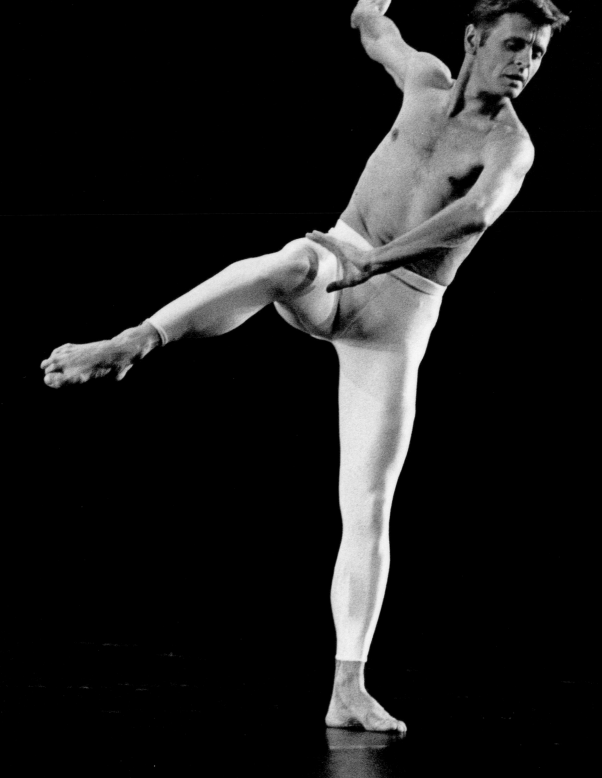

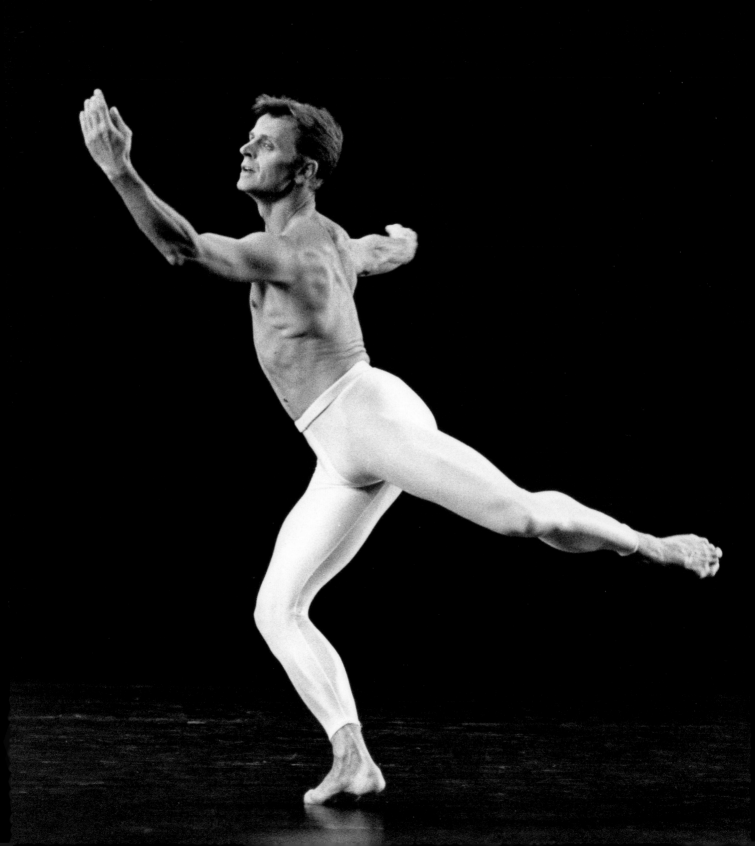

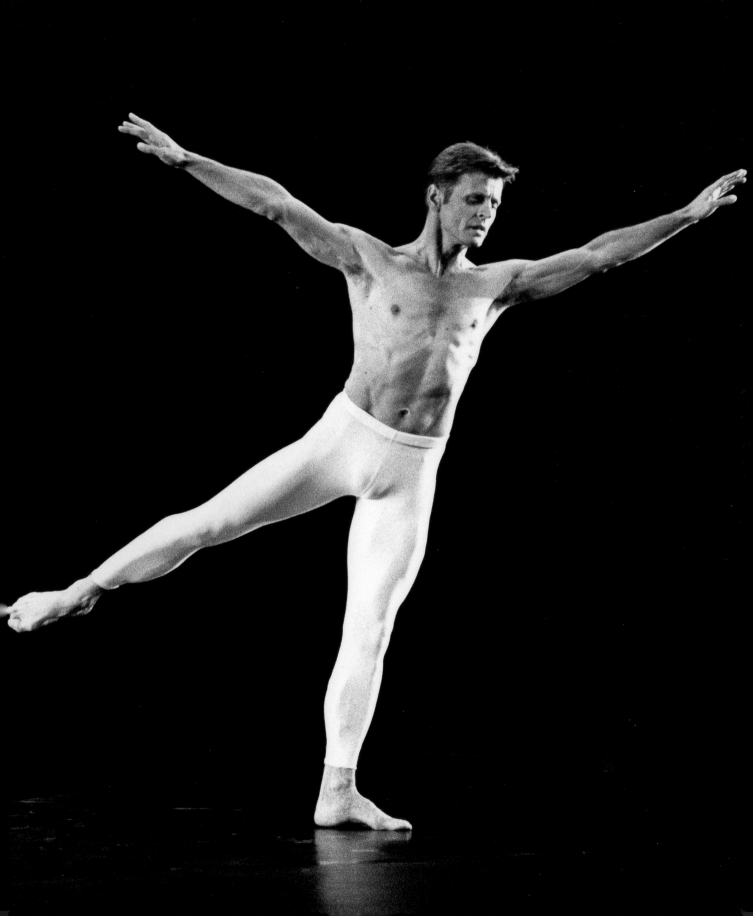

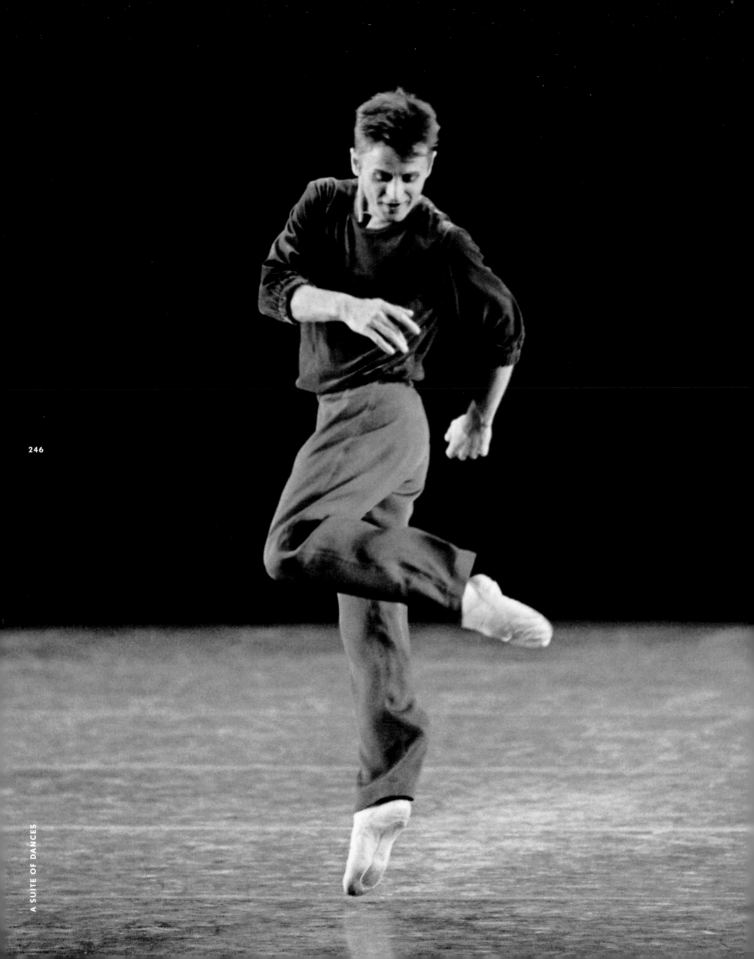

NINETEEN NINETY FOUR

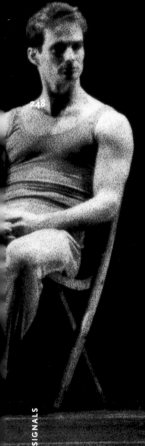

248

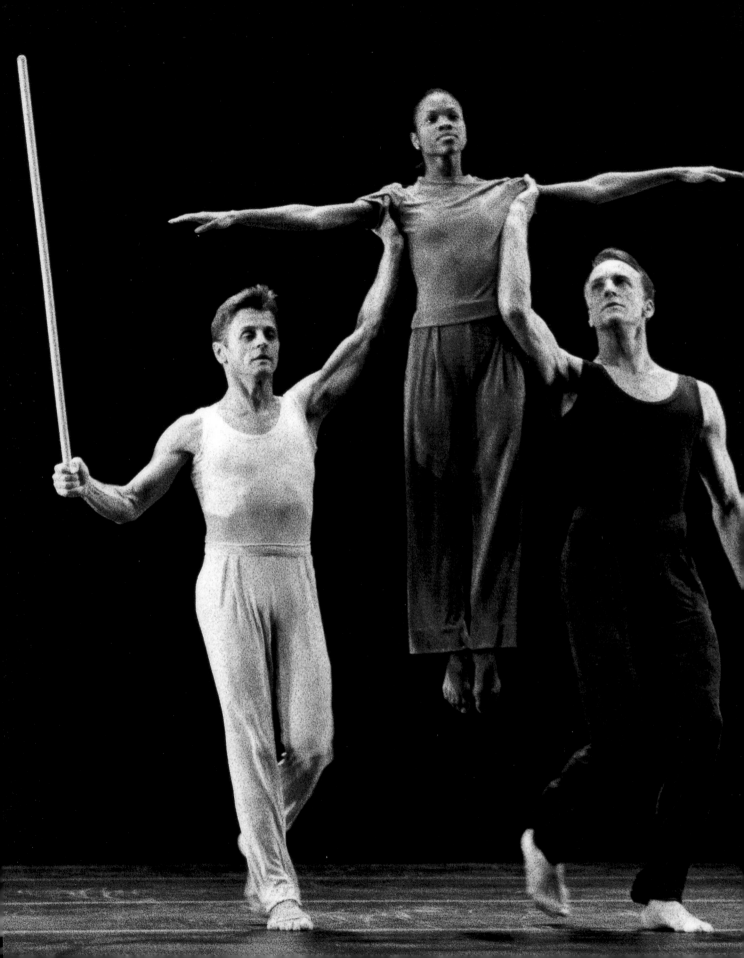

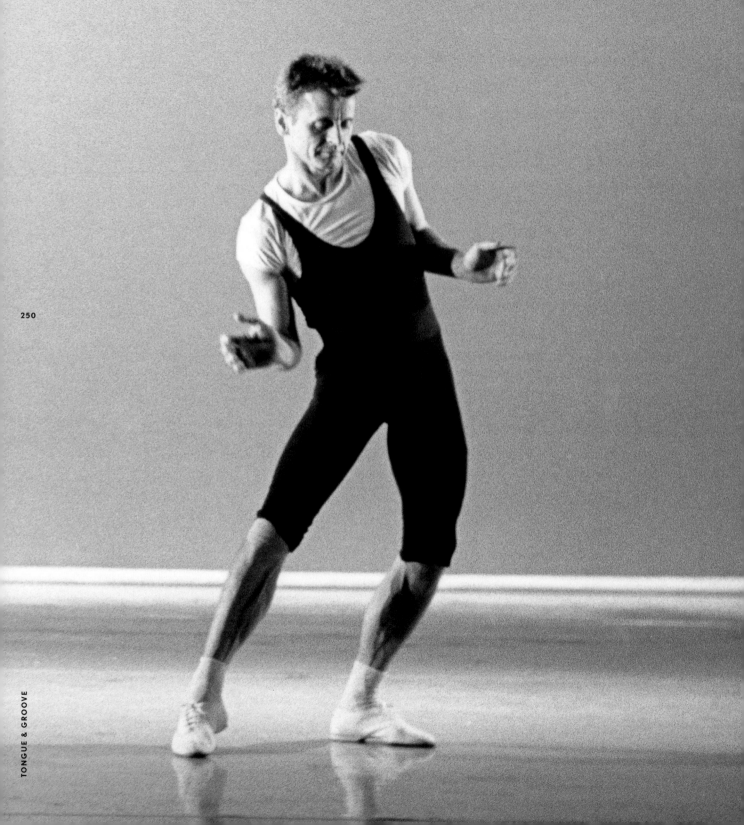

NINETEEN NINETY FIVE

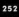

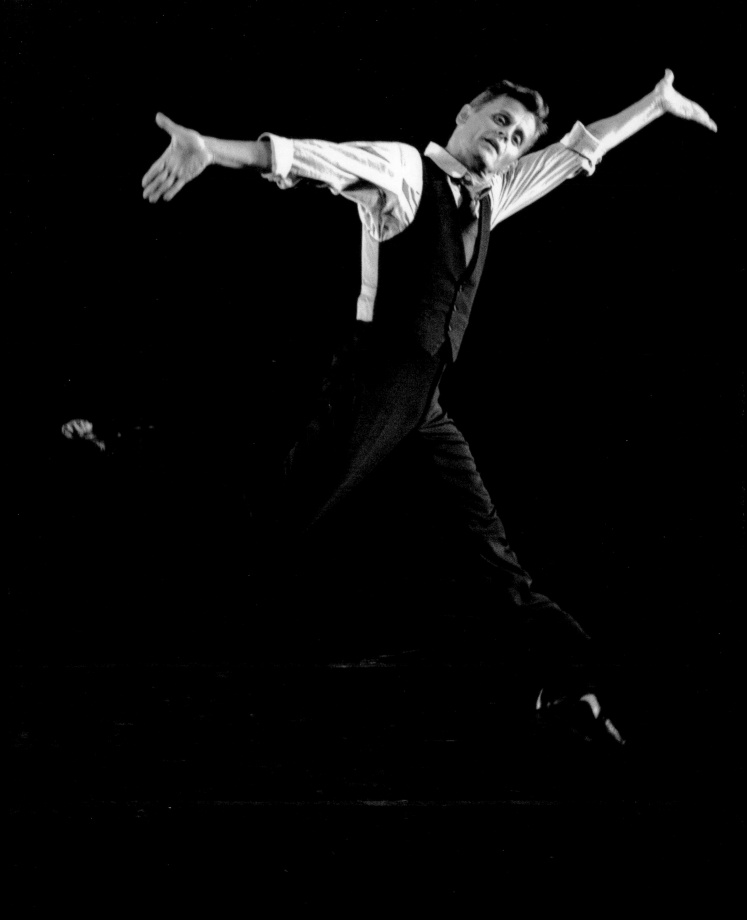

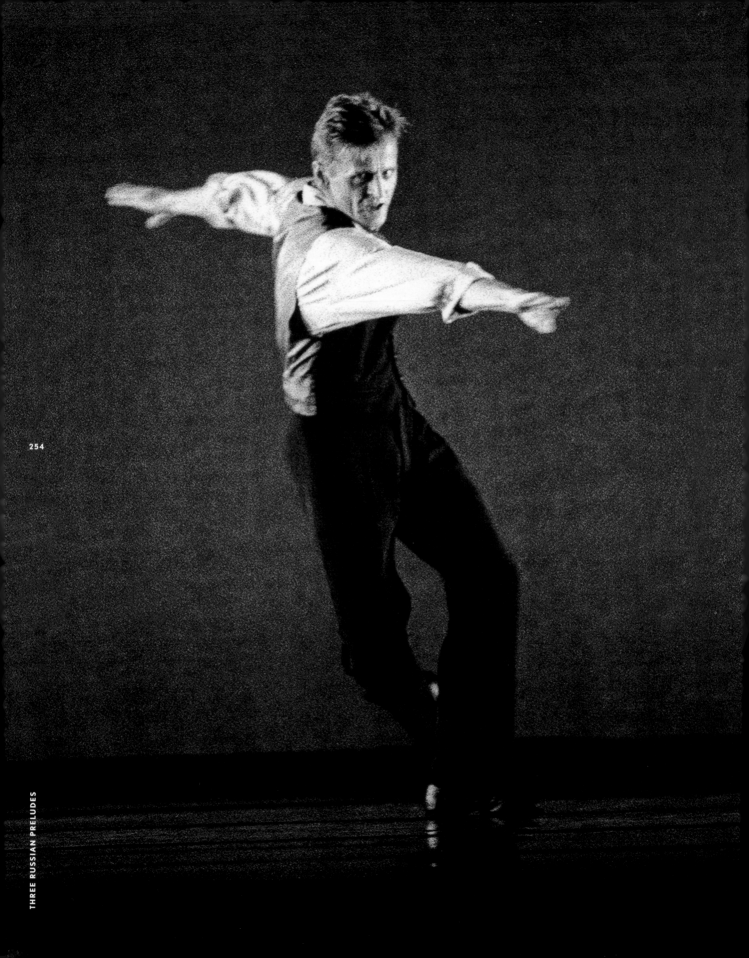

254

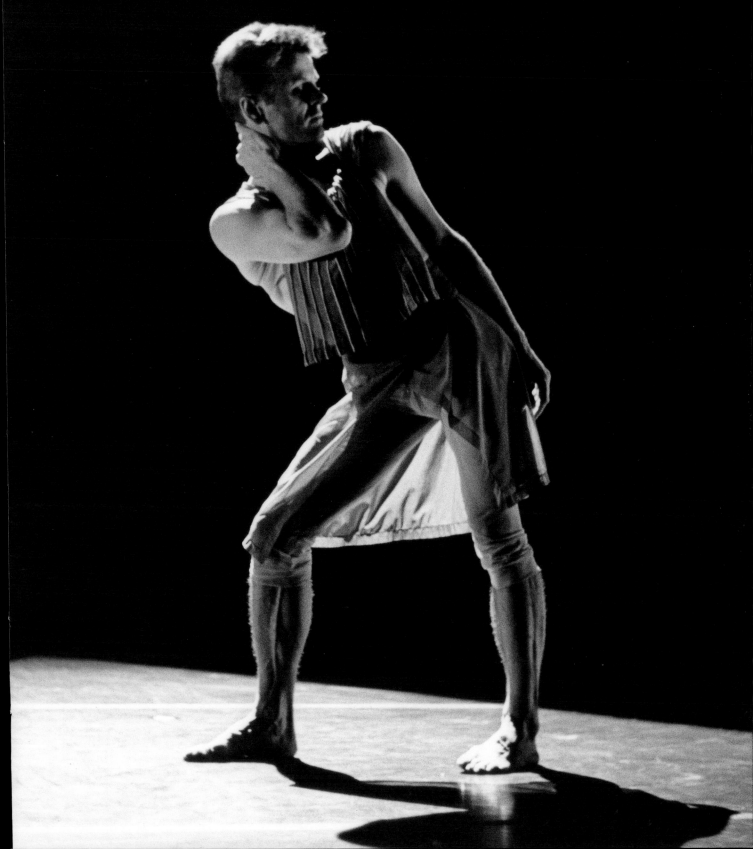

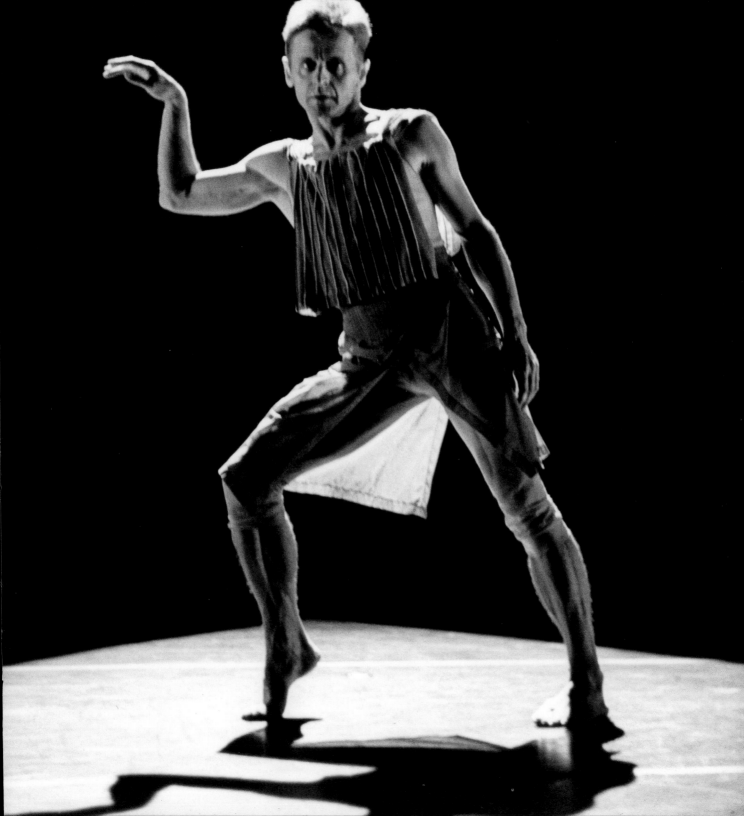

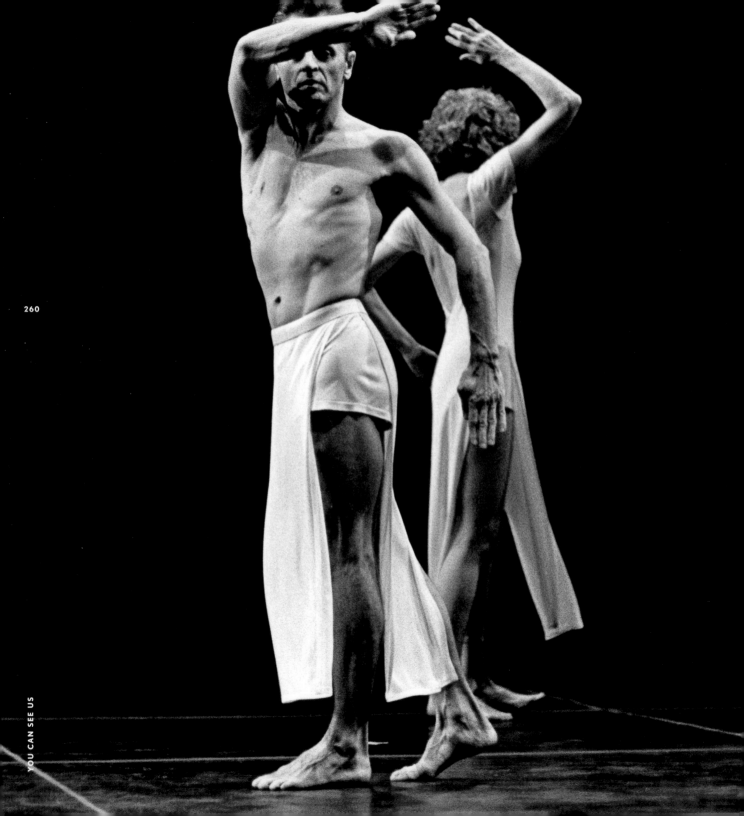

NINETEEN NINETY SIX

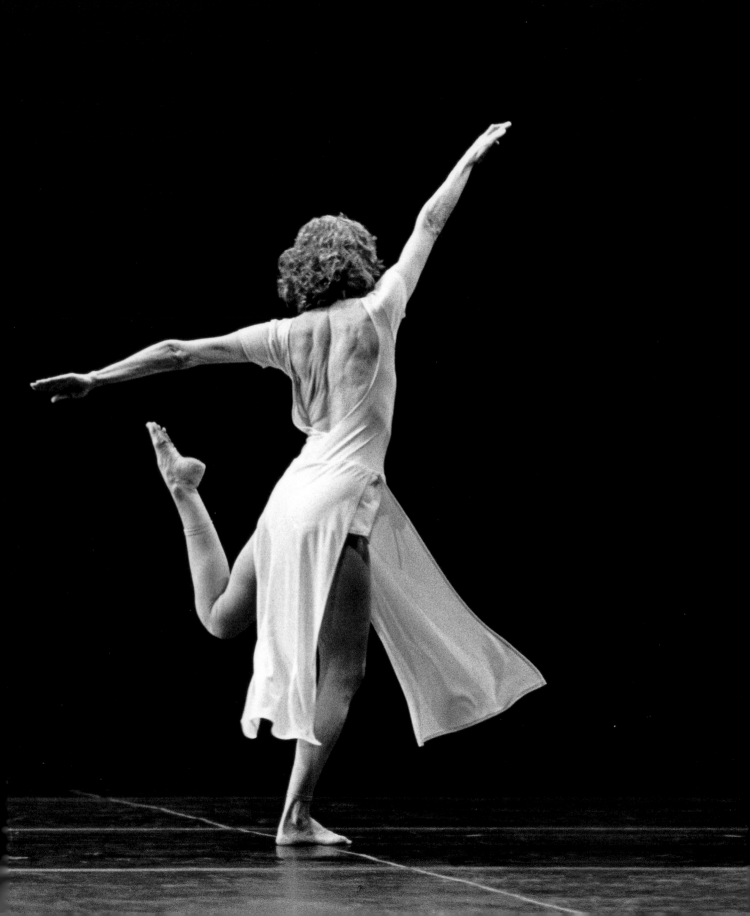

264

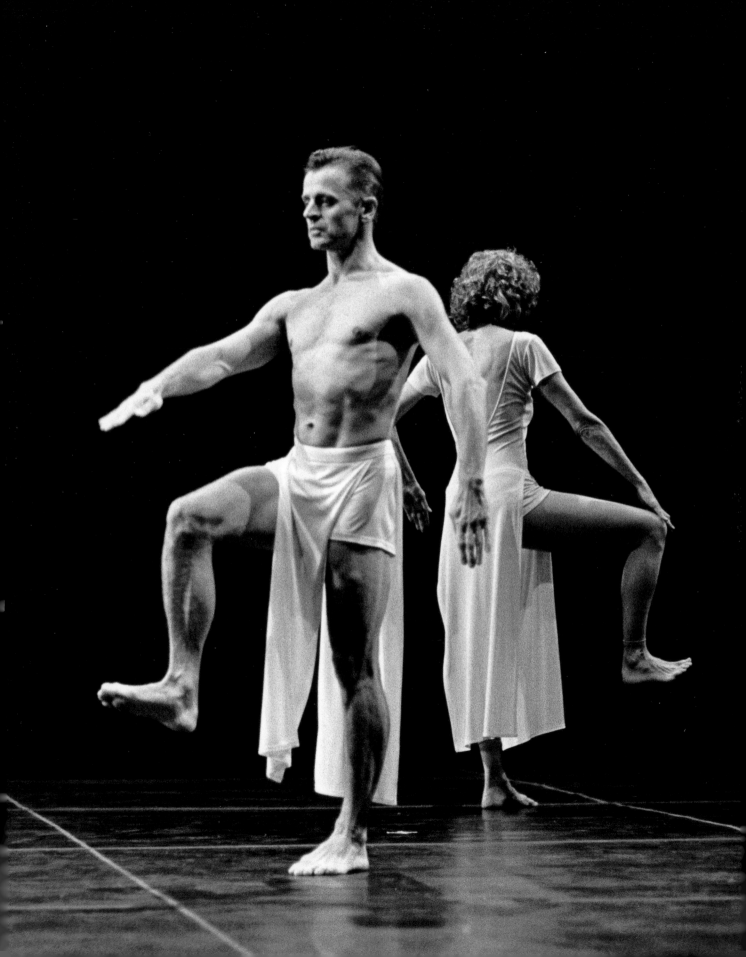

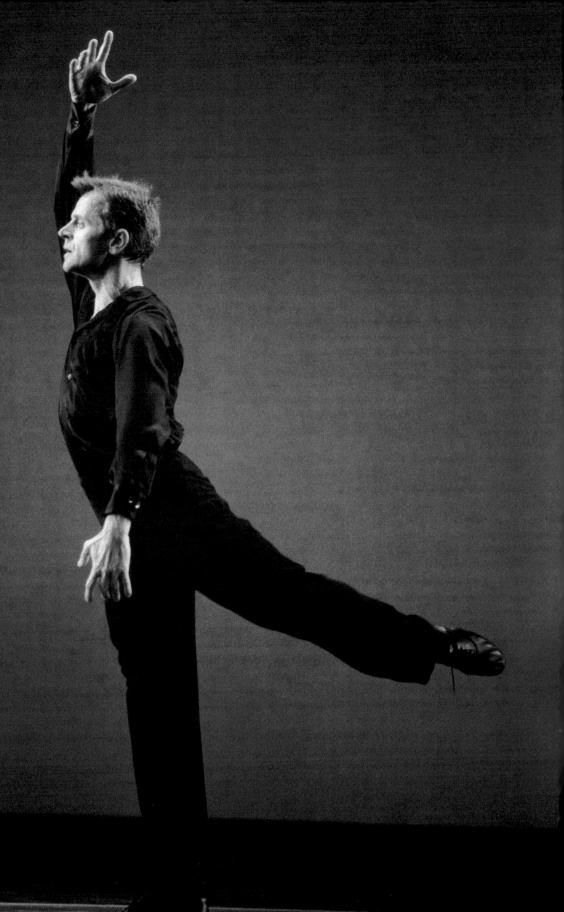

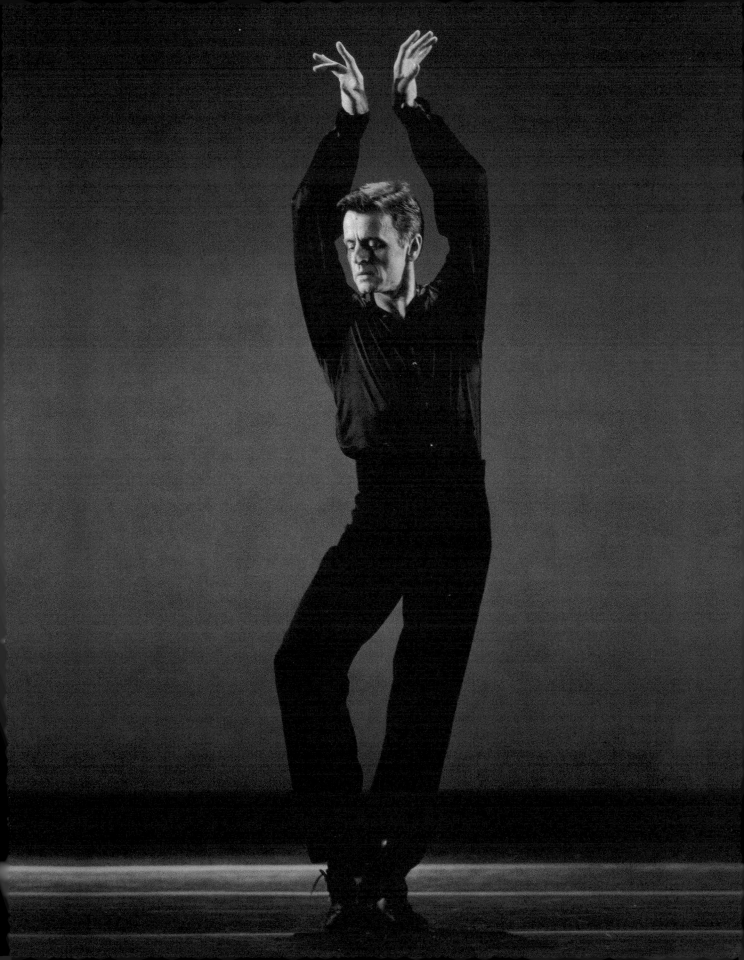

NINETEEN NINETY SEVEN

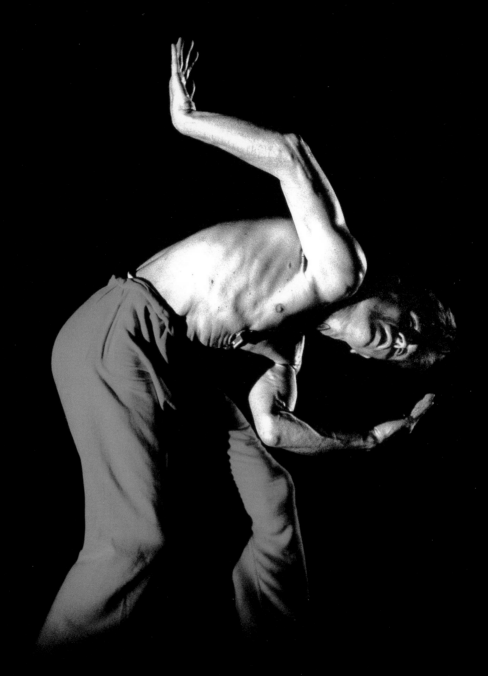

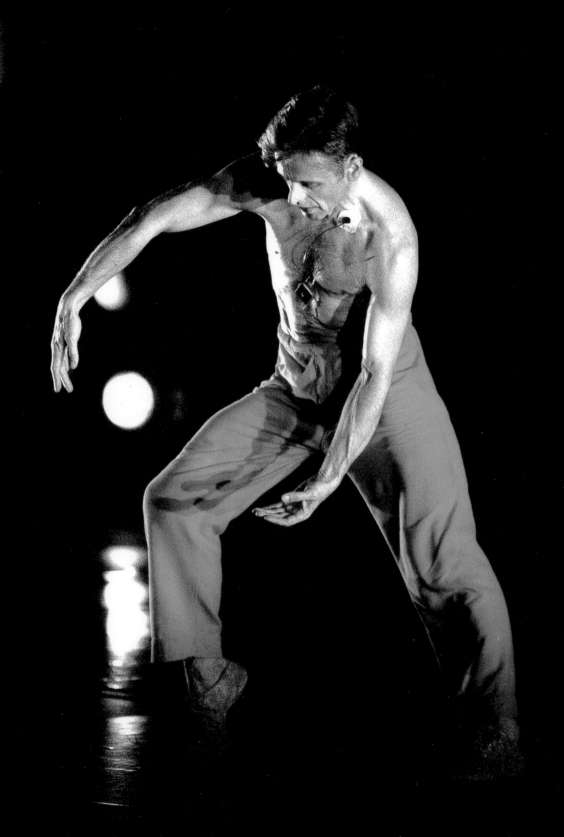

274

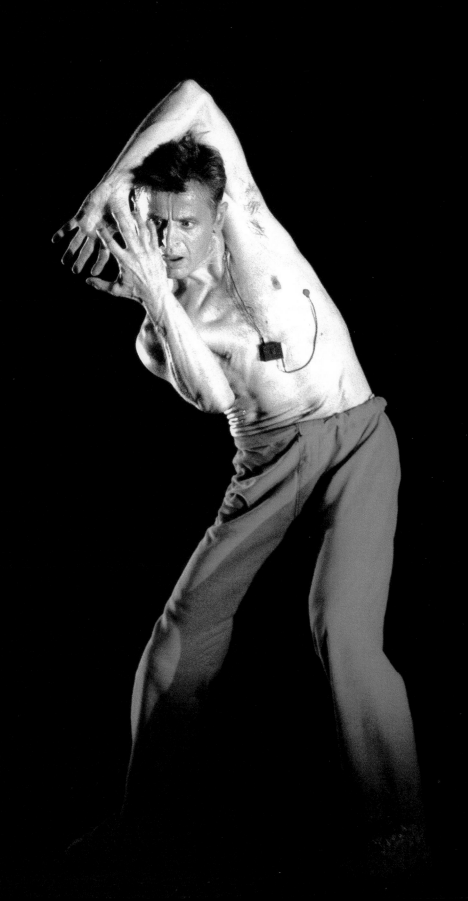

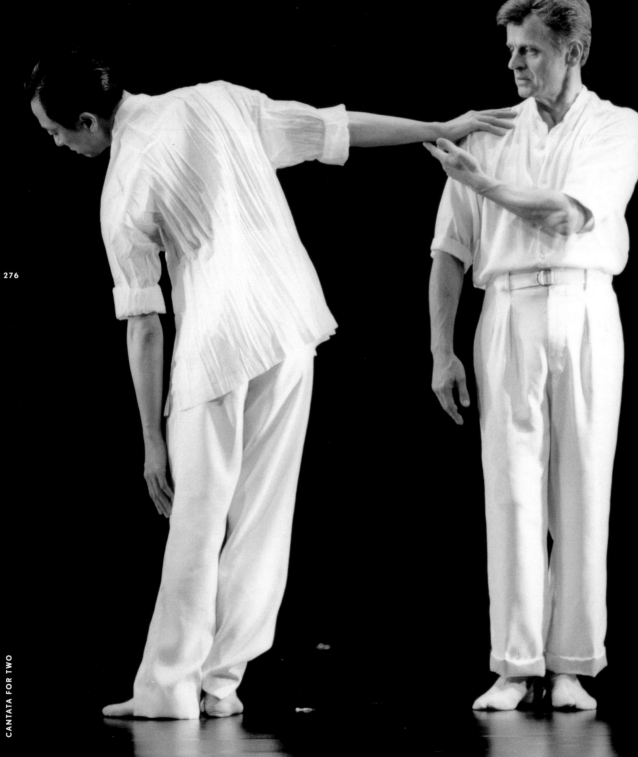

NINETEEN NINETY EIGHT

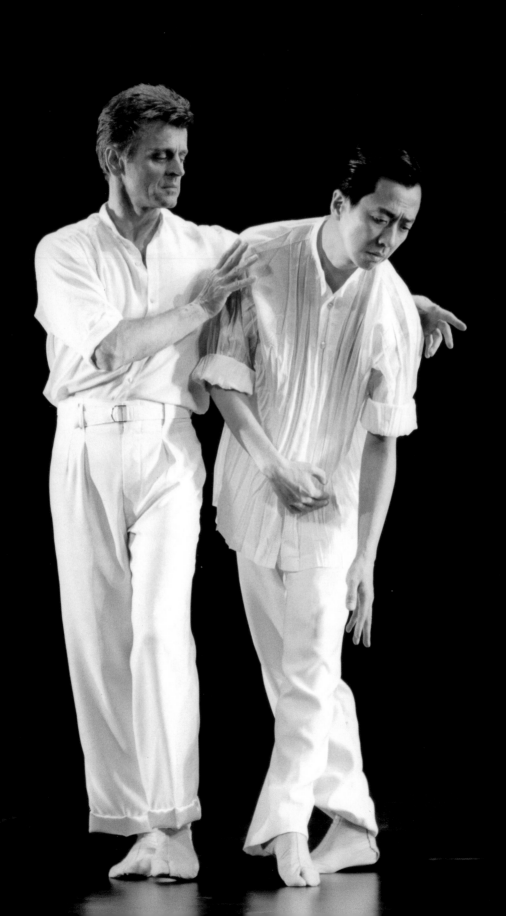

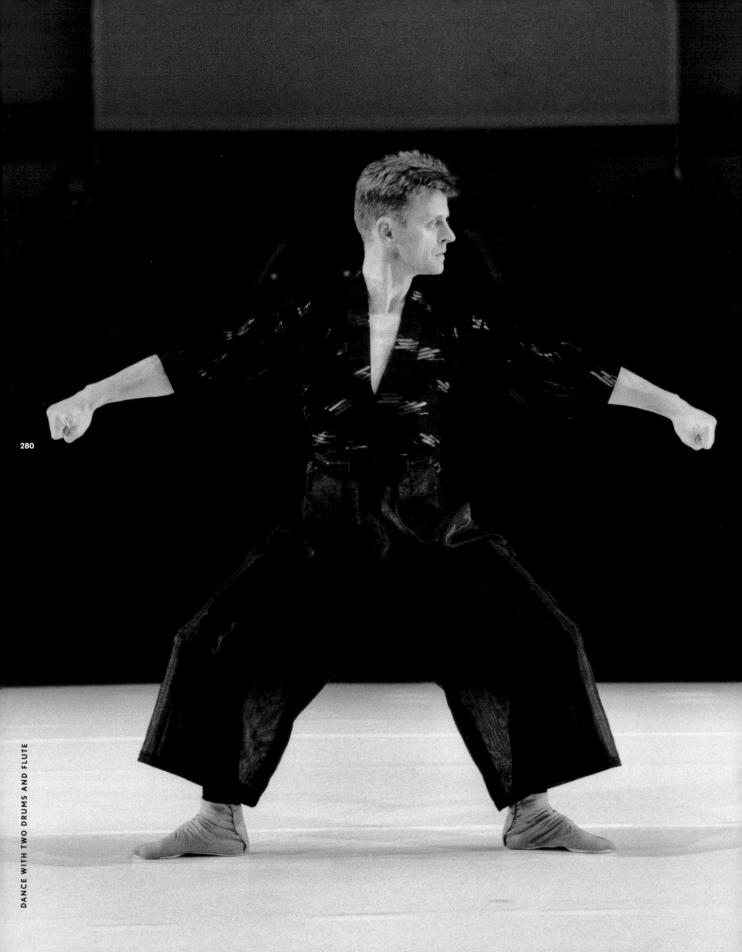

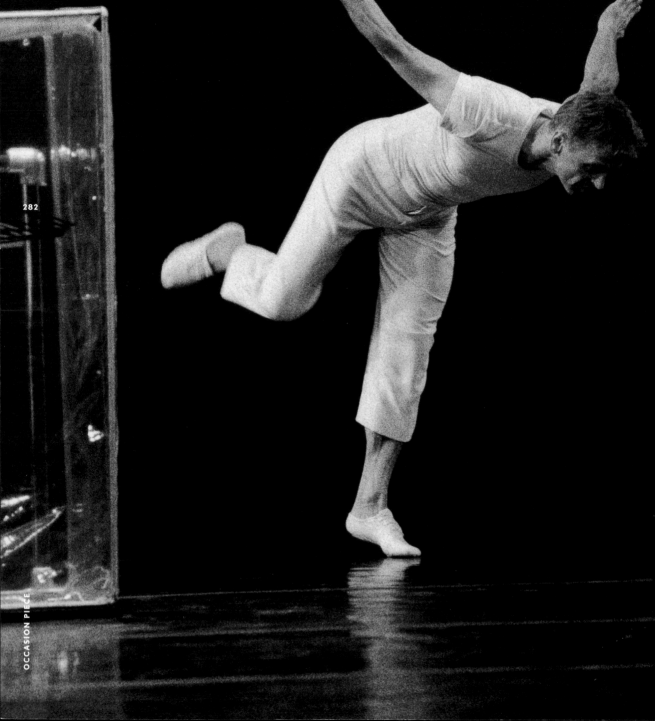

NINETEEN NINETY NINE

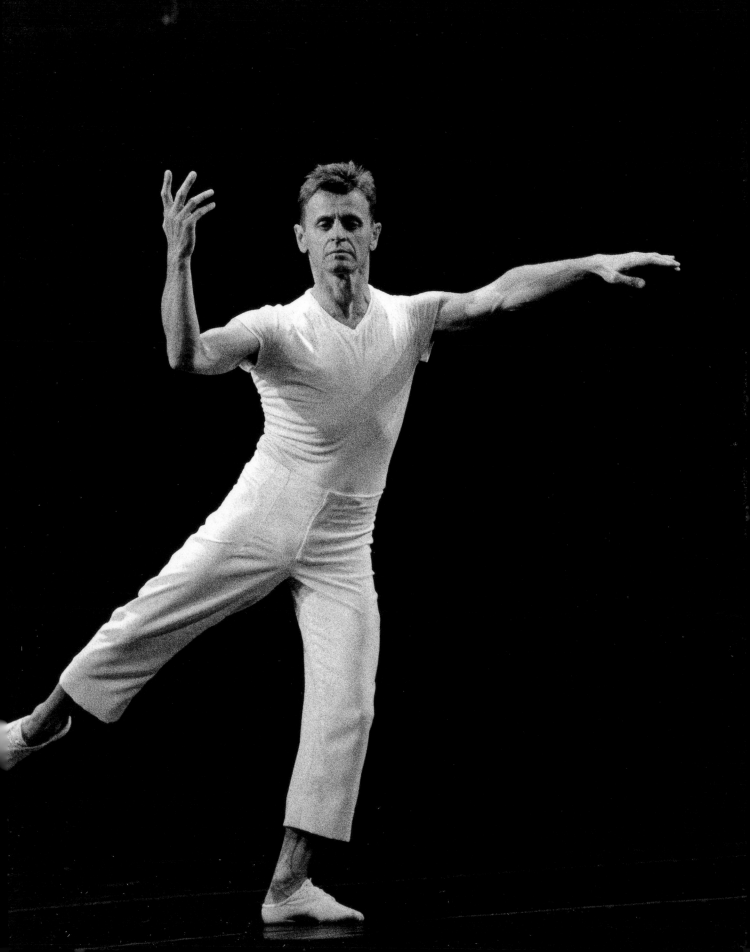

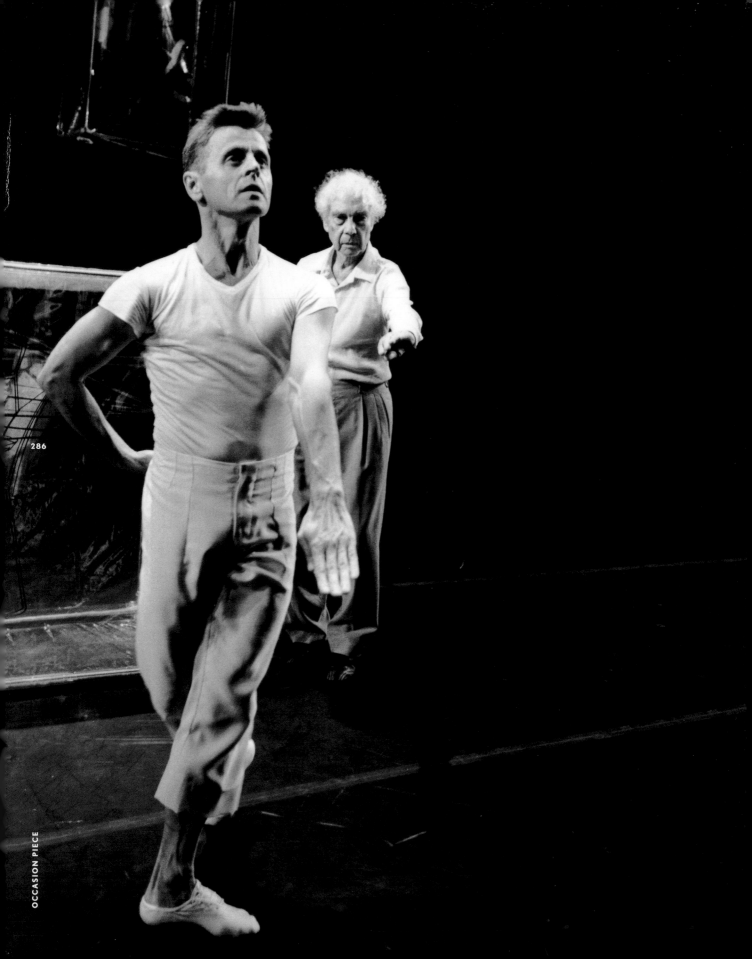

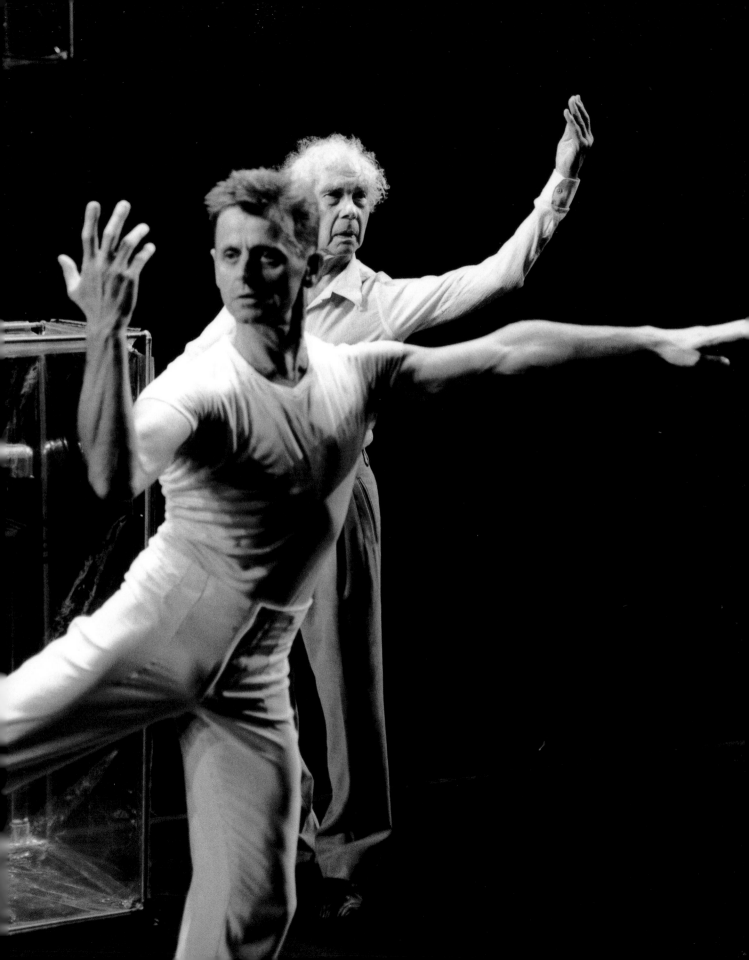

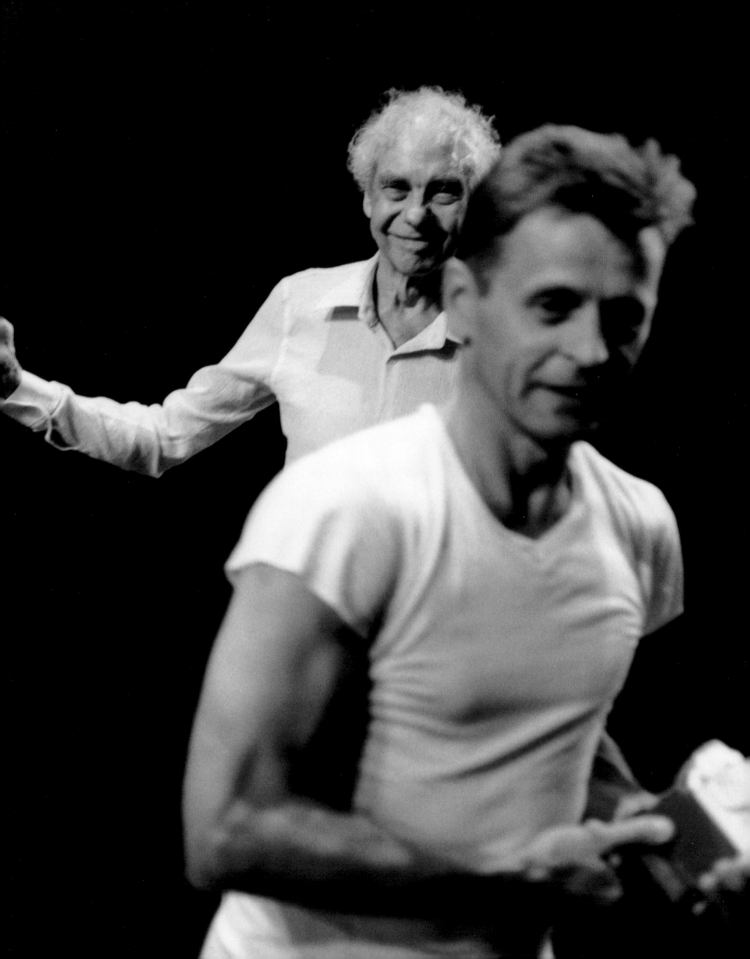

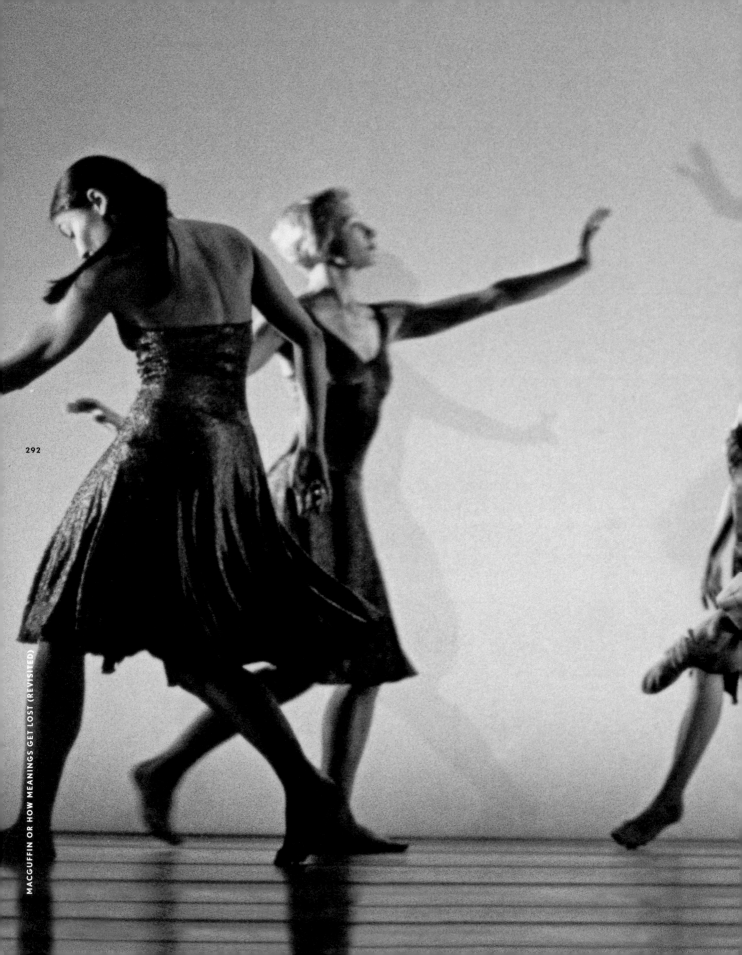

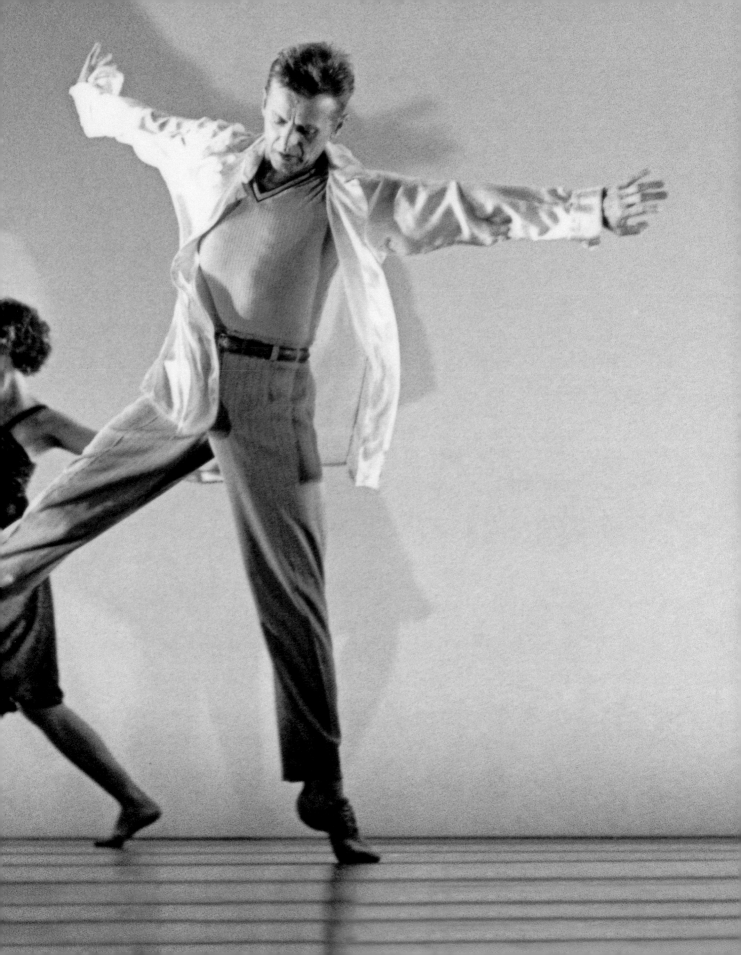

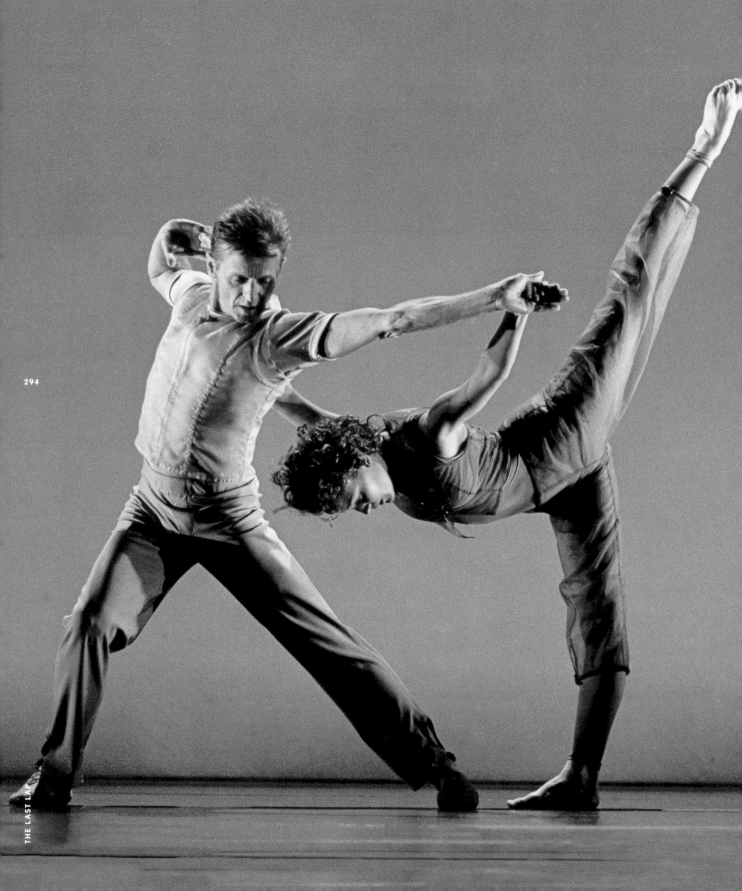

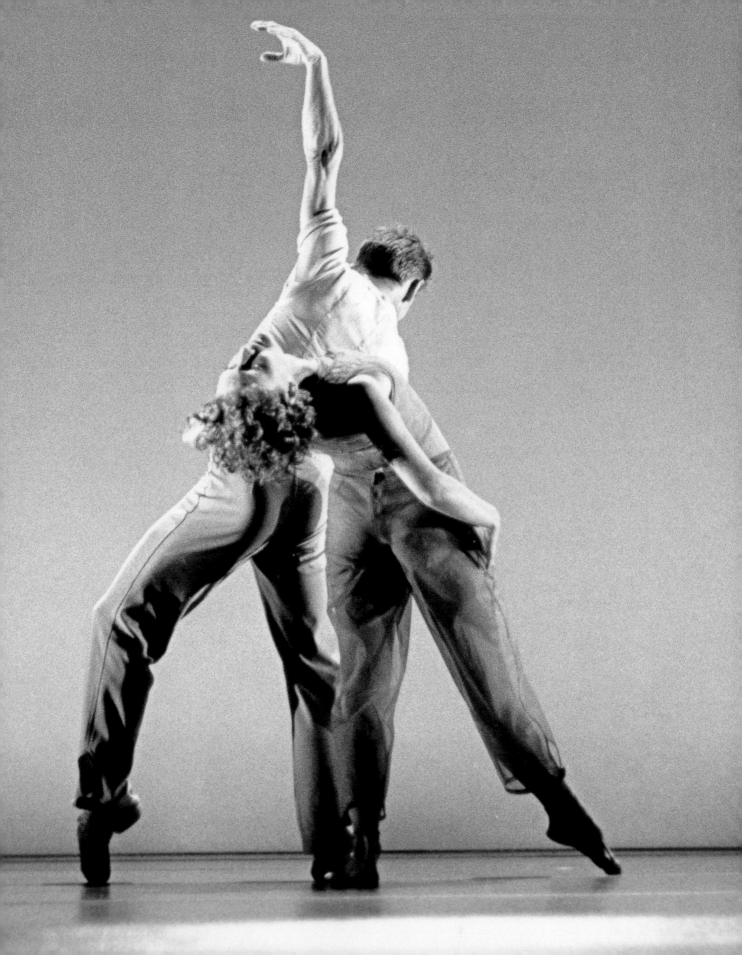

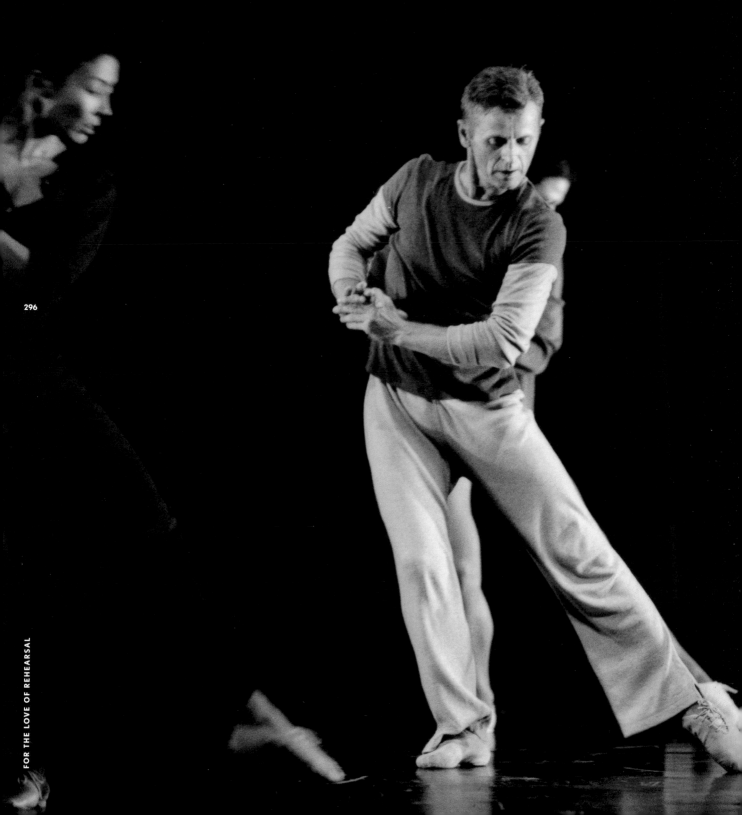

TWO THOUSAND

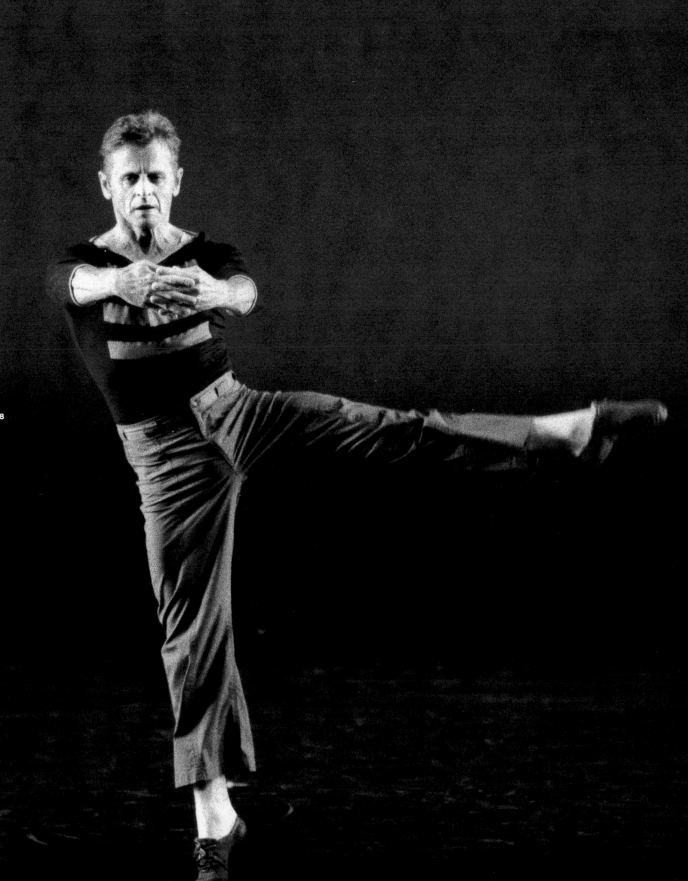

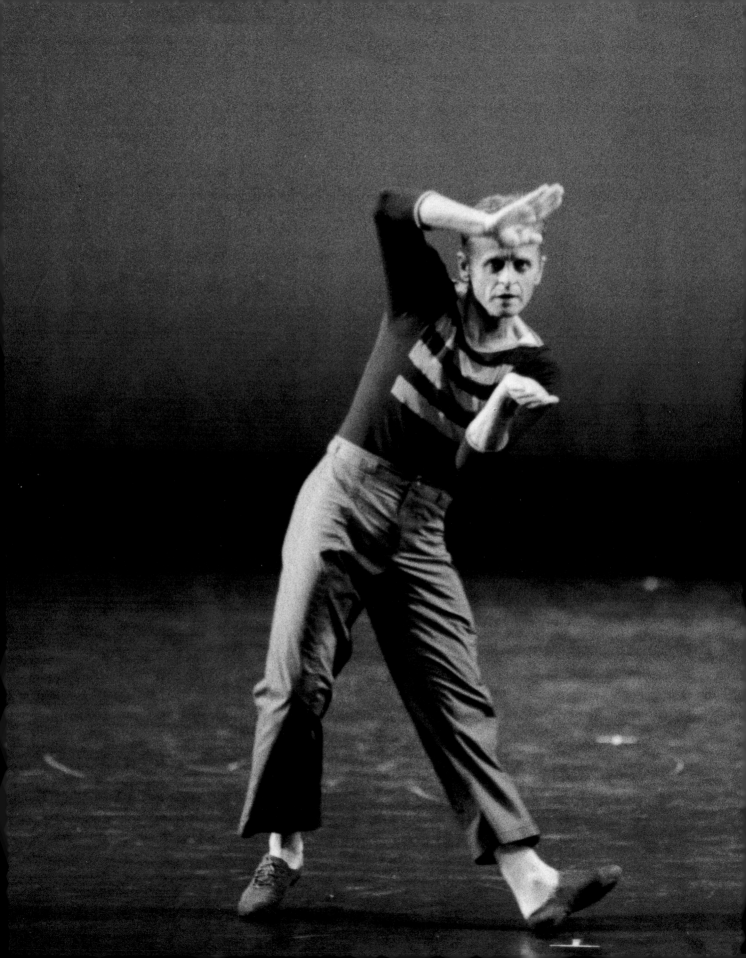

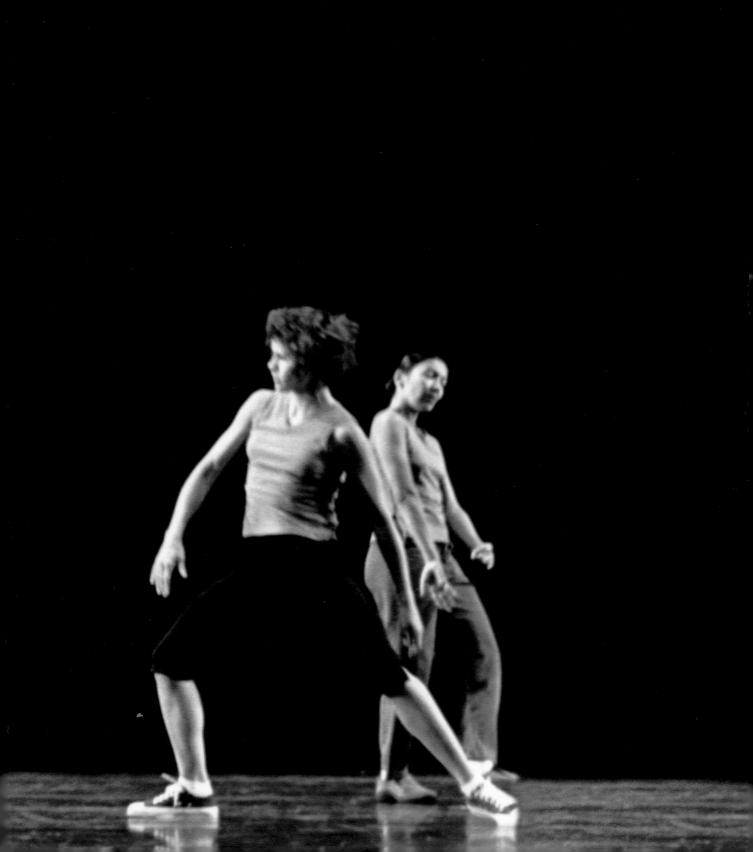

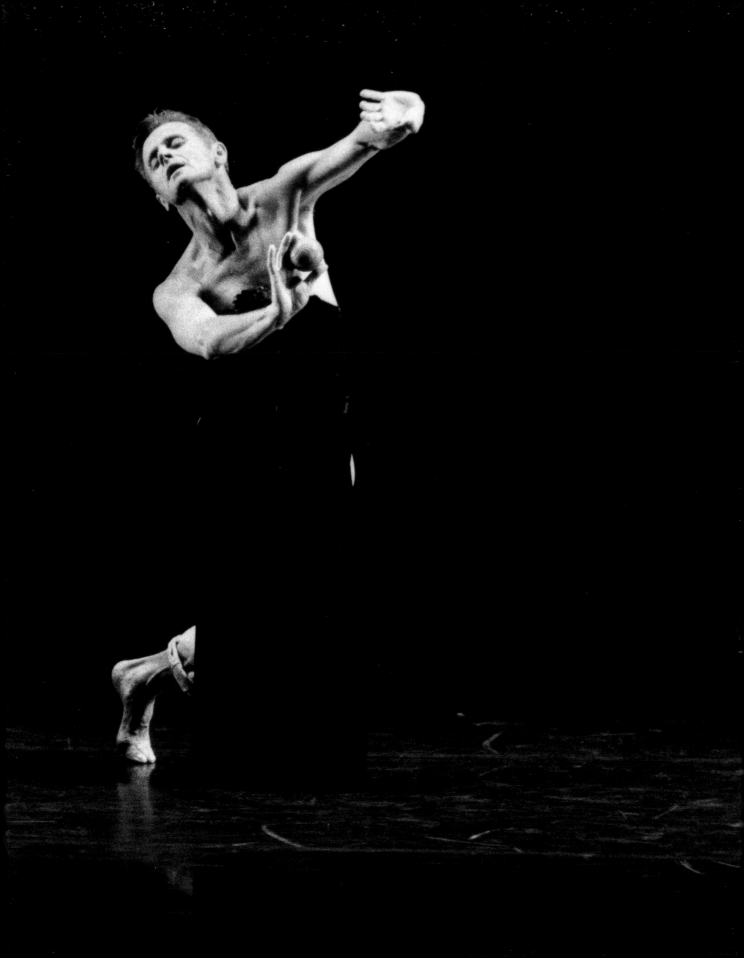

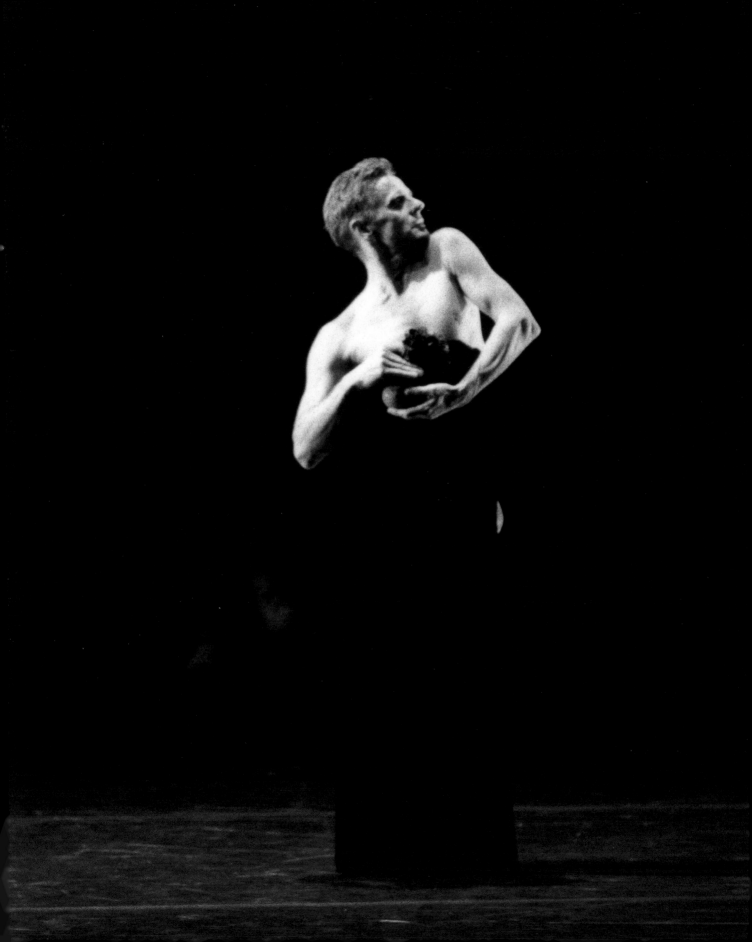

306

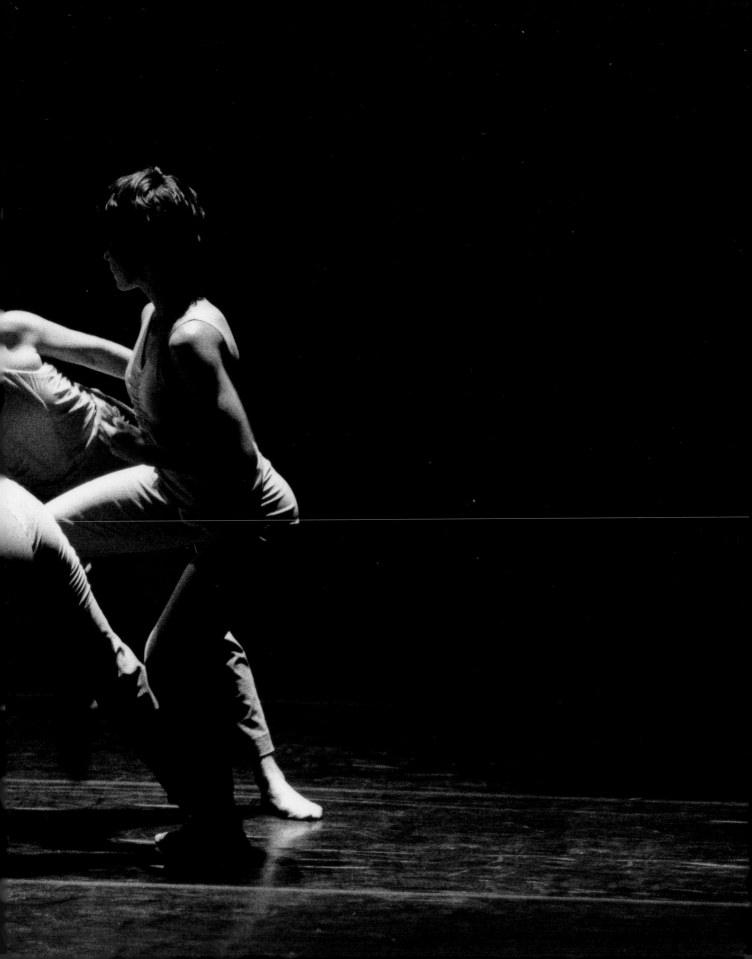

308

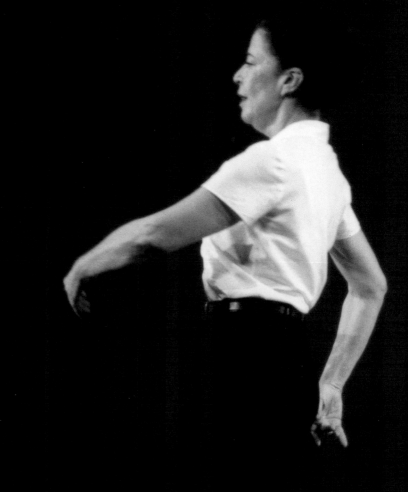

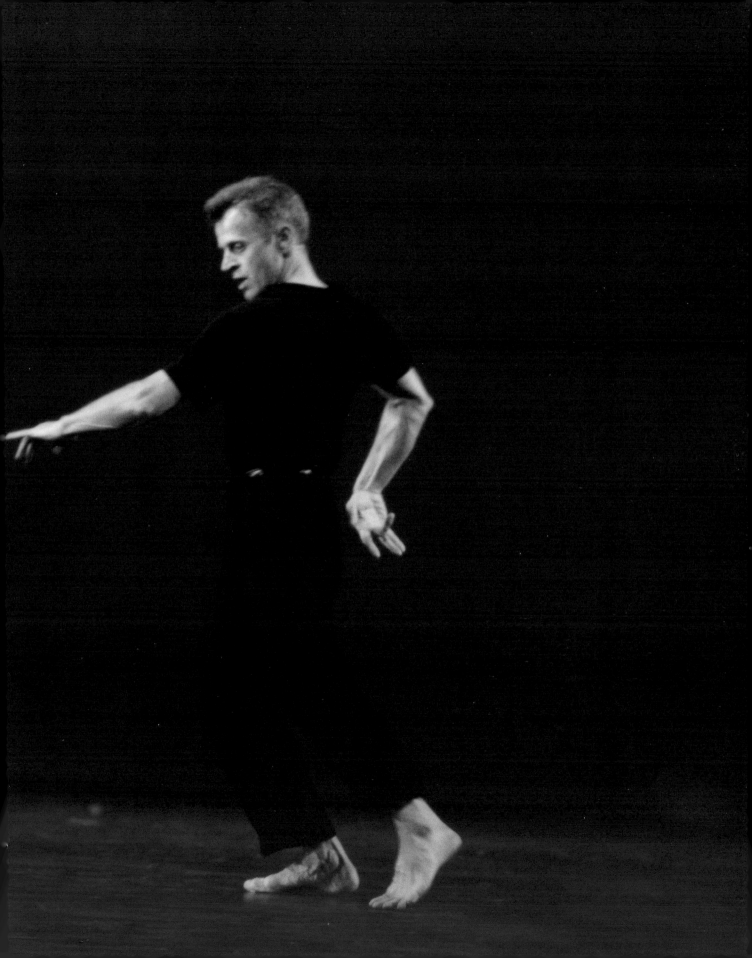

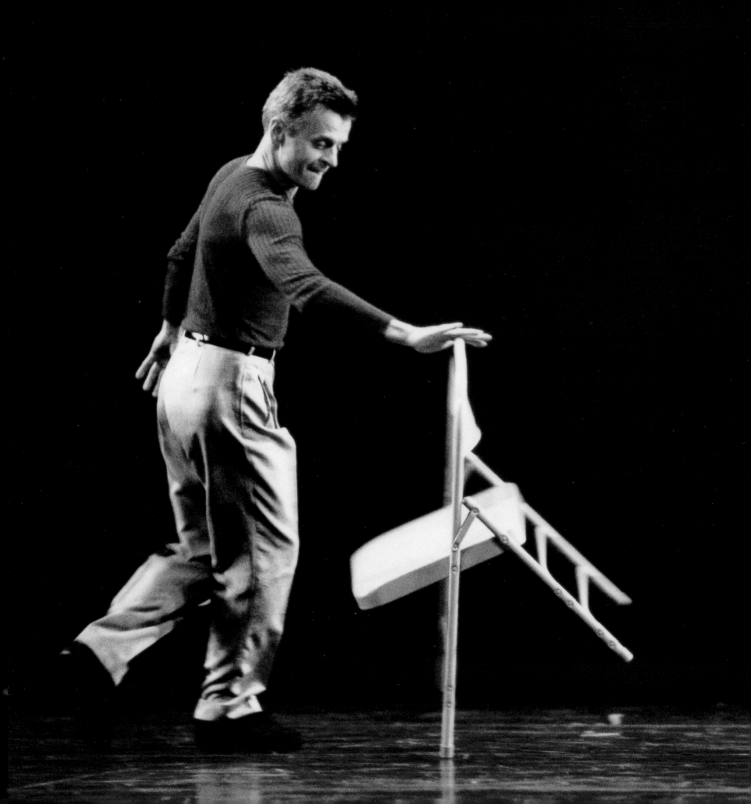

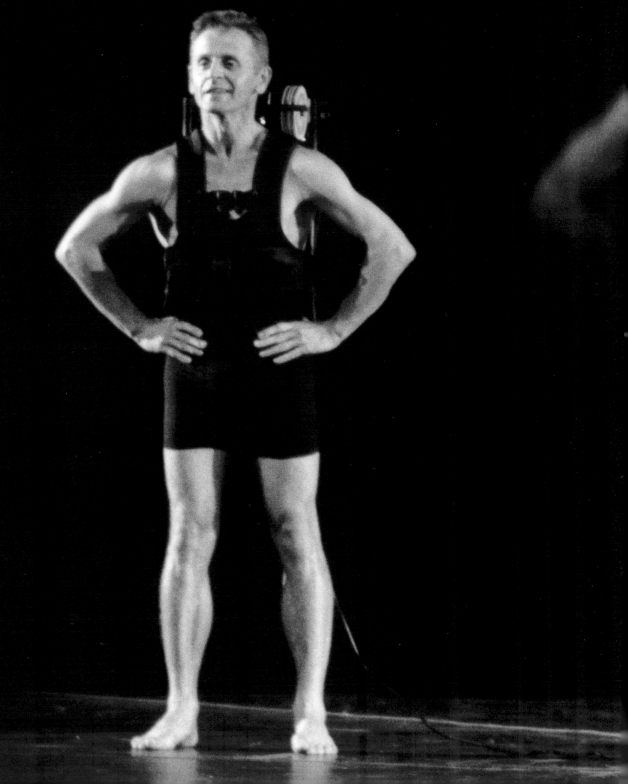

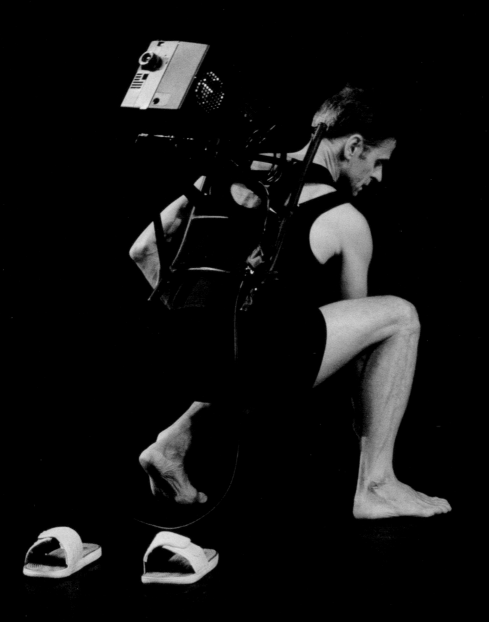

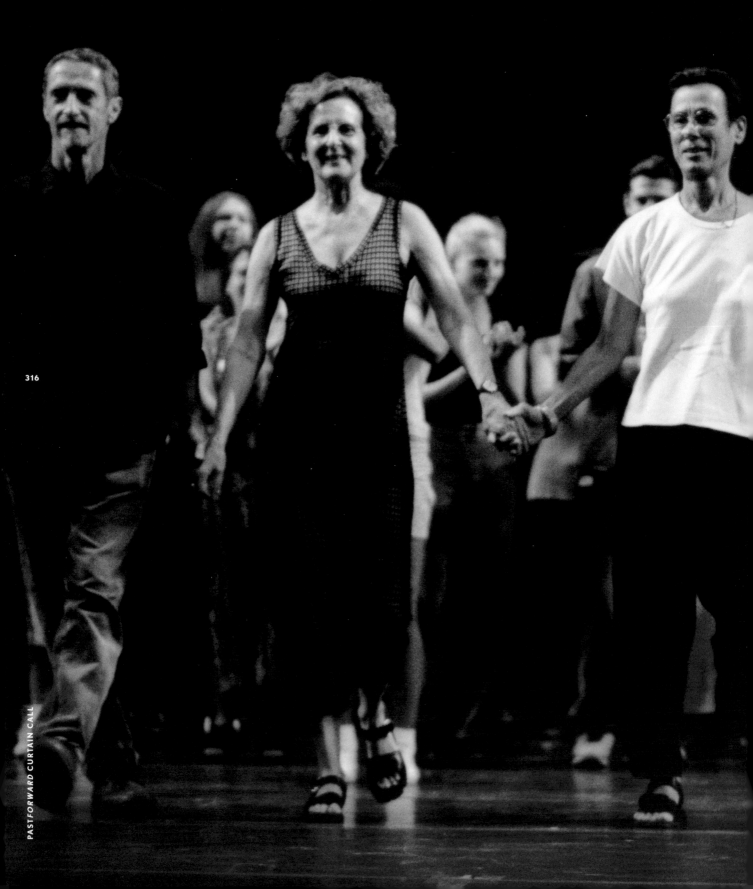

316

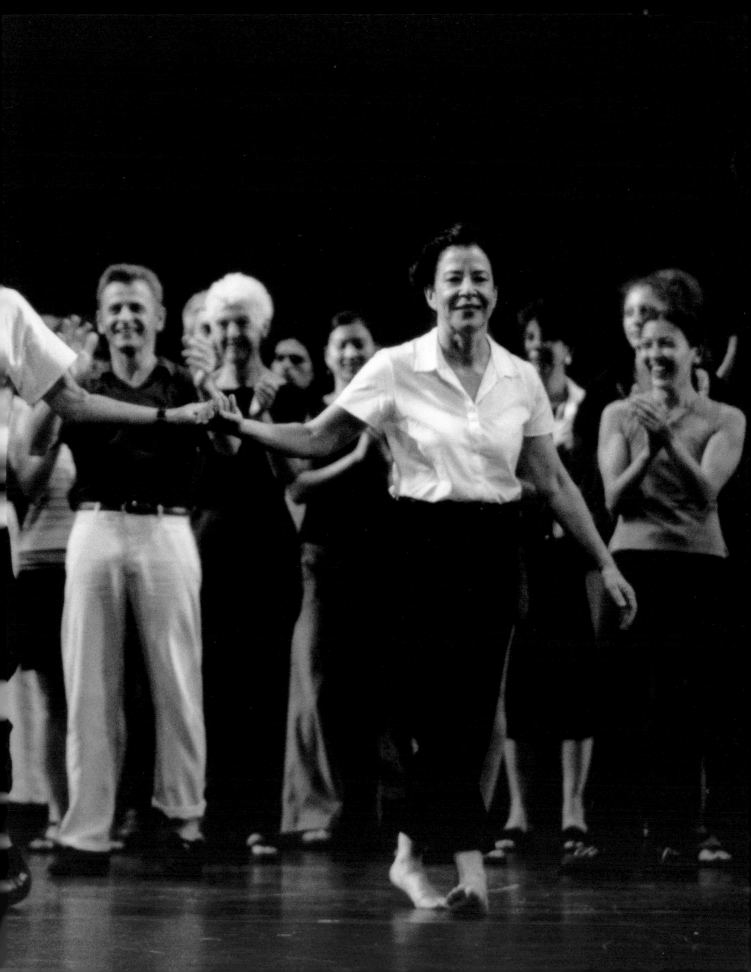

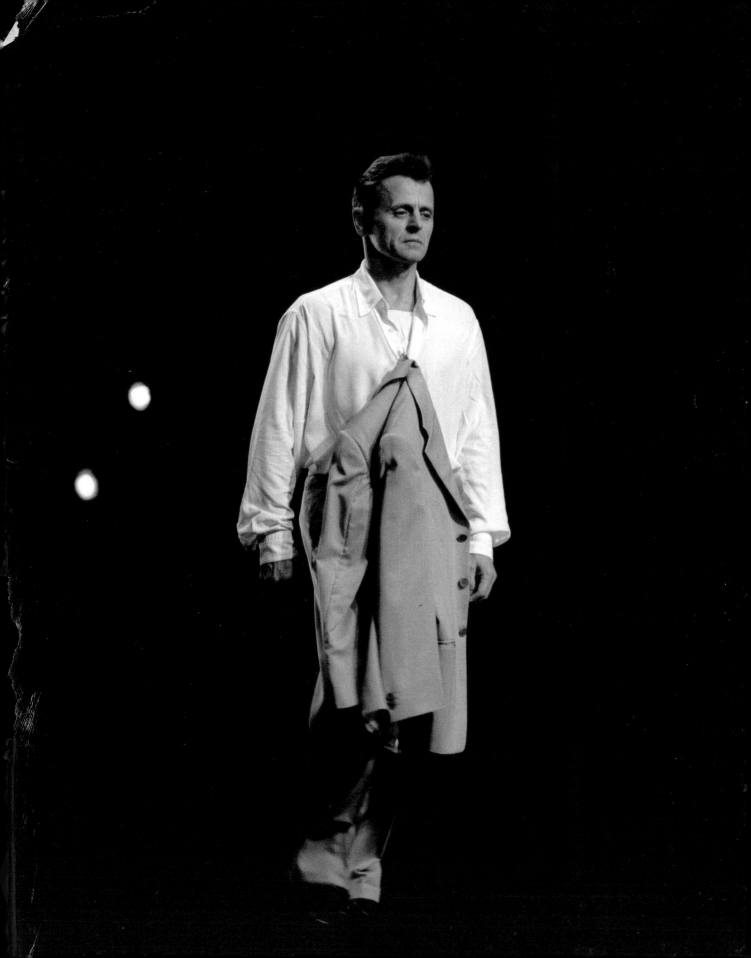

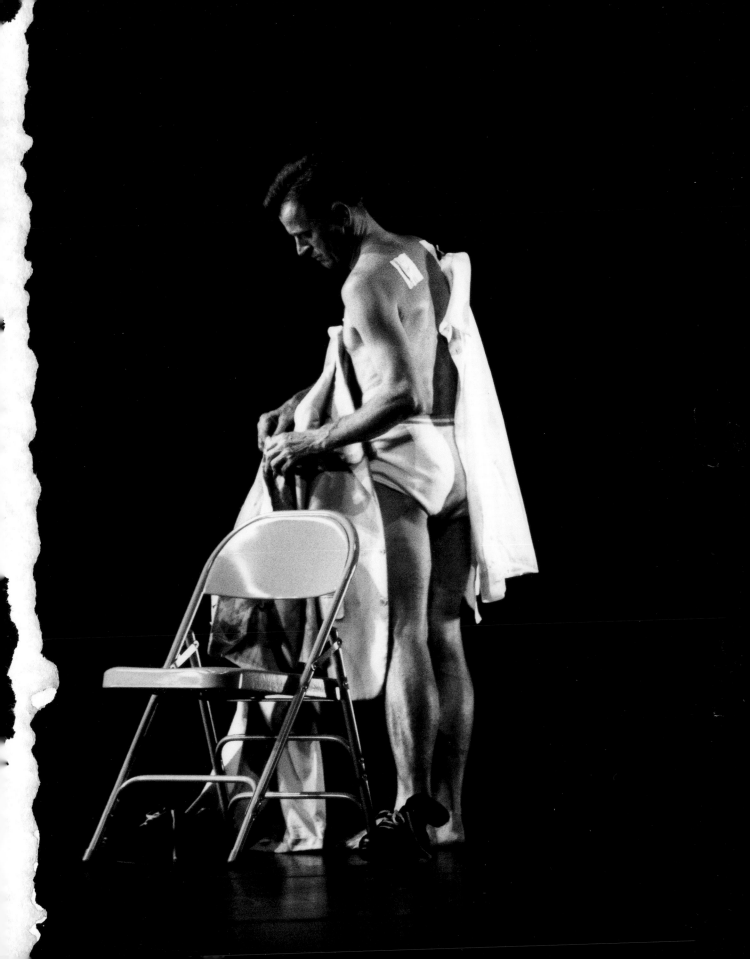